VIENNA BY MAK
PRESTEL MUSEUM GUIDE

Edited by Peter Noever

Edited by Peter Noever

Project coordination: Thomas Gratt, Martina
Kandeler-Fritsch, Johannes Wieninger
Catalogue editing: Martina Kandeler-Fritsch,
Johannes Wieninger
Editorial assistance: Julia König
Copy editing: Evelyn Fertl, Anna Mirfattahi
Translations: Nita Tandon, Michael Strand
Graphic design: Perndl+Co
Production: Prestel Verlag

© Texts, photos by the authors and photographers
© 2008 MAK Vienna and Prestel Verlag
Munich · Berlin · London · New York

Die Deutsche Bibliothek lists this publication
in the Deutsche Nationalbibliografie; detailed
bibliographic data is available in the Internet
at http://dnb.ddb.de

ISBN 978-3-7913-2837-9

Prestel Verlag

Königinstraße 9
D-80539 Munich
tel (+49-89) 24 29 08-300
fax (+49-89) 24 29 08-335

www.prestel.de

4 Bloomsbury Place
London WC1A 2QA
tel (+44-20) 7323-5004
fax (+44-20) 7636-8004

900 Broadway, Suite 603
New York NY 10003
Tel (+1-212) 995-2720
fax (+1-212) 995-2733

www.prestel.com

MAK
Stubenring 5
1010 Vienna, Austria
phone (+43-1) 711 36-0
fax (+43-1) 713 10 26
e-mail office@MAK.at
www.MAK.at

Josef Hoffmann Museum, Brtnice
A joint branch of the Moravská galerie in Brno
and the MAK Vienna
náměstí Svobody 263, 58832 Brtnice,
Czech Republic
phone (+43-1) 711 36-250
e-mail josefhoffmannmuseum@MAK.at

Cooperation **MAK / MUAR** – Shusev State
Museum of Architecture, Moscow

**MAK Center for Art and Architecture,
Los Angeles**

Schindler House
835 North Kings Road
West Hollywood, CA 90069, USA
phone (+1-323) 651 1510
Fax (+1-323) 651 2340
e-mail office@MAKcenter.org
www.MAKcenter.org

Mackey Apartments
MAK Artists and Architects-in-Residence Program
1137 South Cochran Avenue
Los Angeles, CA 90019, USA

Fitzpatrick-Leland House
MAK UFI – Urban Future Initiative
Mulholland Drive/8078 Woodrow Wilson Drive,
Los Angeles, CA 90046, USA

THE SCHINDLER HOUSE

FOR ART·ARCHITECTURE, L.A.

CENTER

CONTENTS

4 **Mission Statement**

7 **The History of the MAK**

15 **The Permanent Collection**
16 Artistic Interventions
18 Romanesque Gothic Renaissance
28 Baroque Rococo Classicism
38 Renaissance Baroque Rococo
48 Empire Style Biedermeier
58 Historicism Art Nouveau
68 Art Nouveau Art Déco
84 Wiener Werkstätte
94 20th/21st Century Architecture
100 Contemporary Art
108 Orient
118 Asia
126 Artists' Biographies

129 **The Study Collection**
132 Works on Paper Room
134 Design Info Pool
138 Study Collection: Glass
142 Study Collection: Ceramics
144 Study Collection: Metal
148 Study Collection: Seating Furniture
150 The Frankfurt Kitchen
152 Furniture in Focus
154 Study Collection: Textiles

159 **Other Scientific Institutions**
160 Library and Works on Paper Collection
162 Restoration Department

165 **The Exhibitions**

189 **The MAK Branches**
190 MAK Depot of Contemporary Art Gefechtssturm Arenbergpark
194 CAT – Contemporary Art Tower
196 Geymüllerschlössel
198 The MAK in Public Space
202 Josef Hoffmann Museum, Brtnice
204 MAK Center for Art and Architecture, Los Angeles

207 **Vienna by MAK**
208 MAK Tips
217 MAK Tours

225 **Service**

239 **MAK Publications**
243 **Index of Artists and Persons**
249 **Maps**
256 **Photo Credits**

Peter Noever, 2007

MISSION STATEMENT

The MAK is a center for ART. At the MAK, the ideas of the artist and the intentions of the work are given free rein. Often art is created on the premises; and if necessary, art is defended.

The MAK is a hub of emerging global communication. Thus, the MAK Center for Art and Architecture in Los Angeles[1], and the Artists and Architects in Residence program at the Mackey Apartments, as well as the MAK UFI – Urban Future Initiative at the Fitzpatrick-Leland House are central to an intense discourse on the interweaving of contemporary themes in art and architecture.

With an extraordinary collection of applied and contemporary art, the MAK serves a dual purpose as a conservator of significant art objects and as a center for the scientific research of art with a special emphasis on its production, preservation, and reorientation. The MAK regards itself as a laboratory of artistic production and a research center of social awareness. The powerful ideas created here today will serve as models for tomorrow.

Founded in 1864 as the Imperial Royal Austrian Museum of Art and Industry, the MAK has pursued a continued commitment to combining practice and theory, art and industry, production and reproduction. The School of Applied Arts, originally an outgrowth of the Museum, was later developed into an independent institution, known today as the University of Applied Arts.

When the Museum was restructured and remodelled in 1986, the Museum's original purpose was reconfirmed and radically expanded. The current MAK identity was created and a fundamental agenda, bold and decentralized, was introduced. One of the significant elements of the restructuring included the exhibition design for the presentation of objects determined by the interventions of contemporary artists. The

development of new display strategies for the permanent collections reorganized formal modes of presentation, allowing an unparalleled interplay of historicism and contemporary intervention. Artists involved with the re-presenting of historical artifacts have included Barbara Bloom, eichinger oder knechtl, Günther Förg, Gangart, Franz Graf, Jenny Holzer, Donald Judd, Peter Noever, Manfred Wakolbinger, Heimo Zobernig, Sepp Müller, Hermann Czech, and James Wines/SITE.

Another important priority of the MAK's programming is the commissioning of new works for public spaces both at home and abroad. Recent commissions include: Donald Judd's "Stage Set", Philip Johnson's "Wiener Trio", Michael Kienzer's "Stylit", Franz West's "Four Lemurheads", James Turrell's Skyspace "The other Horizon" and MAKlite.

Transforming a World War II antiaircraft tower in Vienna's Arenbergpark, the CAT – Contemporary Art Tower will be an international center, showcasing important contemporary projects. Through its unique avantgarde architecture and pioneering program, this "monument of barbarism" will become Vienna's foremost venue for contemporary art.

Art functions both as an investment in, and a prophesy of, the future of society. A museum construct is the ultimate transmitter for communicating the ideas and products of individuals across generation and nationality. Through its connection to the past, a museum also serves as a projection screen and a producer of utopian potentiality, thereby articulating an alternative to the business model of the entertainment industry and its resulting lifestyle that seeks easy sensation and simulated experience.

The museum must continue to develop as a place of awareness, free of external influences, by advancing the discourse between the interplay of experience and perception. Since it navigates along the borders that separate art and awareness from innumerable forms of fashionable consumption, the museum's articulation of qualitative assessment makes it a central forum for resistance against the widespread loss of meaning pandemic in contemporary popular culture.

This is the unalterable position of the MAK.

Peter Noever
C.E.O. and Artistic Director MAK

[1] Schindler House, residence and studio of R. M. Schindler and Clyde Chase (1921–22), 835 North Kings Road, West Hollywood; Mackey Apartments (R. M. Schindler 1939), 1137 South Cochran Avenue, Los Angeles, and Fitzpatrick-Leland House, Mulholland Drive/8078 Woodrow Wilson Drive, Los Angeles.

THE HISTORY OF THE MAK

THE HISTORY OF THE MAK

1863 On the 7th of March, after long efforts by Rudolf von Eitelberger and persuasion from his brother Archduke Rainer, the Emperor Franz Josef finally sanctions an Imperial and Royal Austrian Museum of Art and Industry. The building, inspired by the South Kensington Museum (today Victoria and Albert Museum), was built in 1852. Rudolf von Eitelberger, the first professor for history at the University of Vienna, is appointed director.
The museum is to serve as an exemplary collection for artists, industrialists, and the public, and as a training and higher education center for designers as well as craftsmen.

1864 On the 12th of May, the museum is opened in the Hofburg's Ballhaus.

1865 – The magazine "Mittheilungen des k. k. Österreichischen Mu-
1897 seums für Kunst und Industrie" is published.

1867 Founding of the School of Applied Arts where theoretical and practical training are united.

1871 After three years of construction, the new building on Stubenring is opened on the 15th of November. Built in the style of the renaissance according to the plans of Heinrich von Ferstel, it is the first of the museums on the Ring. The objects can now be permanently displayed and grouped according to material. The School of Applied Arts also moves into the house on Stubenring.

1873 World Fair in Vienna.

1877 Opening of the new School of Applied Arts building on Stubenring 3, adjacent to the museum on the Ring. Also designed by Ferstel.

1897 Arthur von Scala, director of the k.k. Orientalisches Museum (later known as Handelsmuseum or Trade Museum), takes over as director of the Museum of Art and Industry. Scala succeeds

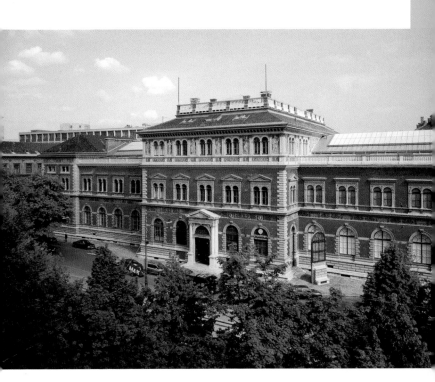

in getting Otto Wagner, Felician von Myrbach, Koloman Moser, Josef Hoffmann and Alfred Roller to work in his museum and at the School of Applied Arts.

1898 Archduke Rainer resigns as Protector resulting from the conflicts between Scala and the Arts and Crafts Association, founded in 1884, which sees its influence on the museum dissipating. New statutes are established.
Between 1898 and 1921 a new museum magazine called "Kunst und Kunsthandwerk" is published and soon attains international renown.

1900 Administrations of the Museum and the School of Applied Arts are separated.

1907 The Museum of Art and Industry takes over a large part of the Austrian Imperial and Royal Trade Museum collection.

1909 The School of Applied Arts and the Museum are separated. After three years of construction, the extension on Weiskirchnerstraße, planned by Ludwig Baumann, is opened.

1919 After the founding of the First Republic the holdings previous-
ly in the possession of the Habsburgs are handed over to the
Museum – e.g. oriental carpets.

**1936
and
1940** The Museum on Stubenring gives a part of its sculpture and
antique collection to the Art History Museum. In exchange it
receives the arts and crafts section of the Figdor collection as
well as that of the Art History Museum.

1938 The Museum is named "State Arts and Crafts Museum in
Vienna" after Austria's Anschluss with the National Socialist
German Reich.

**1939 –
1945** Museums take over several stolen private collections. In this
way, the collections of the "State Arts and Crafts Museum" also
expand. Owing to provenance research, it has become possible
since 1998 to return numerous collections.

1947 The "State Arts and Crafts Museum" now calls itself "Öster-
reichisches Museum für angewandte Kunst" (Austrian Museum
of Applied Arts).

1949 Reopening of the Museum after repair of war damages.

**1955 –
1985** The Museum publishes the magazine "alte und moderne
kunst".

1965 Geymüllerschlössel becomes a branch of the Museum.

1986 Peter Noever becomes director of the Museum.
Beginning of the Collection of Contemporary Art.

1989 A total restoration of the old buildings and the construction of
a two-storied underground storage begin. Additionally, a large
depot for the collections as well as further exhibition space
are built.

1993 The Museum reopens after reconstruction and redesigning of
the permanent exhibition rooms by artists. The house on Weis-
kirchnerstraße, however, is reserved for an exhibition program.
The halls on Stubenring house the permanent collection, the
study collection as well as the MAK Gallery.

Beat Wyss, Professor for Science of Art and Media Theory at the Karlsruhe Academy of Design, and Peter Noever, Director MAK (right), on the occasion of "KEEP UNQUIET!", the MAK Annual Press Conference (left)
2008

1994 The Arenbergpark flak tower becomes an annexe of the Museum.

1995 Peter Noever founds the MAK Center for Art and Architecture in Los Angeles at the Pearl M. Mackey House and in the Rudolph M. Schindler House.

2000 The Museum becomes a public scientific institution.

**2001 –
2002** The project CAT – Contemporary Art Tower is presented in Vienna after exhibitions in New York, Los Angeles, Moscow, and Berlin.

2005 The Josef Hoffmann Museum in Brtnice, Czech Republic, the artist's birthplace, is managed as a joint branch of the MAK, Vienna and the Moravská galerie in Brno.

2008 The Fitzpatrick-Leland House, Los Angeles (R. M. Schindler, 1936) is donated to the MAK Center for Art and Architecture. Since then, the location has been home to the new MAK UFI – Urban Future Initiative Fellowship Program.
The MAK is considering the founding of a new institution that reaches out beyond Austria and takes on responsibility for developments in design, art, and architecture and their impact on society. The new institution "**MAK+** Center for Design, Arts, Architecture & Research" (originally initiated by Peter Noever and Gerald Bast, Rector University of Applied Arts Vienna) will be operating in an international and networked manner, moving between research, training and art production.

WINNER OF THE COUNCIL OF EUROPE STRASBOURG MUSEUM PRIZE 1996

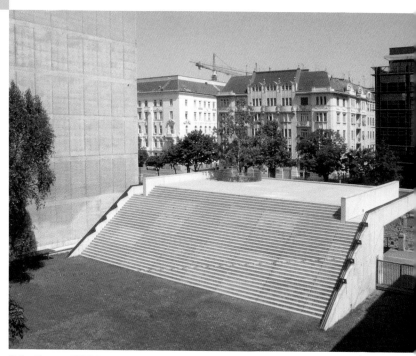

Peter Noever, MAK Terrace Plateau in the garden
1991–93

James Wines / SITE, Gate to the Ring
1992

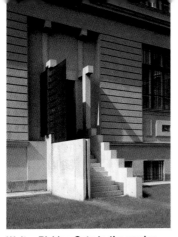

Walter Pichler, Gate to the garden
1990

Sepp Müller, Connecting wing
1991

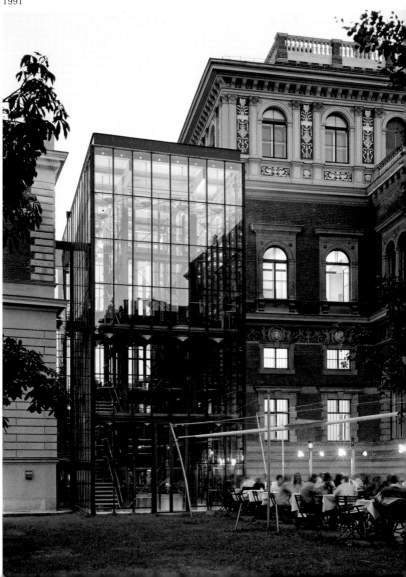

THE PERMANENT COLLECTION

ARTISTIC INTERVENTIONS

The reinstallation of the MAK's permanent collection and redesign of the gallery spaces by contemporary artists was the first experiment to be realized in the course of the Museum's search for a new identity. Here, for the first time, one can sense what the notion of fruitful confrontation between traditional collections and new artistic trends signifies. A conscious decision was made not to have architects design any of the spaces. It was hoped that different new positions and viewpoints in relation to the objects in the collections would supply the objects with fresh, contemporary legibility in a way that re-educates our eyes and our perception towards the specific sensitivities and strengths of the individual materials.

Objective display is impossible in a museum; to display is at once to present, to interpret, and to evaluate. The MAK choses to realize the viewpoints of significant contemporary artists, who reinstalled the permanent collection after intense collaboration and long discussions with the responsible curators.

The permanent collection is arranged in chronological order – not, however, with the intention of "covering" each stylistic epoch as completely as possible, but rather of introducing the Museum's highlights, its particularly interesting and unique objects. (In the study collection, on the other hand, the Museum's traditional arrangement according to materials has been preserved in a concentrated, orderly form of presentation.) Working with colors, special lighting installations, electronic text displays, special show cases, enclosures, pedestals, and special perceptual alienation effects, the artists found a variety of spatial solutions for their respective rooms. Particularly striking was that, while pursuing their highly personal strategies, they carried out their tasks with such a respect and understanding for the objects that it always remained unmistakable that displaying these objects was their primary motivation. One has to subject oneself to the qualities of the rooms and decide for oneself whether or not this concept has proved to be right; whether the artistic involvement adds a new dimension to contemporary interpretation; whether it actually contributes to the complexity and multiplicity to which the Museum aspires.

The artists themselves responded energetically to the unusual task, albeit with varying degrees of enthusiasm and periods of intense frustration in the process. Donald Judd, for example, ended up thinking it would have been better to install the Dubsky Chamber underground, partly because he had problems with any kind of museum installation;

and Barbara Bloom committed the sacrilege of mentioning the bent-wood furniture – the serial, almost minimalistic variations of which she made clearly visible – in the same breath as the mass-produced furniture of IKEA. All of the rooms have been the subject of much discussion. But in fact, the Museum could not ask for anything better than to spark off a radical, critical debate about the relation of old to new, about how to bring old, traditional spaces into the present day and into correspondence with the work of contemporary artists. / Peter Noever

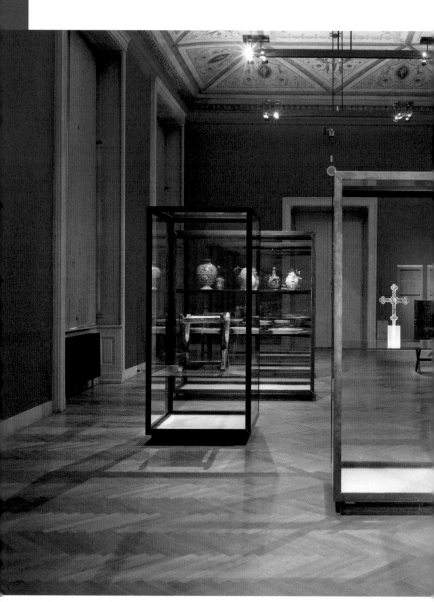

Display cases: Mathis Esterhazy

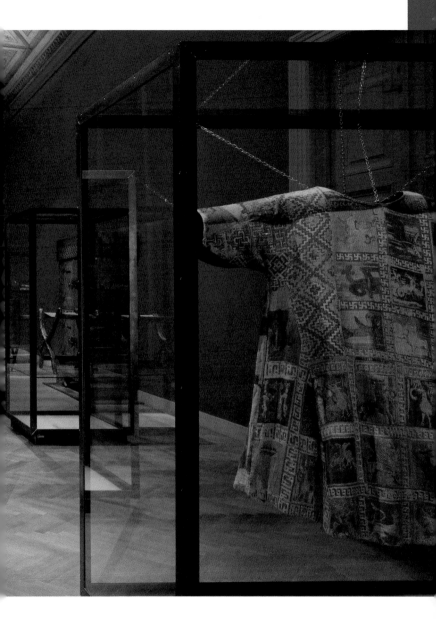

GÜNTHER FÖRG
Curator: Angela Völker

When the MAK asked me to install the Romanesque, Gothic, and Renaissance room, there was for me only one possible solution – to link our time with the past. The pieces on display consist of the Göss paraments, various majolica pieces from the Renaissance, and a few items of furniture. For conservation reasons, almost all of these have to be protected by glass display cases.

The idea for the design is based on two direct interventions: firstly, providing a colored frame for the walls, and secondly, redesigning the display cases. For the first intervention, a connection had to be made between the delicate coloring of the Göss paraments, the strong, unfaded colors of the majolica – here predominantly ultramarine and ochre – and the room's ceiling color. I decided on a light cobalt blue, which has a certain festive quality, but is also discordant with the color of the ceiling.

The design of the display cases was carried out with Mathis Esterhazy, the goal being to arrive at a classic display case that would also reflect our own time. Objects such as the Göss paraments are shown with natural folds, and others, such as the portable writing desks, at a natural height. / Günther Förg

Much medieval handicraft has been preserved in churches and monasteries, and from these it has occasionally made its way to museums. This is the case with the most significant Romanesque works in the Museum, the "Göss Paraments" and the folding stool from Admont.

The furniture and ceramics of the fifteenth and sixteenth centuries from northern and southern Europe that are presented here illustrate specific regional characteristics, and the survival of stylistic features over long periods. Austrian handicrafts of the fifteenth century, for example, are still considered as Gothic. Although the Renaissance began in Italy during the first quarter of the fifteenth century, its influence was only felt north of the Alps from the second half of the century, continuing into the early seventeenth century, as the richly inlaid bureau cabinet from Augsburg and the painted table top from Swabia show.

Decorative motifs, classical ornament and grotesques, landscapes and figures from the High Renaissance on majolica vessels illustrate how pictorial representations were successfully transferred into a different medium. The scenic depictions are of exceptional quality. / Angela Völker

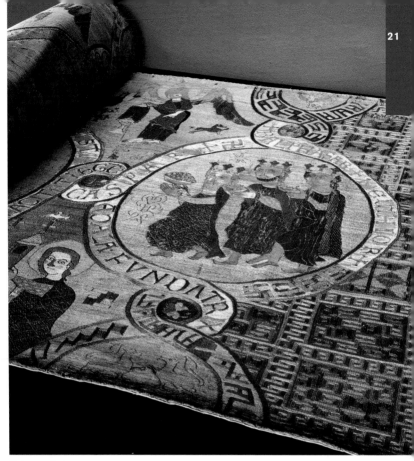

Antependium
Linen, silk embroidery
Inv. no. T 6902/1908
Depicted in the medallions: Annunciation to the Virgin, Virgin enthroned with Child,
the Three Magi. Below left, alongside the central medallion: Kunigunde, donator of
the paraments; to her right, St. Adala, founder of the Convent at Göss, with a model
of the church.

Paraments from the Convent at Göss
Göss (Styria), mid-13th century
Linen, silk embroidery
Inv. no. 6902–6906
Acquired from the Convent at Göss in 1908

The Museum's collection of textiles includes a wealth of medieval religious textiles,
the most significant of which are the paraments from the Benedictine convent at Göss
– the only surviving ensemble of church robes preserved from such an early period
(ca. 1260). The priest wore the chasuble and cope, the deacon and sub-deacons the dal-
matic and tunic. The antependium was an ornamental covering for the front of the
altar table. This assortment of paraments can easily be recognized as an ensemble on
the basis of its shared technique, coloring, style, and embroidery that entirely covers
the simple fabric. Some serious alterations made during the course of the centuries, as
well as the free form of the ornamentation, give the vestments a particularly colorful
and unusually decorative appearance today.
Kunigunde, Abbess of the Convent from 1239 to 1269, donated the vestments and,
together with other canonesses, stitched them herself. The images and inscriptions on
the antependium, chasuble, cope, and dalmatic are evidence of this quite unusual pro-
cedure for the Middle Ages. A painter using ink on the cloth probably designed the
scenic representations in the medallions. The nuns then embroidered the scene with
colored silk, using various types of stitches. The originally concealed sketches can be
seen quite well in places where the embroidery is damaged. The ornamentation and
pattern, by contrast, were produced without any precise design, which explains their
unorthodox distribution.

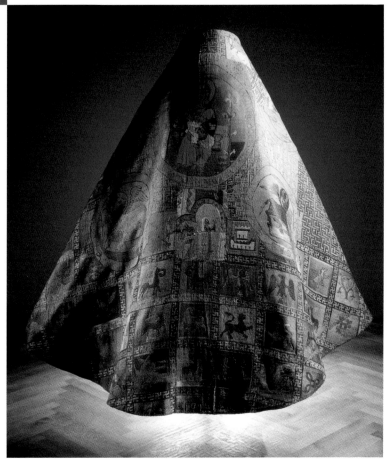

Cape
Linen, silk embroidery
Inv. no. T 6903/1908
Depicted in the medallions: Mary suckling the Christ Child, surrounded by the
emblems of the four Evangelists: eagle (John), angel (Matthew), lion (Mark), and
bull (Luke). Beneath the large medallion: Kunigunde with a nun, originally part
of the chasuble.

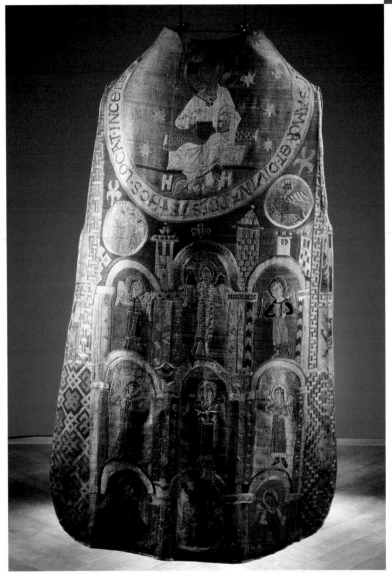

Chasuble
Linen, silk embroidery
Inv. no. T 6904/1908
The chasuble, like the cope, originally consisted of a semicircle, which was closed in front and embroidered. Today's much smaller form does not date back further than the sixteenth century. Back: Christ enthroned with the emblems of the four Evangelists, and below the nine angels in three rows of stilted-arch arcades. Front: Crucifixion, and beneath it eight Apostles in two rows of stilted-arch arcades, corresponding to the angels on the back.

Table top
Swabia, late 15th century
Cherry wood, painted
Inv. no. H 255/1871

Folding stool
Salzburg (?), early
13th century
Pear wood, carved
and painted; leather
seating added later
Inv. no. H 1705/1935

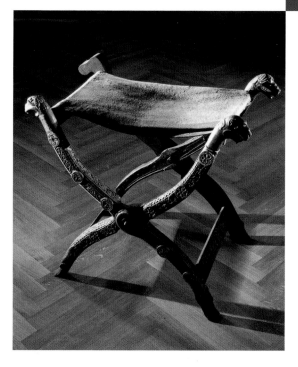

Cabinet
South Germany,
Augsburg (?), last third
of the 16th century
Maple wood, veneered,
marquetry in various
types of wood; etched
and gilded ironwork
Inv. no. H 218/1871

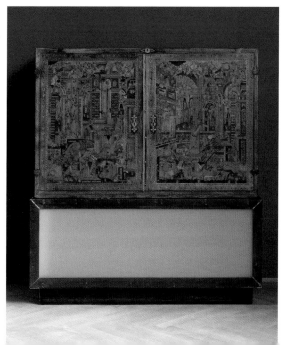

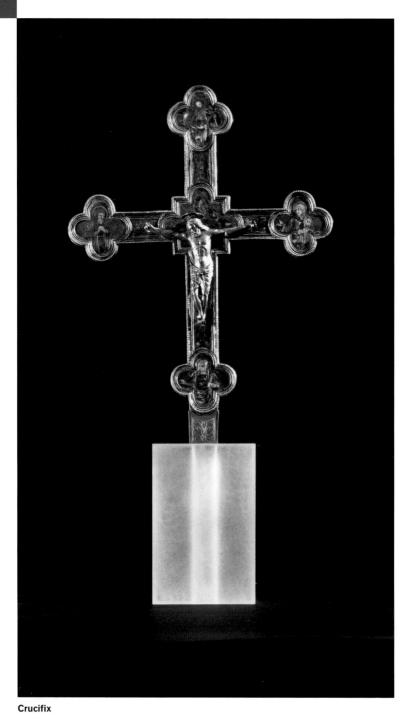

Crucifix
Italy, mid-15th century
Probably Maso Finiguerra; silver, partially moulded, basse-taille
enamel, translucent, opaque
Inv. no. Em 55/1869

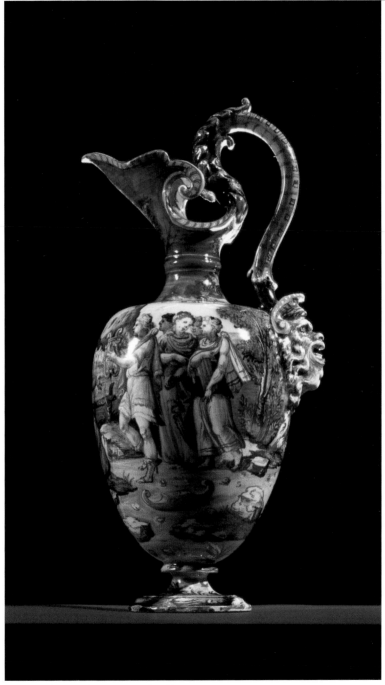

Majolica pitcher with grotesque handle
Urbino, 16th century
Painted majolica, Apollo and Marsyas
Inv. no. KHM 27/1940

DONALD JUDD
Curator: Christian Witt-Dörring

I was doubtful about the idea of artists making installations of earlier objects; I am still doubtful. I think installation should be the responsibility of the curators of the objects, although I continue to be critical of the generally artificial way in which objects are installed. To have artists make such installations is likely to perpetuate devious installation. I accepted the problem as a favour to the museum, and I accepted as a premise for myself that I would not contradict the judgement of the curator responsible, Christian Witt-Dörring. I think we did our best. The museum's premise, the installation's set fact, was that the Dubsky room, originally a room in a palace, had to be reconstructed in a much larger room of the museum. I was told there was no alternative. The room could be remade either in one of the corners of the exhibition room, leaving an awkward right angle for the other furniture, or it could be remade in the center of the room, leaving a symmetrical space and possibly establishing a room within a room – a good idea. I asked that this be done. The Dubsky room is too large and is awkward, but placing it in the center was the right decision. The room and most of the other furniture were made in the eighteenth century for the aristocracy. The room's grandeur is uncertain, and therefore excessive. It is uneasy; Chardin is not uneasy. All architecture and most installations are now uneasy. Why is Chardin simple, strong and easy? The separate pieces of furniture are placed symmetrically, usually in pairs, usually opposite each other. A rectangular space usually determines this. The positioning of the furniture was also carefully decided with regard to the size, color, and type of each piece. I asked for part of the moulding under the ceiling of the large room to be repeated around the exterior of the Dubsky room, to further incorporate it into the eighteenth century space made in the nineteenth century, and to reduce the excessive generality of its exterior. This is a small, uneasy room uneasily placed in a large, doubly uneasy room. I think it should be in the basement. But Witt-Dörring and I did our best, uneasily. / Donald Judd

The MAK's collections contain some splendid examples of eighteenth-century cabinet-making. The emphasis in the collection is on pieces from the cultural realm encompassing Austria, France, and Germany. These bear witness to the tremendous typological, technical, and formal developments that took place during the course of the eighteenth century. The bureau cabinet, with its origins in the seventeenth century, is gradually replaced as a prestigious furniture item by the writing desk, the southern German form of which is known as a "tabernacle cabinet." In France, the chest of drawers develops as a new kind of case furniture providing storage space in the living area, a reaction to the growth of the private sphere and the increasing desire for comfort. Forms of writing furniture that arise include the basic desk and the cylinder desk. The surface decoration of furniture becomes more varied, and is used to meet novel requirements and fashions (wooden and Boulle marquetry, lacquer, porcelain, etc.). Interior design itself becomes more uniform with the development of mobile and immobile furnishings. Furniture enters into decorative unity, and often structural unity, with the room. The porcelain room from the Dubsky Palace in Brno eloquently documents this, as well as marking the beginning of porcelain production in Vienna, from 1719 onward. / Christian Witt-Dörring

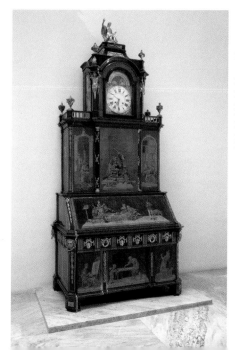

Bureau Cabinet
Neuwied am Rhein, 1776
Design and manufacture:
David Roentgen
Clock: signed "Knitzing à
Neuwied"
Maplewood stained brown,
rosewood and myrtle, various-
ly colored woods, gilded
bronze fittings
Inv. no. H 269/1871

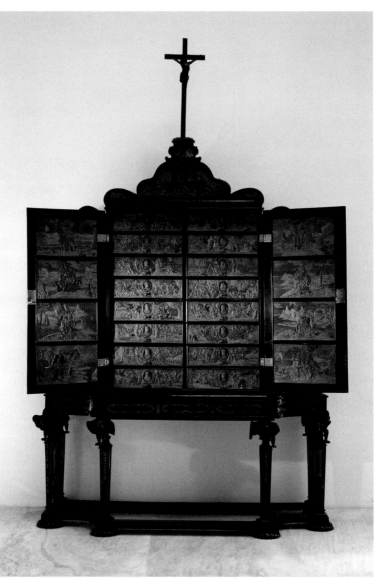

Cabinet
Cheb (Czech Republic), 1723
Design and manufacture: Nikolaus Haberstumpf
Signed: "Johann Nickolaus Haberstumpf fecit 1723 kunstdischler und mohler in Eger" [cabinet-maker and painter in Eger (the German name for Cheb)]
Veneered ebony, relief marquetry and marquetry in various types of wood
Inv. no. H 1760/I941

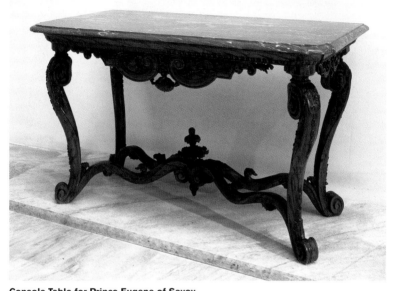

Console Table for Prince Eugene of Savoy
Vienna, ca. 1728/30
Design: Claude le Fort du Plessy (?); nut wood, partially glazed, marble top
Inv. no. H 1579/1923

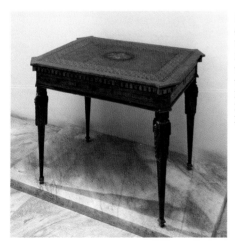

Desk for Countess Régine d'Aspremont
Vienna, 1790
Design and manufacture: Franz von Hauslab; marquetry in various woods, gilded fittings
Inv. no. H 508/1883
Donation of Franz Ritter von Hauslab

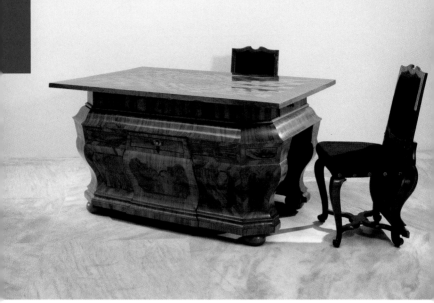

Library Table
Vienna, ca. 1730
Nut and maple wood, veneered
Inv. no. H 1185/1909

Porcelain chamber from the Dubsky Palace in Brno
Vienna, ca. 1740
Inv. no. Ke 6201/1912

Around 1700, it became fashionable in Europe to decorate rooms as so-called "porcelain chambers." Initially, only European faience was available, but as time went on its place was taken by Chinese imports and, from 1700, by Japanese porcelain. The porcelain chamber from the Dubsky Palace in Brno is one of the first rooms to be decorated with European porcelain.

The decoration of the room can be traced as far back as the years following 1724, from the coat of arms of the Czobor von Szent-Mihály family over the trumeau.

At this period, Duchess Maria Antonia of Czobor, Frau auf Göding, born Princess of Liechtenstein, purchased in Brno what was later to become the Dubsky Palace.

The porcelain from the Vienna manufactory Du Paquier (1718–44) also dates from this period. Studies of the room's fixed wall panelling, and the fact that, even in Brno, the fireplace had no smoke outlet and therefore could not be used, show that the decoration must have been originally designed for a different location, still unknown, and was only later adapted to the smaller dimensions of the Brno palace. However, there is a discrepancy in time that has still not been clarified between the examples of early Viennese porcelain, produced prior to 1730, and the ornamentation of the wall panelling and some of the furniture, the earliest dating for which can only be to the 1740s.

In 1745, the palace came into the possession of Johann Georg von Piati, whose son Emanuel Piati von Tirnowitz inherited it in 1762. The family's coat of arms was formerly painted over that of the Czobor, and was only removed in 1912 when the room was purchased by the Museum. The addition of paintings, and of a wall-clock signed by the Brno master clockmaker Sebastian Kurz, also dates from the Piati period, around 1790. The palace received its current name when Emanuela von Piati, the daughter of Johann Georg, married Franz Dubsky von Trebomyslic in 1805. Later additions of porcelain from the Herend Porcelain Factory (founded in 1839), and items from the Viennese Porcelain Factory dated 1847, show that extensive restoration and readaptation of the room must have been carried out around 1850. The chairs, as well as the console table on the long wall and the sofa table, also very probably date from this period.

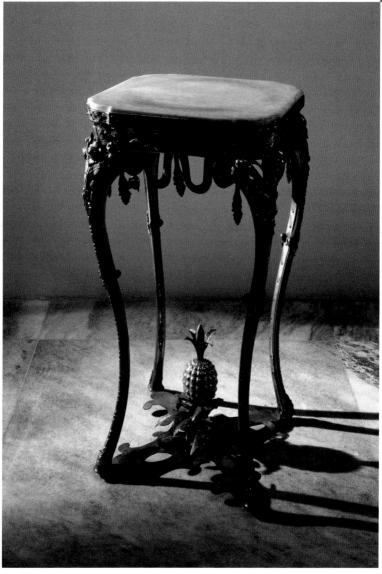

Small Table
Vienna, 1769
Design and manufacture: Wilhelm Gottlieb Martitz
Signed: "W. Martitz In Wienn Den 19 August Anno 1769"
Glided bronze, silver leaf, marble
Inv. no. LHG 1412/1973
Lent by the Creditanstalt-Bankverein

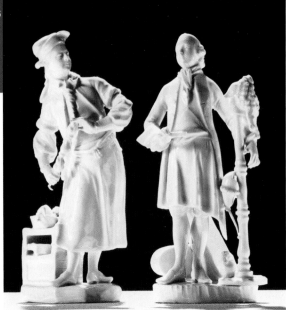

Bratlkoch (a Viennese market cry)
Marks: "Bindenschild" in underglaze blue, stamped
embosser's mark "P" (= Anton Peyer), "5" (inscribed)
Inv. no. KE 6823/18/1926
Wigmaker (Perückenmacher)
Marks: "Bindenschild" in underglaze blue, stamped
embosser's mark "0" (= Dionysius Pollion), "5" (inscribed)
Inv. no. Ke 6823/22/1926

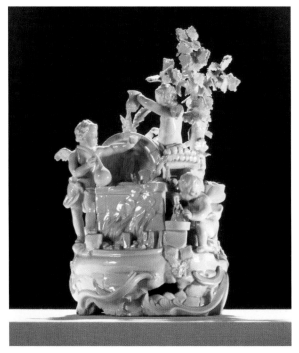

The Production of Porcelain (Die Porzellanerzeugung)
Central group
Mark: "Bindenschild" in underglaze blue
Inv. no. Ke 6823/1926

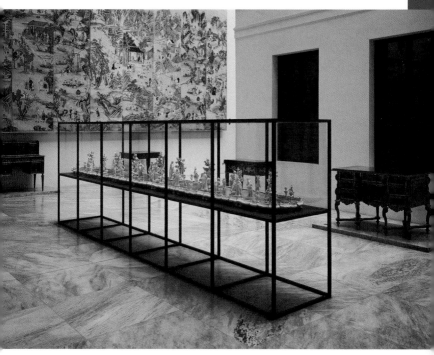

Table centerpiece from Zwettl Monastery
Vienna, 1768 and earlier
Glazed, unpainted porcelain; the support consists of
nine parts standing on low legs and is set with mirrors,
428 x 51 cm with 60 figure groups, individual figures
and vases
Inv. no. Ke 6823/1926
The centerpiece was ordered on the occasion of the
golden jubilee of the ordination of Abbot Rayner I.
Kollmann of the Zwettl Monastery. The "whole dessert in
three crates" was transported to Zwettl by carriage in
May 1768 and presented to the Abbot at his jubilee cele-
bration. For this occasion Joseph Haydn composed his
"Applausus," which may be related to the table center-
piece, as the female allegories of the virtues that appear
on it also feature in Haydn's composition as female
voices.

Display case: Donald Judd

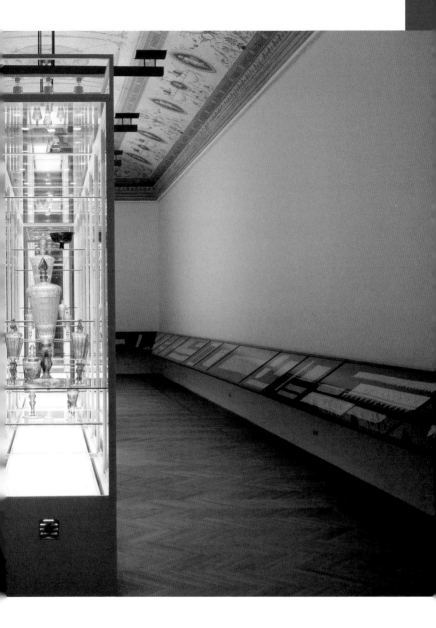

FRANZ GRAF
Curator: Angela Völker

*A design intention = states of affairs. The wealth of appearances. The legacy of those who were here before us = the form of actions, our inheritance = memory: museums are also, like cemeteries, our quiet bliss: because the nature of the encounter also gives rise to understanding: it seems there can be no truth concerning this, but only original, brilliant works: silence is the word extinct. Because the same thing once meant something else: because the essence of things is forever dead, and its material properties maintain this expansion into a different world: because a past exists that the living individual can reach into and at least the possibility is hinted at of coming to an end through oneself and beyond with the early ***** appearance.* / Franz Graf

The MAK's collection of lace, and its holdings of glassware – especially Venetian glass – are today considered among the finest and most varied in the world. Even in the Baroque period, Venetian glasswork was particularly treasured, and both men and women spent vast sums on the sumptuous lace decoration that fashion demanded.

While glass-making is one of the oldest handicraft techniques in the world, the history of lace-making only begins in the late Renaissance period, probably in Italy. A distinction is made between needlepoint lace and bobbin lace, but combinations of the two techniques are often seen. Florence, and later Venice and Milan, were the centers of Italian lace-making in the sixteenth and seventeenth centuries, before lace-making in France and Flanders began during the eighteenth century.

Venice was the center of European glass-making from the Middle Ages onwards. Around 1500, Venetian glass-makers succeeded in producing clear, colorless glass. Glassblowing spread from Venice across the whole of Europe. In the north, centering on Bohemia and Silesia, there was a preference for harder glass that could be decorated with relief or intaglio engraving, or glass decorated with enamel, *Schwarzlot* ("black solder"), or gold.

This presentation of glasswork and lacework is not based only on art-historical criteria, but also on the visual effects of the materials – their "transparency," material delicacy, and the virtuosity of the craftsmanship involved in their production – which may today be the aspect of them that arouses the greatest admiration. / Angela Völker

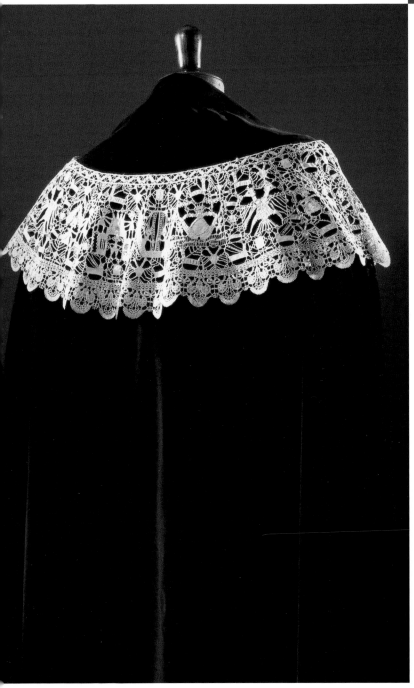

Broad collar with figures and ornamentation
Italy, second half of the 16th century
Needlepoint lace with bobbin-lace edging, linen yarn
Inv. no. T 8596/1932

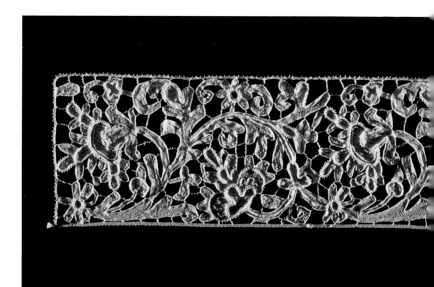

Cravat
Brussels, first quarter of the 18th century
Bobbin lace, linen yarn
Inv. no. T 3708/1884

Fitted relief lace
Venice, mid-17th century
Needlepoint lace with bobbin-lace edging, linen yarn
Inv. no. T 6543/1906

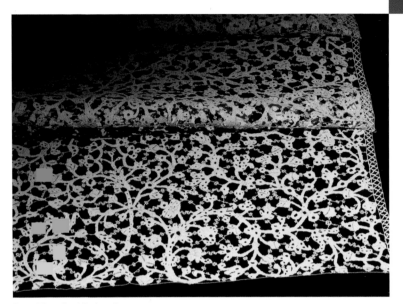

Broad lace braid trimming
Venice, ca. 1700
Needlepoint lace with bobbin-lace edging, linen yarn
Inv. no. T 10073/1935

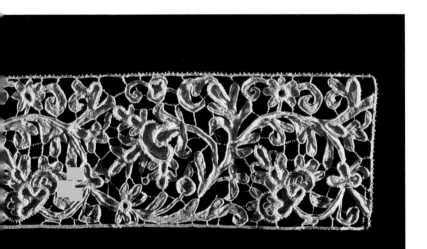

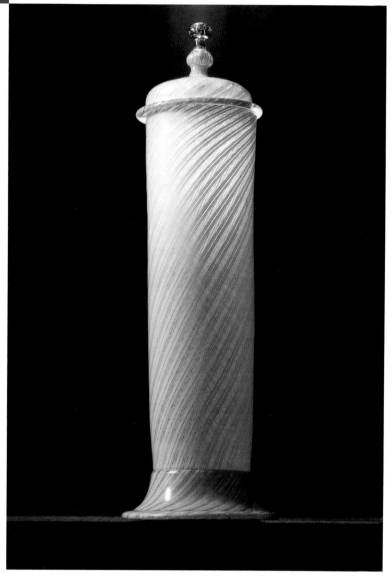

Cylindrical glass with lid
Venice or Imperial Glass Factory, Innsbruck, ca. 1570
White threaded pattern melted into colorless glass
Inv. no. KHM 316/1940

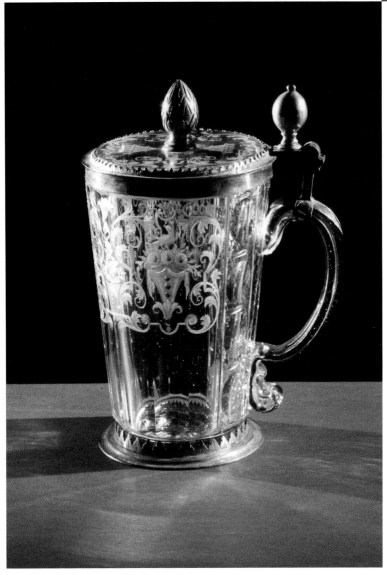

Beaker with handle and base
Bohemia, ca. 1725
Colorless cut-glass; face: matte and polished, gilded silver
Inv. no. Gl 856/1871

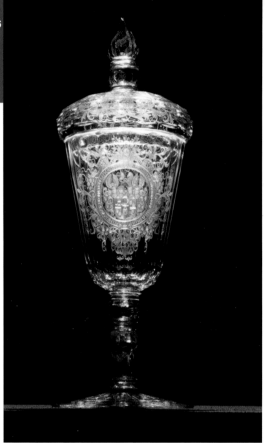

Goblet with court of arms
Bohemia, ca. 1720
Glass, with faceted shaft, gold and ruby threading; face: matte and polished;
the knob of the lid continues the gold and ruby threading of the shaft.
Engraved coat of arms of Duke Christoph Wilhelm von Thürheim, the Older
(1661–1738), from 1713 "Captain of the land on the Enns"
Inv. no. Gl 172/1867

Beaker with Imhof coat of arms
Nürnberg, dated 1678
Signed: Johann Keyll
Colorless glass, black enamel
decor
Inv. no. Gl 2161/1907

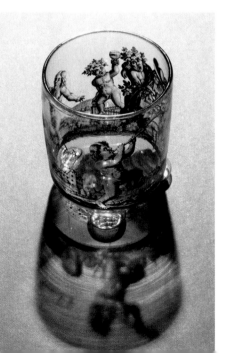

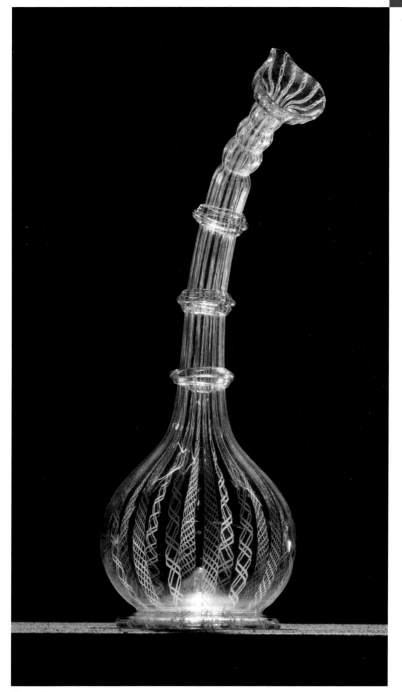

Kuttrolf
Venice or Imperial Glass Factory, Innsbruck, ca. 1580
Glass, with white threading patterns
Inv. no. KHM 317/1940

JENNY HOLZER
Curator: Christian Witt-Dörring

I have never liked museum labels and brochures. I wanted to find another system to present information about the collection and about the times in which the objects were made. I tried to think of an appealing way to show a super-abundance of text on Biedermeier and Empire. I chose electronic signs with large memories to talk about why what was produced for whom. The signs display the predictable facts, and softer material such as personal letters of the period. Because some people hate to read in museums, I placed the signs near the ceiling so they can be ignored. To encourage people who might read, I varied the signs' programs and included special effects. For serious, exhausted readers, I provided an aluminum mock-Biedermeier sofa on which to sit. I also rearranged the furniture, silverware, glassware, and porcelain, as would any good housewife. / Jenny Holzer

A heterogeneous mass of consumers arose during the first half of the nineteenth century, something never previously seen in Austrian cultural history. With the effects of the Industrial Revolution and the growing cultural, social, and economic strength of the middle class, it became both possible and necessary to produce differentiated products for these consumers. It now became both necessary and possible to put at the disposal of the more general public items that had previously only been available to a small circle of consumers. Besides the wide variety of tastes, the range of products on offer was therefore also marked by a subtle gradation from expensive luxury items to cheap substitutes. A generally understood language for materials and forms thus emerged, which was no longer specific to any particular social stratum, but instead determined by financial factors. The depictions were no longer symbolic in character, but were related to real people, things, and events.

The selection of objects displayed here therefore shows, alongside outstanding achievements of Austrian art and craft production, above all the variety of designs and materials used for everyday commodities during the Empire and Biedermeier period. The explosion of richly varying forms is demonstrated by a series of variations in chairs, porcelain cups with a limitless range of moods, glasses conveying all sorts of information, and silverware pieces with designs ranging in character from abstract to decorative. / Christian Witt-Dörring

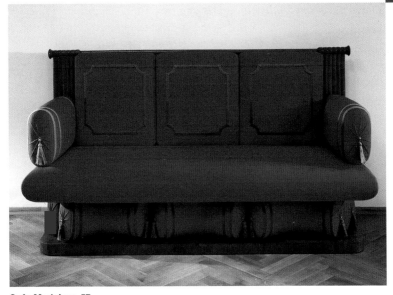

Sofa Model no. 57
Vienna, ca. 1825/30
Design and manufacture: Danhauser's Furniture Factory
Cherry wood, veneer on solid and soft wood; upholstery
reproduced
Inv. no. H 2726/1983

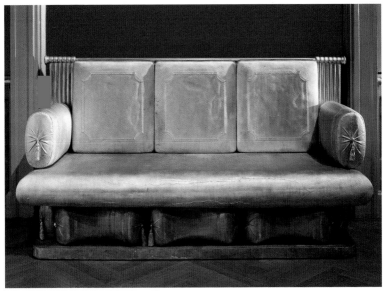

Jenny Holzer, Sofa for visitors (*for use!*)
Aluminum cast after an original by Josef Danhauser
Manufacture: Herbert Fischer, Großstelzendorf, 1993
Inv. no. GK 99/1993

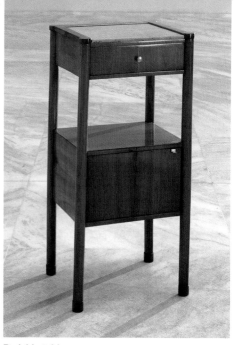

Bedside table
Vienna, ca. 1825/1830
Cherry wood, solid and veneered;
Kehlheim table top; brass fittings
Inv. no. H 3042/1989

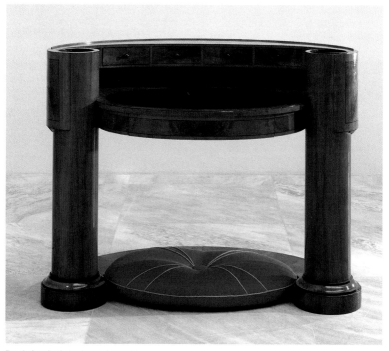

Desk for Archduchess Sophie
Vienna, ca. 1825
Cherry wood, solid and veneered; wood, stained black; tin insets
with green lacquer; footpad renewed
Inv. no. H 2558/1940

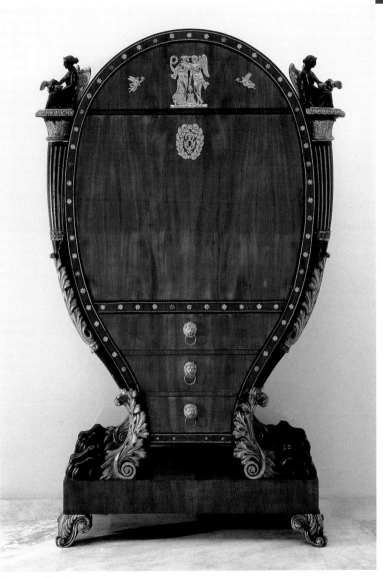

Bureau cabinet
Vienna, ca. 1815
Mahogany, wood stained black, carved limewood, partly painted black and with
verd-antique finish, partly gilded and bronzed; gilt brass and bronze fittings, partly
solid and pressed; inside, maple, grained wood, stained red
Inv. no. H 2027/1955

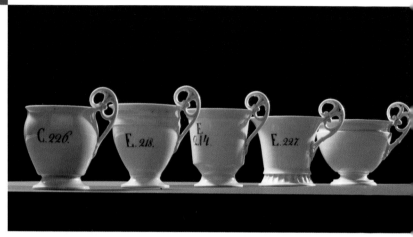

5 cups with spiral-shaped handles
Viennese Porcelain Factory, 1813–17
From left to right, stamp of year 817 (=1817), red form number C 226, inv. no. Ke 9984/1981;
stamp of year 817 (=1817), red form number E 218, inv. no. Ke 10019/1981;
stamp of year 816 (=1816), red form number E 214, inv. no. Ke 10157/1981;
stamp of year 817 (?) (=1817?), red form number E 227, inv. no. 10020/1981;
stamp of year 813 (=1813), inv. no. Dep 305

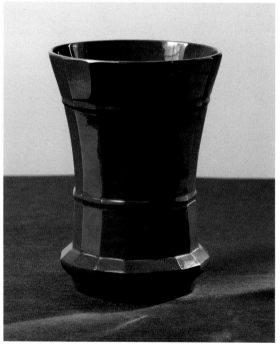

Tumbler
Blottendorf near Haida, before 1835
Copper ruby stain: Friedrich Egermann; green glass from the Harrach
Glass Factory, Neuwelt (Bohemia); cut lythaline glass
Inv. no. Gl 1232/1875

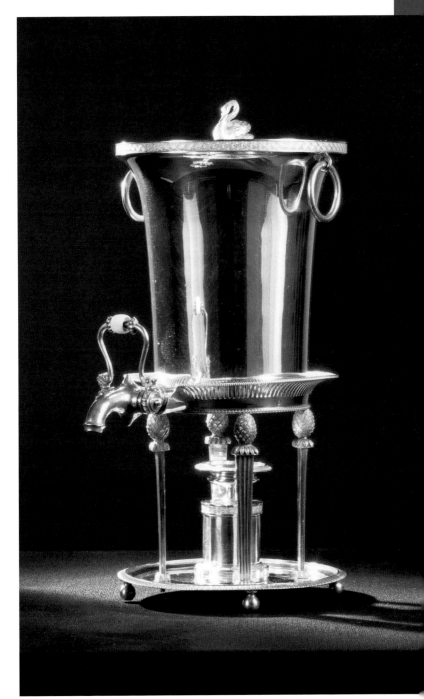

Kettle
Vienna, 1820
Josef Kern, Silver
Inv. no. Go 1333/1907

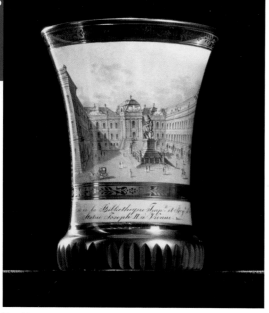

Tumbler
Vienna, ca. 1830
Turnbier flaring upward over fluted base, with enamel decoration and gilding. In a square, bordered field: "Place de la Bibliothèque Imp.^{le} et Roy.^{le} et la Statue Joseph II à Vienne" (Workshop Anton Kothgasser, Vienna)
Inv. no. Gl 2365/1917

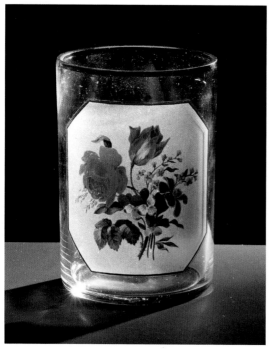

Beaker
Vienna, 1814
Design and manufacture: Gottlieb Mohn
Signed: "G. Mohn. 1814. Wien" and "A H. p." (AH, in metal), glass with bouquet of flowers and gilded rim
Inv. no. Gl 3118/1952

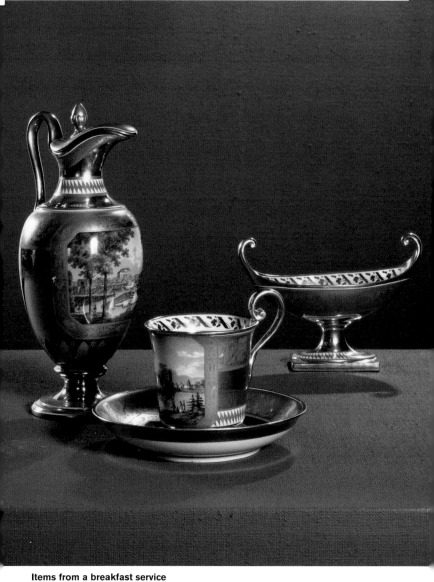

Items from a breakfast service
With views of Imperial palaces and gardens, based in
part on older engravings
Viennese porcelain, ca. 1818
Signed: "Schufrid 1818" (i.e. Jakob Schufrid); gold base,
rich decorations in gold
(kettle with handle, cup with handle, saucer, sugar bowl)
Inv. no. KHM 267/1940

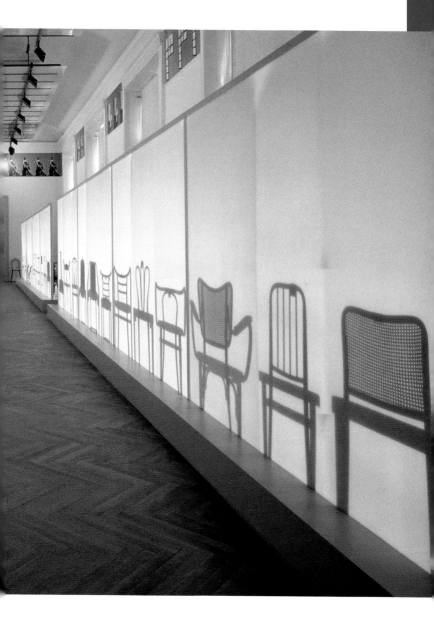

BARBARA BLOOM

Curator: Christian Witt-Dörring

The movie synopsis would read something like this: Michael Thonet, a German chair designer, so impressed an Austrian prince with his elegant designs and innovative manufacturing techniques, that he was commissioned to design some woodworking for a palace in Vienna, and then encouraged by higher-ups to relocate his factory to Austria. There, his business flourished to become a late nineteenth-century international success story.

This is an exemplary case of an aesthetically sophisticated designer who was willing to experiment with production techniques. A man dedicated to reductive methods, in which (as a forerunner for the Modernist's "Form Follows Function") he allowed the intrinsic qualities of his material, wood, to dictate the form of his designs. He was a reductivist in terms of production as well, sparing materials and time with his economical assembly line; turning a handicraft into an international mass-produced industry. He mass-advertised and distributed his furniture by catalogue, indicating that Thonet was also a brilliant early capitalist. He understood the need to develop a consumer society whose needs were created and then met.

It's a good docudrama with a clear linear narrative. I'd like to see the part of Thonet played by someone like Nick Nolte, accented, and convincingly depicting his long and eventful life. There would be International Trade Fair first prizes, certainly several Vienna café scenes, and perhaps a factory class conflict. Good plot!

But I really look forward to (and hope I live long enough to see) a made-for-interactive video-docudrama, which might be made in the early or mid-twenty-first century, about the life of Ingvar Kamprad, the founder of IKEA. This late twentieth-century prototype of business success needs no introduction. But in the future it will be remembered as a marketer of great appeal to a wide range of customers; from most European intellectuals who filed their libraries on "Billy" bookshelves, to young 1 1/2-kid families who were helped over the hurdle of spending money by IKEA's clever tactic of giving every object in their catalogue a proper name. So, you didn't need to buy a couch, when you could bring "Bjorn" home with you.

So, imagine a double-bill of these two movies. Together they form a good paradigm of progress. What lives on? Is it the self-evident aesthetics and design finesse of Thonet? His dedication to experimental techniques? His reductivist methods? Or, some mutant late capitalism, some anthropomorphised form of supply and demand, in which the consumer need is created by "Bambi-fication." I'm sure the IKEA movie will be produced by Disney. / Barbara Bloom

Although bentwood furniture was not a Viennese invention, the bentwood chair is still frequently referred to outside Austria as the "Viennese chair." The technique of bending steamed wood was common as early as the Middle Ages.

Born in Boppard on the Rhine, Michael Thonet (1796–1871) was an innovative furniture-maker, and during the 1830s he attempted to develop a technically more economical version of curved, late Biedermeier furniture shapes. He succeeded, using bent and glued laminates. His move to Vienna in 1842 by arrangement with Prince Metternich opened up to him the much wider market of the Austrian Empire. He continued consistently to develop bentwood techniques further, and in 1852 succeeded in registering a patent for the bending of glued laminates into curvilinear forms, and finally in 1856 a patent for the bending of solid wood. In addition to the further development of bentwood techniques, Thonet's immense achievement lay in his talent for applying these techniques for producing distinctive products whose natural form and timelessness appealed to a broad public. His aesthetic, which developed out of his fascination with a production technique, opened new perspectives in seating furniture.

From its furniture collection, the MAK presents an overview of over a hundred years of production by Thonet and competing firms, from the 1830s to the 1930s. / Christian Witt-Dörring

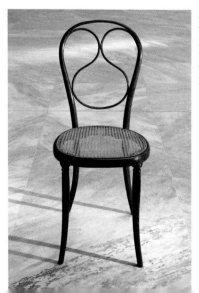

Chair, model no. 1
Vienna, before 1854
Manufacture: Thonet Brothers, ca. 1858
Bent solid beechwood, partly bent laminated wood; palisander glazed; woven cane
Inv. no. H 2299/1975

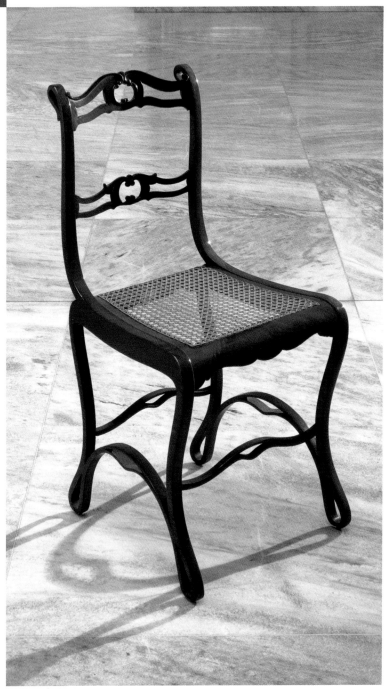

Chair
Boppard/Rhine, ca. 1836/40
Design and manufacture: Michael Thonet
Partly bent laminated wood, solid wood; veneered walnut; cane
Inv. no. H 2967/1987
Formerly in the collection of Alexander von Vegesack

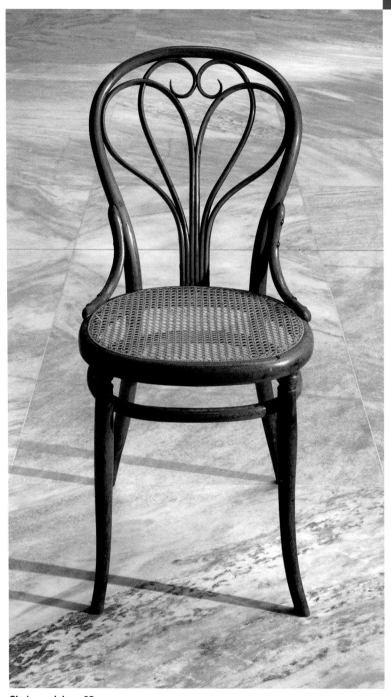

Chair, model no. 25
Vienna, ca. 1910
Manufacture: Mundus
Partly bent solid beechwood, stained brown; woven cane
Inv. no. H 2186/1969
Donation of the Bundeskammer der gewerblichen Wirtschaft

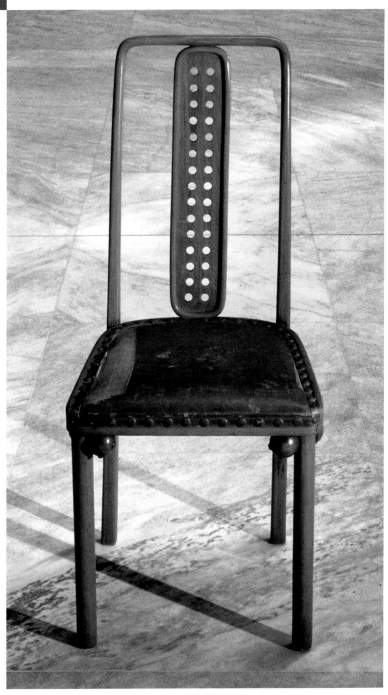

Chair, model no. 322 for the Purkersdorf Sanatorium
Vienna, 1904
Design: Josef Hoffmann; manufacture: J. & J. Kohn
Partly bent solid beechwood, stained brown, laminated wood; original oilcloth upholstery
Inv. no. H 2189b/1969
Donation of the Bundeskammer der gewerblichen Wirtschaft

Chair, model no. 8
Vienna, 1858
Manufacture: Thonet Brothers,
1858
Bent solid beechwood, partly
bent laminated wood; palisander
glazed; woven cane
Inv. no. H 3019/1988
Formerly in the collection of
Alexander von Vegesack

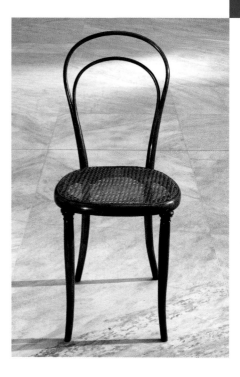

Chair for the Café Museum
Vienna, 1898
Design: Adolf Loos
Manufacture: J. & J. Kohn
Bent solid beechwood, solid
wood, stained red; woven cane
Inv. no. H 2805/1985

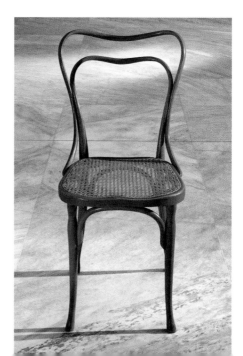

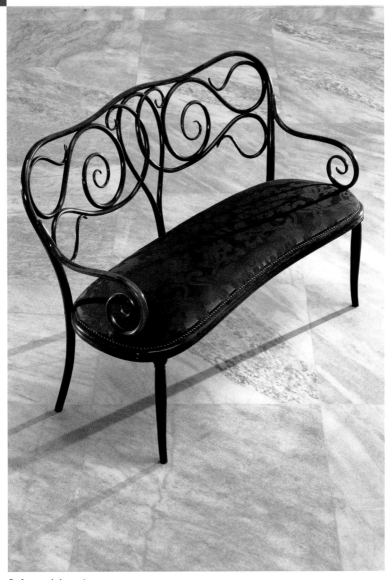

Sofa, model no. 4
Vienna, ca. 1850
Manufacture: Thonet Brothers, ca. 1858/60
Bent solid beechwood, partly bent laminated wood; stained palisander; damask
upholstery (renewed)
Inv. no. H 2978/1988
Formerly in the collection of Alexander von Vegesack

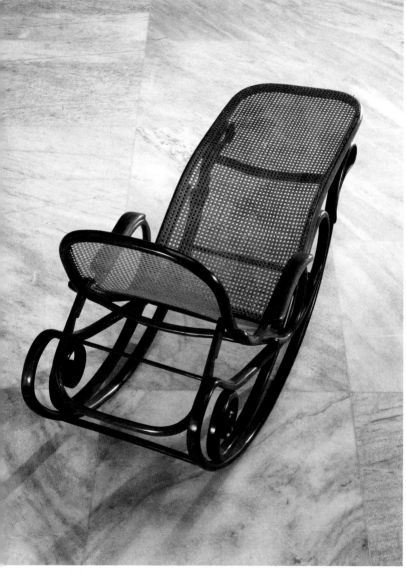

Rocking chaise
Vienna, ca. 1874/82
Manufacture: Thonet Brothers, ca. 1890
Partly bent solid beechwood, turned solid beechwood,
solid wood, stained brown; woven cane
Inv. no. H 2935/1987
Formerly in the collection of Alexander von Vegesack

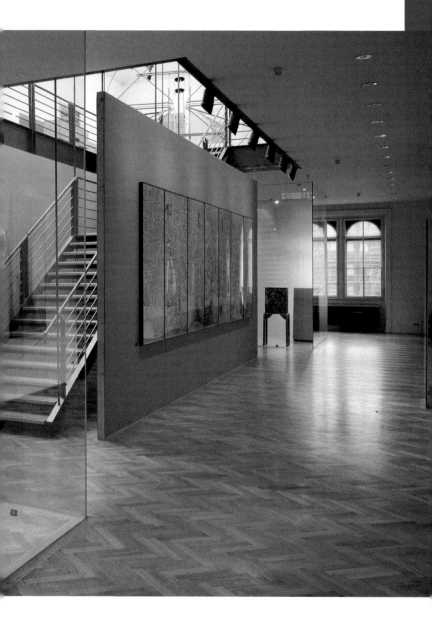

EICHINGER ODER KNECHTL

Curator: Waltraud Neuwirth

tradition *klimt frieze, macdonald frieze, furniture from 1895 to 1820, art nouveau glass* and present day* *a floating display case (23.38 meters long) the glass rooms (each 17.61 square meters) two cardboard walls (height 3.84 meters) the blue box (view downwards).*

the diversity of the objects on display contrasts with the consistent treatment of the materials used: naturally colored corrugated card-board, sandblasted glass, display case lighting filtered by industrial drinking-glasses, a pre-cast concrete element, window frames, metal profiles, glass walls, the view from a wall niche down into the expanse of the exhibition room which was designed by donald judd.

the glass rooms: *two logical spatial surfaces corresponding to the spatial whole. the existing invisible spaces were made visible through glass walls (12-mm securit float glass): size 4.35 meters by 4.26 meters and 4.05 meters high. the glass sheets, arranged in u-shapes, stretch from floor to ceiling. each wall side is formed by three equal-sized single glass sheets. the entrance side consists of only two glass sheets leaving an asymmetrical entrance to these walk-in display cases. the three glass plates facing the entrance are sand-blasted to soften the light from the windows to the museum garden and the stubenring behind them. at varying intervals furniture by krenn, wimmer, peche, wagner, breuer, singer, haerdtl, frank, hoffmann, loos, van de velde will be shown.*

the hanging display case: *consisting of 6 (7) glass cases, each 3.34 meters long, arranged in a straight row. the display cases are hung from the ceiling with orni profiles and raise the colored glass objects that are displayed in them to eye level. an intermediate level of industrial glasses arranged in series serves as an ultraviolet filter and refractor for the light falling on the hanging display case from above. this shining cross-beam of glass and metal allows the pieces exhibited – art nouveau glassware and metalware – to be seen from three sides at once: from in front, behind and below.*

the two cardboard walls *are protective boxes for very fragile exhibits: klimt's werkstätte sketches for the stoclet palace, and "the seven princesses," a painted plaster relief with semiprecious stones by margaret macdonald. the cardboard walls emphasize an alternative relationship with raw materials: there is no difference in the handling of these materials verses other materials, and recyling and possible reuse ennobles the material so that even recyclable corrugated cardboard is taken seriously.*

the blue box: *a window of blue glass in an existing wall niche provides a view from above into the exhibition room, designed by donald judd. this small chapel is formed by a pedestal 30.7 meters high (precast concrete) and a standing, sand-blasted glass sheet.* / Eichinger oder Knechtl

In 1902 Fritz Waerndorfer, co-founder and financier of the Wiener Werk-stätte, commissioned Charles Rennie Mackintosh from Glasgow to install a music room in his Viennese villa, next to the dining room designed by Josef Hoffmann. Mackintosh's wife, Margaret Macdonald, designed the frieze for the salon using motifs of the Belgian poet Maurice Maeterlinck. Since 1916 the room's entire contents were thought to have been lost until the "Waerndorfer frieze" resurfaced during the Museum's reconstruction.

From 1905–9 Gustav Klimt worked on a frieze that was created for the Stoclet Palace in Brussels (architect: Josef Hoffmann). The frieze was commissioned by the Wiener Werkstätte, manufactured to Klimt's design by Leopold Forstner's "Viennese Mosaic Factory" and installed in Brussels in 1911.

These works, which were commissioned by progressive art aficionados of the upper middle class illustrate the characteristics of the era: the Secession sought the dissolution of a hierarchical boundary between "free" and "applied" art. With prestigious objects, such as furniture, glass, and ceramics, non-industrial arts and crafts became an accepted part of private households. A programmatic equilibrium developed between the artist (design) and the craftsman (execution). The stylistic elements varied around Europe but the network of artists was closely knit. "Art Nouveau represents the last attempt by art to escape from the ivory tower in which it is besieged by technology" (Walter Benjamin, 1935). Historicism lingers on in its desire for the synesthesia of the *Gesamtkunstwerk;* aesthetic comfort is forfeited and the modern movement is anticipated in the effort to find the proper form and adequate material. / **Birgit Flos**

* "tradition und gegenwart, bewahrung und experiment" ["tradition and present day, conservation and experimentation"]: a sequence of excerpts from the press conference "transformation of a place" with the director of the MAK, peter noever.

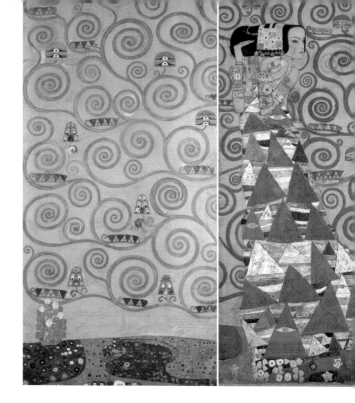

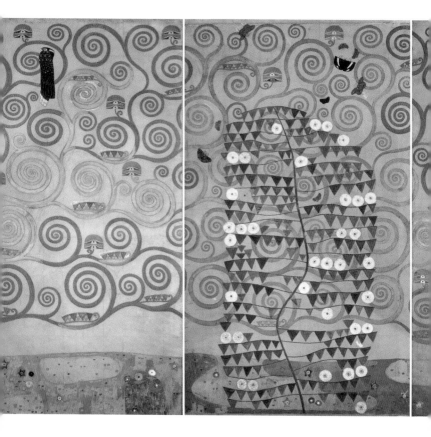

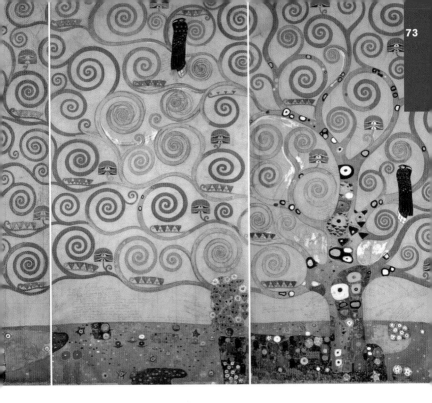

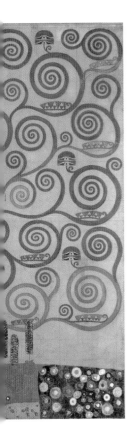

Gustav Klimt, Stoclet Frieze
Vienna, 1905–12
Design: Gustav Klimt
Drawing in 9 pieces for the mosaic at the Stoclet
Palace in Brussels; gold leaf and silver leaf on
wrapping paper of various thicknesses, with a grid
and various manuscript markings
Inv. no. Mal 226a–i/1961

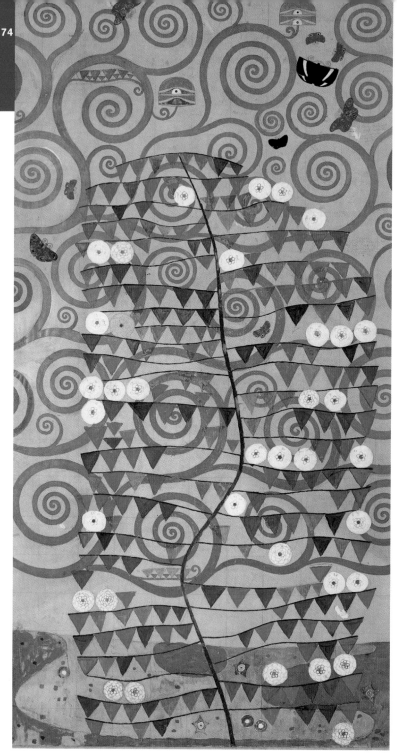

Gustav Klimt, Stoclet Frieze (detail)
Vienna, 1905–12
Part 6: Tree of Life with rosebush
Various manuscript markings: "6. Teil von links" ["6th part from left"] and notes:
"Blüthe nicht Mosaik Stengel Mosaik. Schmetterlinge nicht Mosaik anderes noch zu
bestimmendes Material Strauch samt Blumen und Stiel nicht Mosaik sondern ande-
res Material S" ["Flowers not mosaic stem mosaic. Butterflies not mosaic other mate-
rial still to be decided. Bush with flowers and stalk not mosaic but other material S"]
Inv. no. Mal 226a–i/1961

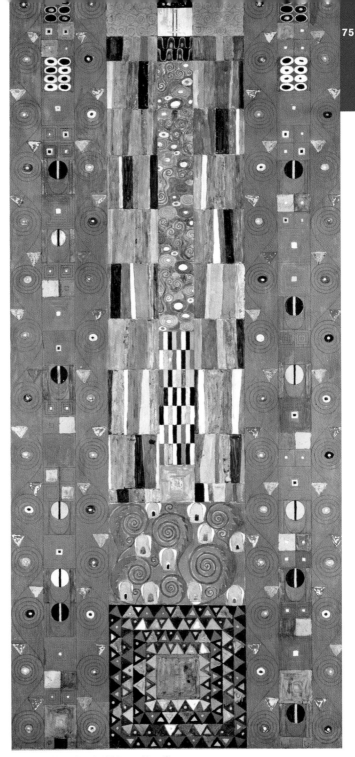

Gustav Klimt, Stoclet Frieze (detail)
Vienna, 1905–12
Inv. no. Mal 226a–i/1961

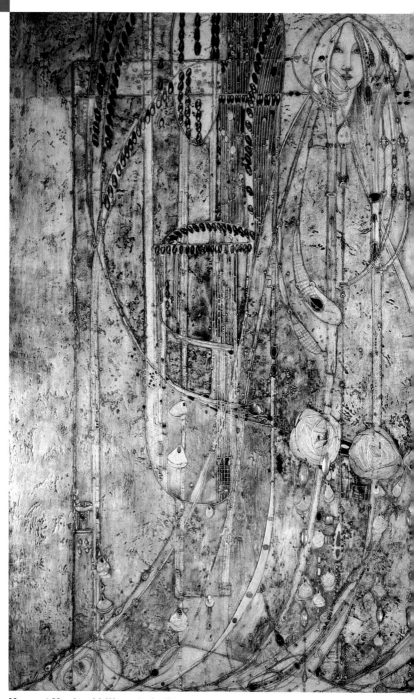

Margaret Macdonald, Waerndorfer Frieze
Detail of the central panel
Design: Margaret Macdonald
Three gesso panels based on Maeterlinck's "The Seven Princesses"
Executed in 1906 for the music room in the home of Fritz Waerndorfer
Each panel: 152 x 200 cm
Inv. no. Mal 348/1961

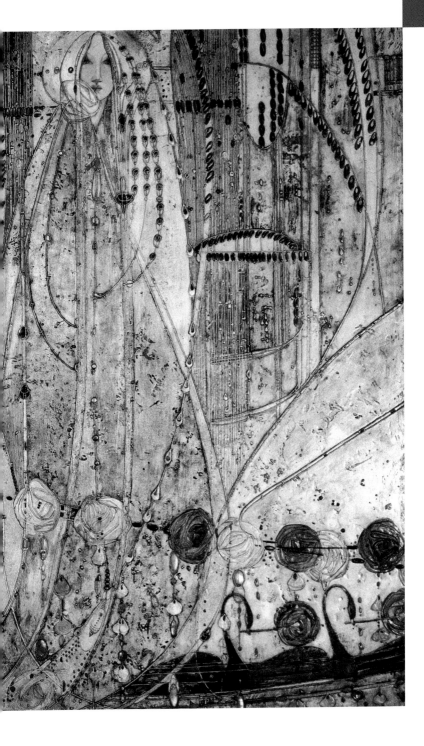

Sliding table
Vienna, 1903
Design: Koloman Moser, manufacture: Caspar Hrazdil (?)
Maple wood, natural and with dark stain, solid and veneered; nickel fittings
Inv. no. H 2630/1981
Donation of Gertrud von Webern

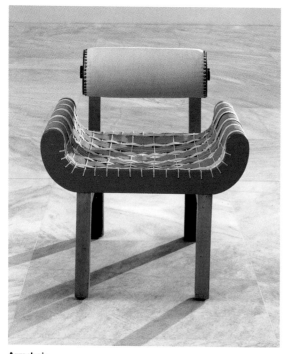

Armchair
Vienna, 1927
Design: Franz Singer
Maple, solid, natural and with brown stain, beechwood
panelling; painted red; strips
Inv. no. H 3004/1989

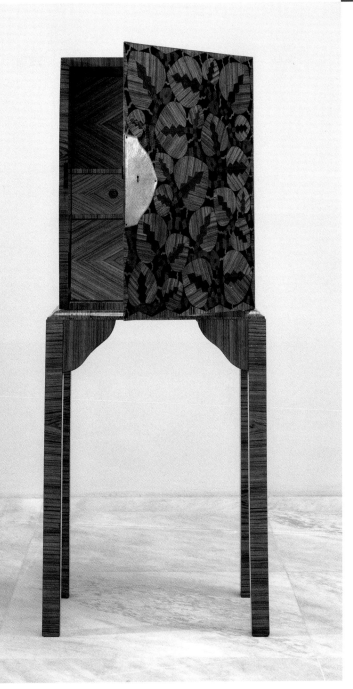

Ornamental cupboard
Vienna, 1912
Design: Rosa Krenn; manufacture: Karl Adolf Franz (marquetry work), Florian Hrabal (cabinetmaking)
Zebrawood and black-stained maple wood, veneered; marquetry in zebrawood, amaranth, and maple wood; brass fittings
Inv. no. H 1397/1912

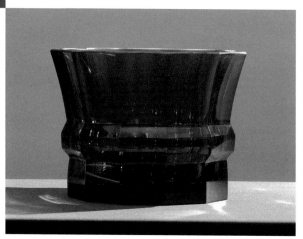

Bowl
ca. 1914/15
Design: Josef Hoffmann (Wiener Werkstätte)
Violet colored cut glass
Inv. no. Gl 3111/1972

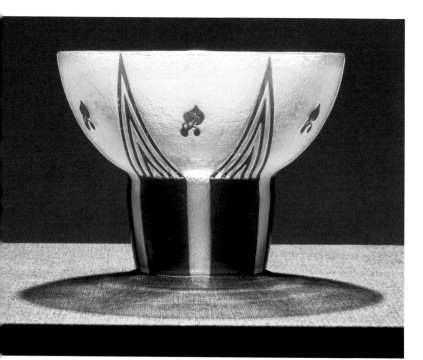

Bowl
ca. 1913
Design: Josef Hoffmann
Bluish opal-colored glass with green verre doublé,
cut decoration on raw-etched ground
Inv. no. W.I. 1594/1915

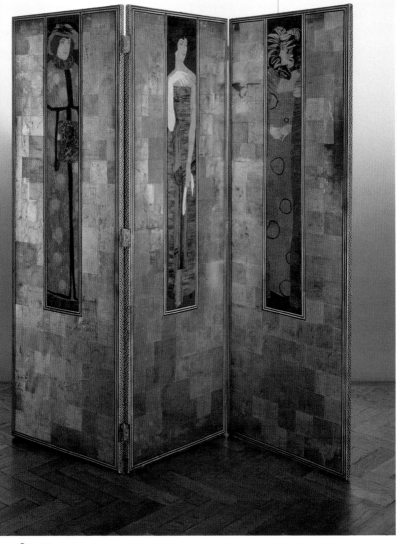

Screen
1906
Design: Koloman Moser, manufacture: Karl Beitl, Therese Trethan,
produced in the Wiener Werkstätte
Gold leaf, paper collage, on wooden frame
Inv. no. WWPA 830/1995
Donation of Tokyo Shimbun

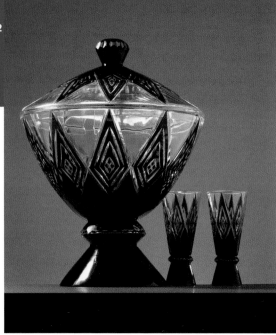

Pieces from a punch bowl set
Prague, before 1915
Design: Josef Rosipal for Artěl
Glass with verre doublé, cut decoration on raw-etched ground
Inv. no. W 1523/1, 3–5/1915

Vase
ca. 1900
Three double-curved handles
Mark: "Loetz Austria" (engraved)
Inv. no. W.I. 15/1902
Donation of Max Ritter von Spaun

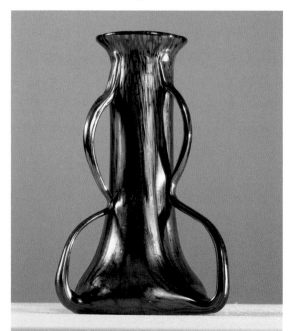

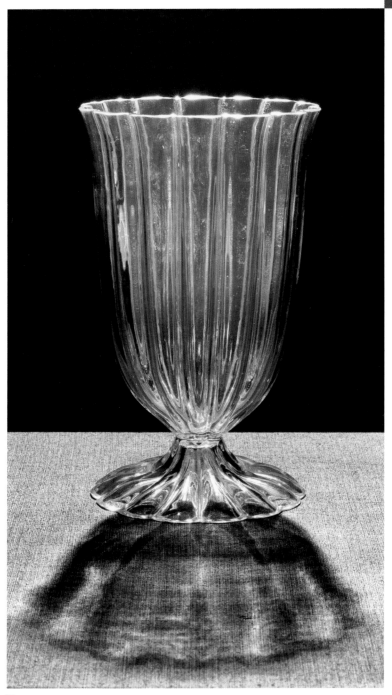

Vase
Design: Josef Hoffmann, ca. 1923; manufacture: commissioned by the Wiener Werk-
stätte, probably in Bohemia (1923–28, around 400 pieces in various designs)
Model number: va 35 (not marked)
Inv. no. Gl 3311/1972

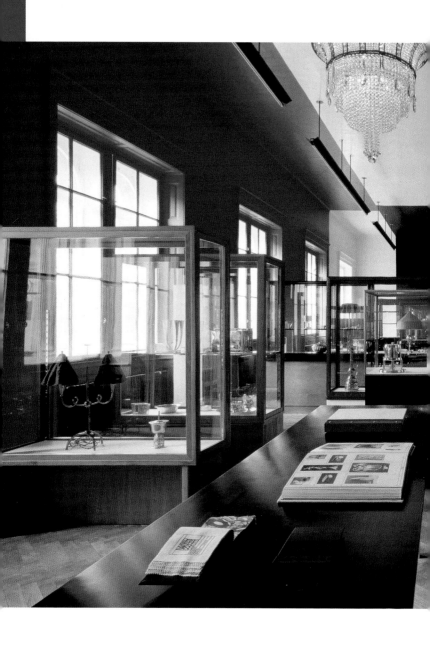

HEIMO ZOBERNIG
Curator: Elisabeth Schmuttermeier

The basis for the choice of color and design in my mural is the fest-schrift that was published for the 25th anniversary of the Wiener Werkstätte in 1929. I did not make any selection from the Wiener Werkstätte collection. The exhibition shows most of the works held by the MAK. The MAK owns the estate of the Wiener Werkstätte. The wall gallery shows the entire extent of the Wiener Werkstätte archives, parts of which can be seen in reproduction in the exhibition room. To exhibit the Wiener Werkstätte objects, I have used MAK display cases that have been in use in the Museum since its inception at various times and for various purposes. / Heimo Zobernig

Founded in Vienna in 1903 by Josef Hoffmann, Koloman Moser, and Fritz Waerndorfer, the Wiener Werkstätte aimed to adapt the formal aspects of everyday commodities to the changed requirements of a new era. Their endeavor to take artistic account of all areas of everyday life was matched by a wide range of goods produced. The planning and execution of architectural contracts was carried out by the Building Office, and items for interior decoration were the responsibility of the cabinetmaking, varnishing, and bookbinding departments and the workshops for metal-work and leatherwork. Between 1910 and 1920, the product range was extended by a fashion department, by designs for fabrics and wallpapers, and also by the artists' workshops, in which work was carried out using a wide variety of materials.

The restraints of the initially strongly geometric forms used in the objects were relaxed as early as 1906 when these forms became inunda-ted with decorative ornamentation. When Dagobert Peche joined the Werk-stätte in 1915, the decorative tendency reached a climax of ornamental fantasy.

The gradual descent of the Wiener Werkstätte to artistic mediocrity, unprofessional management, as well as the world's declining economic situation resulted in dwindling numbers of potential customers and – among other causes – led to the ultimate closure of the enterprise in 1932. In 1937, the Archive of the Wiener Werkstätte was offered for sale to the Austrian Museum of Applied Arts. Its last owner, Alfred Hofmann, do-nated it to the Museum in 1955. The Archive consists of sketches for a wide variety of materials by all of the artists who worked either in or for the Wiener Werkstätte, as well as photograph albums, model books, ori-ginal fabric patterns, production drawings for embroidery and lace, commercial art, files and correspondence, and much more. / Elisabeth Schmuttermeier

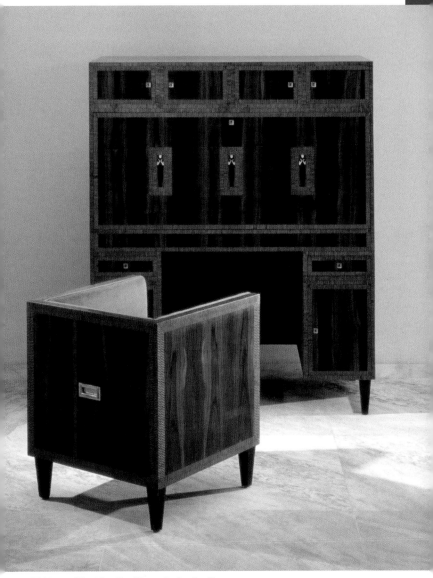

Writing cabinet for the Waerndorfer family
Wiener Werkstätte, 1903/04
Design: Koloman Moser
Veneered Macassar ebony, marquetry in Madagascar ebony,
boxwood, mahogany; ivory, tortoiseshell; brass fittings
Inv. no. H 2305/1976

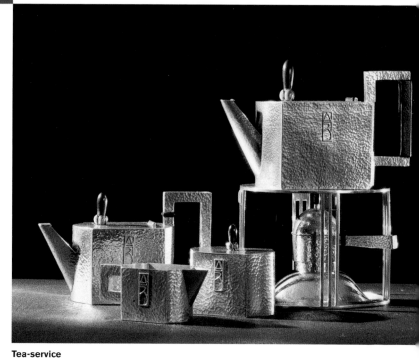

Tea-service
Wiener Werkstätte, 1903
Design: Josef Hoffmann, manufacture: Konrad Koch
Silver, coral, ebony
Inv. no. Go 2005/1965

Pepper and paprika pot
Wiener Werkstätte, 1903
Design: Josef Hoffmann
Silver, cornelian
Inv. no. Go 2108/1990

Vase
Wiener Werkstätte, 1903/04
Design: Koloman Moser
Brass, citrine
Inv. no. Me 915/1965

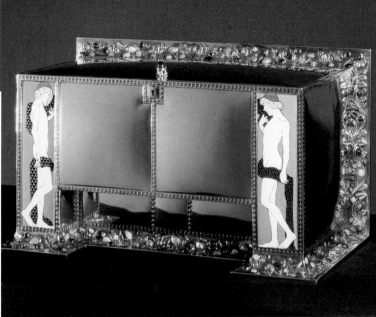

Casket
Wiener Werkstätte, 1906
Design: Koloman Moser, manufacture: Adolf Erbrich, Karl Ponocny
Silver, enamel, semi-precious stones
Inv. no. Go 1397/1908

Gift of honor on Josef Hoffmann's 50th birthday
Wiener Werkstätte, 1920
Design: Dagobert Peche
Silver, ivory, soapstone
Inv. no. Go 1788/1925

Pendant
Wiener Werkstätte, 1903
Design: Koloman Moser
Silver, opal
Inv. no. Bi 1495

AUSTERNGABEL

202 203 FISCHBESTECK 204 205 KREBSBESTECK

Design for "flat cutlery"
Wiener Werkstätte, 1904
Design: Josef Hoffmann
Pencil and ink on chequered paper
Inv. no. K.I. 12086/10/1956

Kneeling Woman (Knieende)
ca. 1908
Design and manufacture: Vally Wieselthier;
original WW ceramic, KO-no. 6000
Inv. no. Ke 7237/1932

Bookbinding
Wiener Werkstätte, ca. 1914
Max Brod, Der Bräutigam, Berlin, n. d.
Polychromatic Morocco leather with appliqué floral
still life and strict linear ornamentation
Inv. no. B.I. 21192/1936

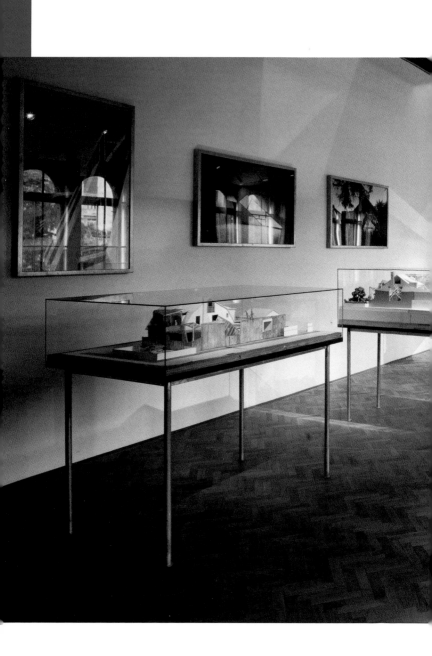

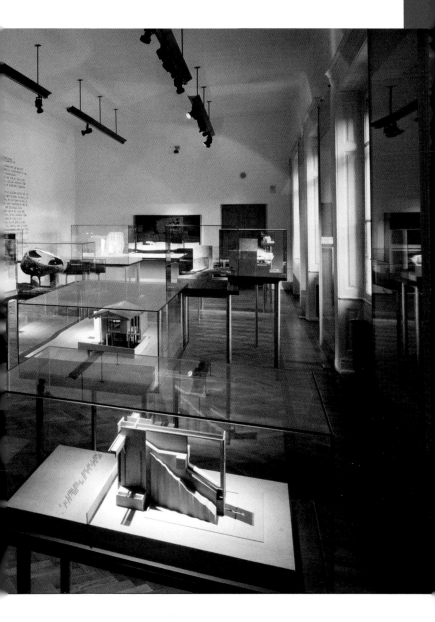

MANFRED WAKOLBINGER

Curator: Peter Noever

Frank O. Gehry, Santa Monica Residence
1978
Model for the rebuilding of his residence
Wood, metal, acrylic glass
Inv. no. GK 84a/1992

Space for Architecture
The glass wall promises a view – of the city and of utopias.
Spread out in the room – spaces.
On the small desks rest ideas, imagined and built.
A new world opens up through every glass cover on every table.
One can discern the manifested object in the images on the wall.
Lebbeus Wood's manifesto written on the wall links everything
together. / Manfred Wakolbinger

The architecture area includes models and drawings by Raimund
Abraham, Günther Domenig, Driendl*Steixner, Frank O. Gehry, Zaha
Hadid, John Hejduk, Coop Himmelb(l)au, Frederick J. Kiesler, Daniel
Libeskind, Thom Mayne – Morphosis Architects, Eric Owen Moss, Carl
Pruscha, Helmut Richter, Rudolph M. Schindler, and Lebbeus Woods.

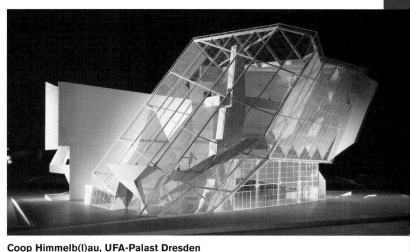

Coop Himmelb(l)au, UFA-Palast Dresden
1997–98
Architectural model, 1994
Wood, brass, acrylic, polystyrene foam, built-in video and sound reproduction
Scale 1:50
Inv. no. GK 215/2000

(Applied) art must also mean questioning the relationship between art and function, between art and everyday life.

The works of the architects shown in this room demonstrate and document a point of view in which the yardstick for architecture is its universal character.

No matter how varied individual positions may be, all the architects represented in the collection have one characteristic in common: they are concerned with a new type of architectural thinking. All of them tell us that there is no longer any prescribed path laid out for contemporary architecture. Utopian architectural visions, ideal proposals, projections of a bridge between rationality and manifestation stand alongside projects that test architecture in terms of its social usefulness. / **Peter Noever**

Daniel Libeskind, Main staircase-facade study model
1994
Jewish Museum Berlin, 1989–99
Architectural model; cardboard, aluminum; scale 1:200
Inv. no. GK 198/1999

Zaha Hadid, Vitra Fire Station, Weil am Rhein, Germany
1996
Architectural model; stainless steel, with steel pedestal; scale 1:50
Inv. no. GK 165/1996

Curator: Peter Noever

The place for contemporary artists had to be literally extorted from the museum's attic. The space is accessed by a staircase that links the area with the rhythm of the existing exhibition rooms without entirely lifting it from seclusion. Free of aesthetic conjecture and formalisms, this bright, clearly laid out and undivided, open "studio" space displays select, autonomous, individual and universal examples of contemporary art production.

Torn from their original context, these independent works, installations and sculptures interact with each other in a complex way and their dynamics, content, and fields of tension create and breathe life into a new spatial and emotional sculpture. / Peter Noever

A collection of contemporary art should not narrowly define art, but test, seek, and explore its depths. The idea of the founders of the MAK – Austrian Museum of Applied Arts was to promote the arts and crafts, to contribute to the improvement of taste and to act as a model; but today, its main concern is to present current events and products from a specific perspective, to illustrate through its collection the inter-connectedness that arises at the borderline between "fine" and "applied" art.

The *Contemporary Art* Collection, established in 1986, seeks to confront the art of our own time and to generate a dialogue with the artists and with the documentation of contemporary art movements. Avoiding a one-sided, museum-oriented appraisal of art, the Collection will continually address questions and themes relevant to our times. Such uncompromising works as those by Donald Judd in Stadtpark, Philip Johnson at Schottenring and Franz West on Stubenbrücke, thus exemplify the Collection's attempt at greater openness and understanding for art.

The MAK *Contemporary Art* Collection is oriented towards an emphasis on contemporary Austrian artistic production and works by artists who, through exhibitions and other events, have direct connections with this institution. Since 1995 a major part of the Collection is on display in the Arenbergpark Flak Tower. Works by Vito Acconci, Herbert Bayer, Günter Brus, Gregor Eichinger, Heinz Frank, Padhi Friedberger, Bruno Gironcoli, Magdalena Jetelová, Donald Judd, Birgit Jürgenssen, Milan Knizak, Brigitte Kowanz, Hans Kupelwieser, Heinz Leitner, Christoph Lissy, Helmut Mark, Oswald Oberhuber, Walter Pichler, Arnulf Rainer, Alfons Schilling, Eva Schlegel, Hubert Schmalix, Rudolf Schwarzkogler, Ingeborg Strobl, Mario Terzic, James Turrell, Manfred Wakolbinger, Hans Weigand, Franz West, and Heimo Zobernig, and many others are shown here alongside experimental architectural projects and

Donald Judd, Untitled (Ohne Titel)
1989
Aluminum, varnished
Inv. no. GK 97/1993

demonstrations by Raimund Abraham, Coop Himmelb(l)au, Günther Domenig, Frank O. Gehry, Zaha Hadid, John Hejduk, Frederick J. Kiesler, Eric Owen Moss, Rudolph M. Schindler, Carl Pruscha, and Lebbeus Woods. / Peter Noever

Gordon Matta-Clark, Bronx Floor: Floor Above, Ceiling Below
1972
Wood, wall plaster, wallpaper
Inv. no. GK 154/1996

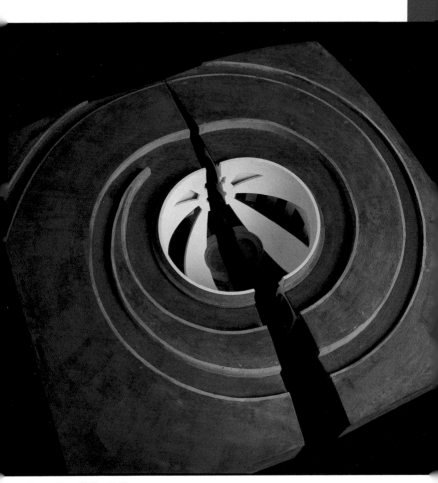

James Turrell, South Space
1998
Model in two parts (Roden Crater); wood, plaster, color
Scale 1:48
Inv. no. GK 193/1998

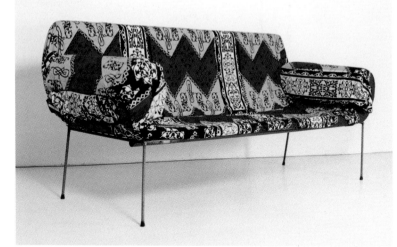

Franz West, 12 Diwans
1996
Iron, foam, jute, African fabrics, consisting of 25 objects
Inv. no. GK 194/1999

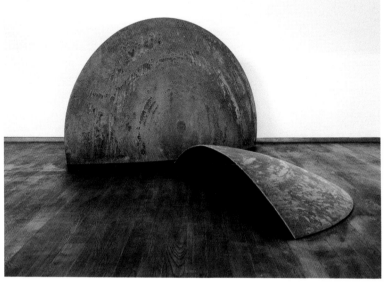

Hans Kupelwieser, Untitled (Ohne Titel)
1988
Iron, two parts
Inv. no. GK 27/1989

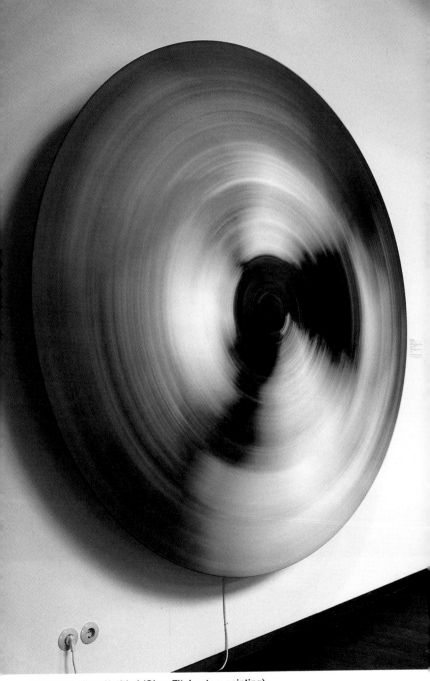

Alfons Schilling, Untitled (Ohne Titel, rotary painting)
1962
Pigments with synthetic resin on canvas (painted in rotation),
rotary engine, sensor
Inv. no. GK 244/2002
Donation of Udo Saldow in memoriam Lore Saldow

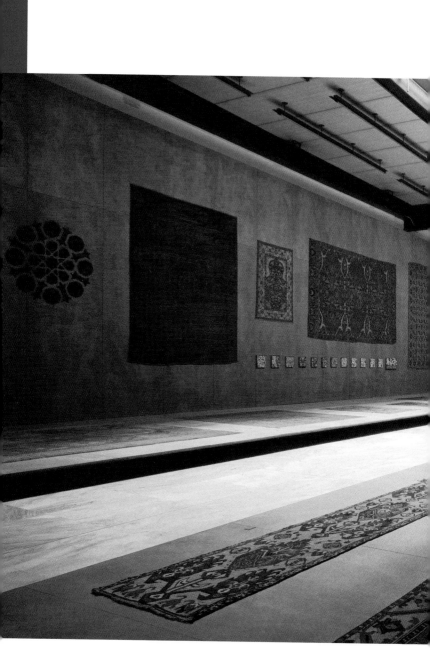

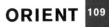

GANGART
Curator: Angela Völker

As a way of approaching the anachronism of carpets hung as if they were pictures, vertical and horizontal presentation surfaces have been produced in the same material, forming a detached unit to provide a "setting" for the exhibits. The carpets are mounted without individual frames, corresponding to their appearance when in use.

The presentation surfaces are proportioned in relation to the given architectonic parameters, and consist of two units with L-shaped sections running along the long axis of the hall. They are distinct from the floor and walls, and their state of "suspension" is enhanced by the restricted lighting. The coloring of the elements is a reaction to the dominant warm tones of the exhibits: they are restrained in character in relation both to the carpets and to the architectonic design elements. The remaining central corridor defines the mode of reception, both by setting the distance from which the exhibits can be observed and by setting the direction of the sequence in which they are observed. / Gangart

The collection of oriental carpets in the MAK is one of the finest, most valuable, and best known in the world, although not one of the most extensive. The collection's emphasis on "classic" carpets of the sixteenth and seventeenth centuries derives from the former Austrian Imperial Family, whose carpets passed to the Museum after World War I. Examples of these are the silk hunting carpet and the silk Mameluke carpet, the only one in the world to have survived. It is still not certain how the carpets came into the possession of the Austrian Imperial Family, in which they were treated as very highly valued household objects, not as collector's items.

In the East Asian world, the knotted carpet laid on the floor is the most important element of interior decoration, both in the nomadic period and in the ruler's palace. Artistic inventiveness, manual dexterity, and precious materials are therefore plentifully applied.

Another source of the collection, which had started acquiring its own oriental carpets very early, is the Imperial and Royal Oriental or Trade Museum, whose carpets passed to the MAK when it was closed in 1907. / Angela Völker

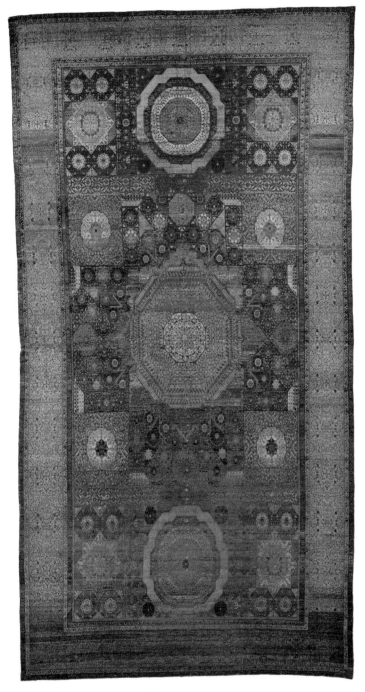

Silk knotted carpet – Mameluke carpet
Cairo (Egypt), beginning of the 16th century
Warp, weft, pile: silk – asymmetrical knots 547 x 298 cm
Inv. no. T 8332/1922
Formerly in the possession of the Imperial Family

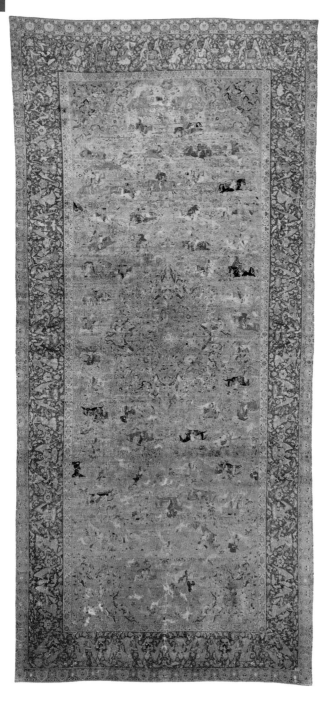

Silk knotted carpet – hunting carpet
Kashan (central Persia), first half of the 16th century
Warp, weft, pile: silk – asymmetrical knots, stitched, 687 x 331 cm
Inv. no. T 8336/1922
Formerly in the possession of the Imperial Family

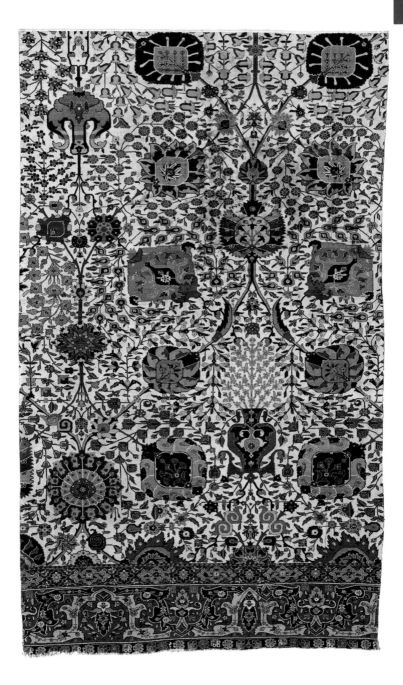

Fragment of a knotted carpet – vase carpet
Kerman (southern Persia), second half of the 17th century
Warp: cotton, weft: wool, silk; pile: wool – asymmetrical knots, 249 x 152 cm
Inv. no. Or 359/1907
Formerly held by the Oriental Museum

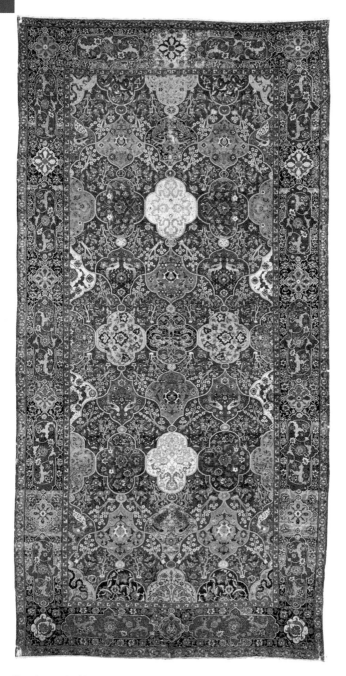

Herat carpet with squares
Eastern Persia, late 16th century
Warp: cotton; weft: cotton, wool; pile: wool; asymmetrical knots
540 x 273 cm
Inv. no. T 9026/1941

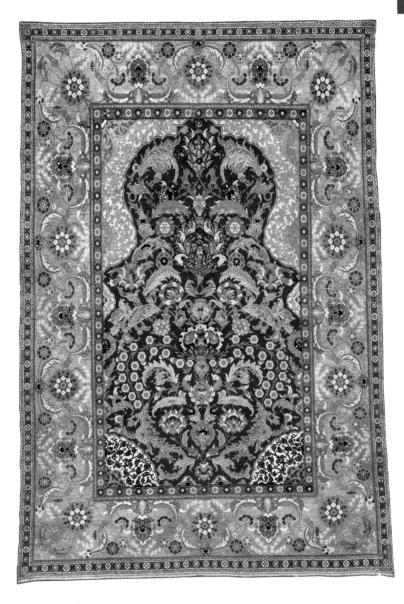

Prayer carpet
Istanbul or Bursa, second half of the 16th century
Warp, weft: silk; pile: wool, cotton – asymmetrical knots
181 x 127 cm
Inv. no. T 8327/1922
Formerly in the possession of the Imperial Family

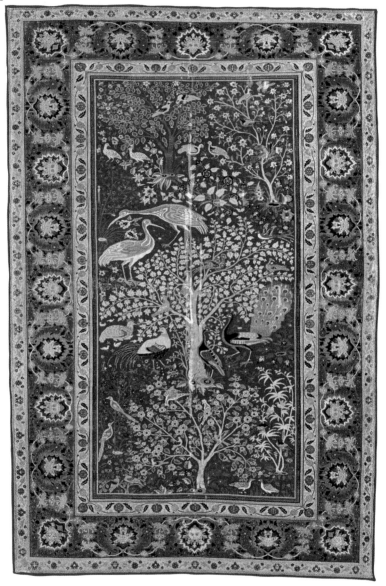

Knotted carpet
Northern India, Lahore, ca. 1600
Warp, weft: cotton; pile: wool – asymmetrical knots,
233 x 158 cm
Inv. no. Or 292/1907
Formerly held by the Oriental Museum

Tile
Persia, 17th/18th century
Ceramic, with geometrical ornamentation and enamel glaze
Inv. no. Ke 10563/1989

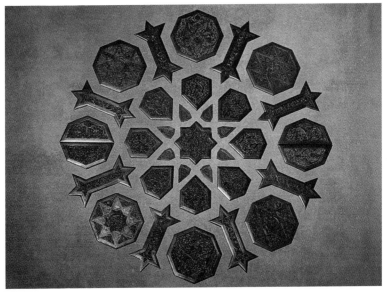

Rosette
Donated by Sultan Lagin in 1296, from the mimbar of the Ibn Tulun Mosque in Cairo
Constructed from 35 carved and inlaid wood panels
Inv. no. Or 3405/1892
Formerly held by the Oriental Museum

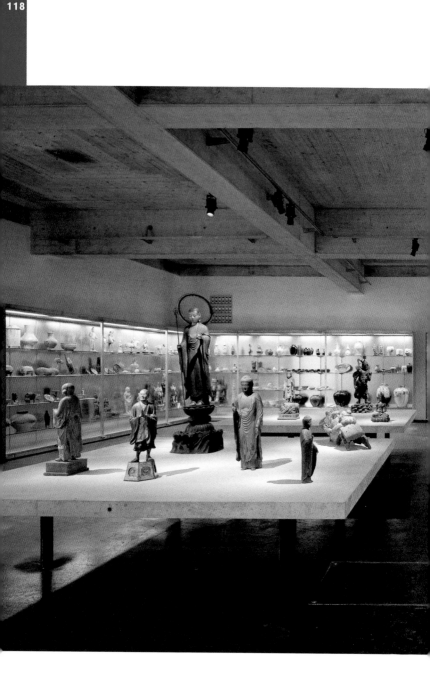

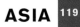

Curator: Johannes Wieninger
Design: Peter Noever

An Asian collection, especially when displayed in association with European art, is a form of Orientalism in itself. All of the art works exhibited here were ultimately chosen by Europeans; a European taste is being represented here in which the centuries-old interrelationship between Asia and Europe survives.

Some of the groups of items shown – such as the examples of K'ang-Hsi porcelain from the collection of Augustus, the Elector of Saxony, objects formerly owned by the Habsburgs, or porcelain pieces with European gold mountings – have been in Europe for centuries, and have had a lasting influence on the history of our art. Others were brought to Europe during the first half of the present century in order to present an image of Asia that corresponded to developments in art history.

The juxtaposition of European and Asiatic works of art is a tradition that goes back to the Middle Ages, and one that is continued in this Museum. Even here, there was no Asian Department until some fifty years ago; until then, the objects were distributed among the "European" departments.

The exhibition hall is a central space around which the study collection is grouped. The display cases primarily contain the collection's "highlights" of Chinese and Japanese ceramics and porcelain the focus being on the 18th century. Most notable here is the tea pottery from China and Japan. Buddhist sculptures and objects from the 4th till the 18th century are permanently displayed on four centrally positioned bases. The form of presentation is inspired by the concept of the "Lapidarium:" the idea is not to recreate the original scenario but much rather an appropriate presentation of the objects and their history, which is often a forceful removal from their original purpose. / Johannes Wieninger

Bowl
China, Yuan Dynasty (1234–1368), mid-14th century
Porcelain with painting in cobalt blue beneath the glaze
Inv. no. Ke 2259/1873

Bowl
China, Ming Dynasty (1368–1644), second half of the 14th century
Wood with carved lacquer in variously colored layers (so-called "Guri lacquer")
Inv. no. La 220/1948

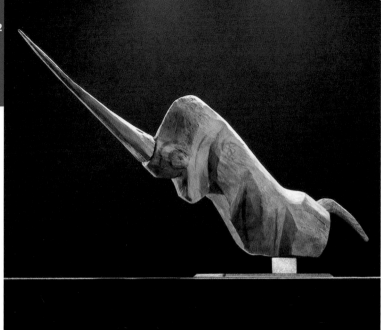

Unicorn (burial figure)
China, Wuwei (Gansu), Later Han Dynasty (25–220)
Wooden sculpture with remnants of black painting
Inv. no. Pl 896/1992

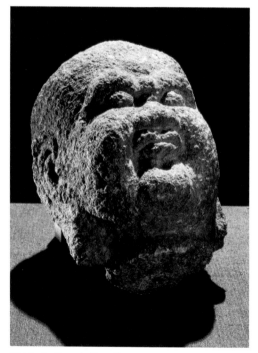

Head of a Temple Guardian
China, Tang Dynasty (618–907)
Fragment of a coarse-grained limestone sculpture
Inv. no. Pl 659/1948

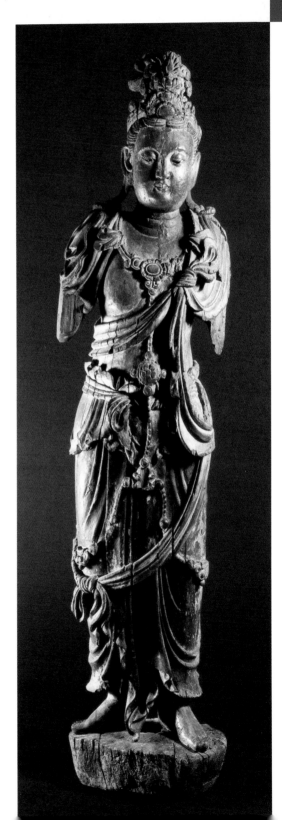

Bodhisattva
China, Sung Dynasty
(960–1279),
12th century
Wooden sculpture
with remains of the
original paint layer
Inv. no. Pl 846/1948

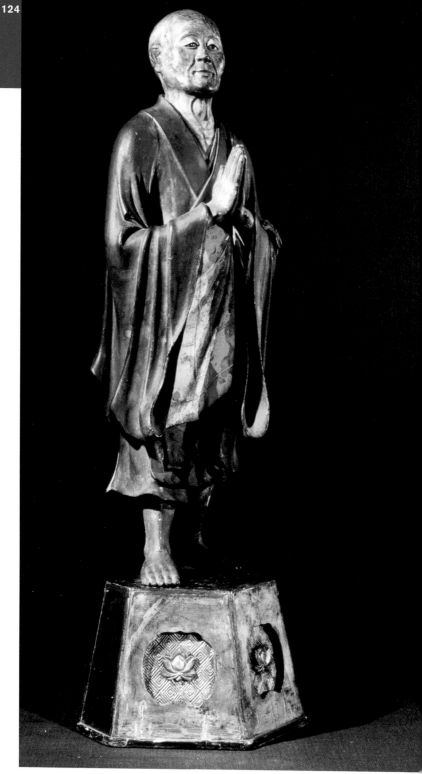

Monk of the Nichiren sect
Japan, Edo Period (1603–1866)
Before 1700
Wooden sculpture with lacquer base
Inv. no. Pl 859/1989

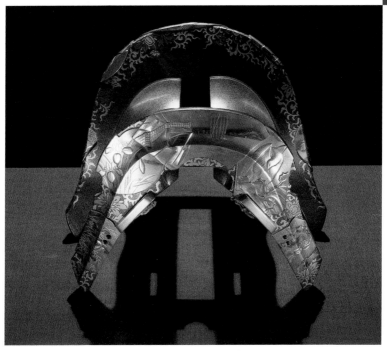

Saddle
Japan, Edo Period (1603–1866), 19th century
Wooden saddle with gold lacquer relief on a gold base, dated
1549, the lacquer decoration renovated in the 19th century
Inv. no. La 257/1948

Box with lid
Japan, Kyoto, Edo Period (1603–1866), second half of
the 17th century
Stoneware with enamel and gold painting on the glaze,
signed "Nonomura Ninsei" (1627–95)
Inv. no. Or 1024/1873

ARTISTS' BIOGRAPHIES

PERMANENT COLLECTION
ARTISTIC INTERVENTIONS

BARBARA BLOOM

Born in 1951 in Los Angeles. Lives and works in New York.

Barbara Bloom transforms in her work objects from various cultures into compositions and installations. Her primary concern lies in themes related to consumerism, information, and reality. Beauty and symmetry serve her as tools for investigating illusion, fragility, and transience in our society.

EICHINGER ODER KNECHTL

Gregor Eichinger: Born in 1956, Christian Knechtl: Born in 1954. Both live and work in Vienna.

Although architecture is the basis for the work of Eichinger oder Knechtl, they have long stopped accepting any limits and restrictions on it. As typographers, they designed the cover of a city magazine, which was like the signs of urban planning that appear at various places simultaneously. Their built projects show Eichinger oder Knechtl creating a link between architecture, typography philosophy, painting, and interior design.

GÜNTHER FÖRG

Born 1954 in Füssen. Lives and works in Areuse, Switzerland.

Günther Förg owes his singular position in contemporary art to the versatility and complexity that underlie his important work groups, done in such diverse techniques as photography and sculpture. Painting, however, remains central to his work.

GANGART

The artist group Gangart, founded in Vienna in 1985, works in a variety of media, such as environment, film, movement, and music. Their carefully planned concepts pursue with utmost consistency questions related to presentation, history, and aesthetics. Developing out of scrupulous research, their interventions are always spatially based.

FRANZ GRAF

Born 1954 in Tulln, Lower Austria. Lives and works in Vienna.

Franz Graf is one of the most important representatives of a neo-conceptual position. His innovative combinations of divergent media such

as drawing, photography, and installation repeatedly lead to new and open structures. The spectrum of his motifs ranges from abstract to ornamental, figurative and emblematic, or to factual representations of reality made with the camera.

JENNY HOLZER
Born in 1950 in Gallipolis, Ohio. Lives and works in New York State.
The media artist Jenny Holzer investigates the means and possibilities for disseminating her own ideas and artistic concerns in public space. Since the 1970s, she has been using such media that allow her work to blend with its environment. The texts in her work are comments that harmonize with their surroundings. They stimulate perception and confront the viewer with social circumstances that are communicated by the specific conditions of the site.

DONALD JUDD
Born 1928 in Excelsior Springs, Missouri. Died 1994 in New York.
The painter, draftsman, sculptor, architect, art critic, and philosopher Donald Judd was one of the most important representatives of Minimal Art. Like no other, he redefined the relation between art and space.
In 1971, Judd moved to Marfa, Texas where he established the Chinati Foundation which was opened to the public in 1986. Works of Judd and of his contemporaries are on permanent display here. The Chinati Foundation exemplifies one of Judd's greatest concerns: the appropriate presentation of artworks. This has gradually led to a change of thought in museums in favor of a more unified and coherent display of artworks.

PETER NOEVER
Born 1941 in Innsbruck, Tyrol, Austria. Designer. Since 1986 C.E.O. and Artistic Director of the MAK, Vienna.
As its Artistic Director he was in charge of the adaptation and renovation of the MAK from 1988 to 1993 for which it received the "Museum of the Year Award" from the Council of Europe, Strasbourg, in 1996.
Various built architecture and design projects. After the opening of the MAK Center for Art and Architecture in Los Angeles in 1996, the realization of the project "CAT – Contemporary Art Tower" is his biggest challenge.

MANFRED WAKOLBINGER
Born 1952. Sculptor. Lives and works in Vienna.
Manfred Wakolbinger is concerned with questions related to the three-dimensional realm. In his work Wakolbinger investigates his personal relationship with the physical world in an attempt to develop a sculptural

vocabulary for communicating with it. A continual confrontation and reflection about the representational possibilities inherent to sculpture and the energy of elementary forms have inspired every stage of his work.

HEIMO ZOBERNIG

Born 1958 in Mauthen, Carinthia, Austria. Lives and works in Vienna. Heimo Zobernig's versatile oeuvre is a significant contribution to the international discourse on the way society deals with art. By efficiently applying a reduced vocabulary, he questions our rigid patterns of perception and takes a critical position toward art as a system.

THE STUDY COLLECTION

THE STUDY COLLECTION

ln its study collection the MAK displays a selection of its numerous possessions in an arrangement that is specific to the material and technology of the objects and that correspondens with the specialization of the director of each collection. Additionally museum exhibits are placed within typological, historical, or function-related contexts.

The *Furniture Collection* displays a diverse typology of seating furniture in one room while in another room temporary exhibitions show pieces mainly from its wood section. The collection also includes a permanent exhibit of a replica of Margarete Schütte-Lihosky's "Frankfurt Kitchen." Presenting the metal objects in categories brings out the diversity of the *Metal Collection*. Candlesticks, beakers, kettles or bowls all convey to the visitor an idea about the various stages of development in style and function.

The *Porcelain Collection* documents the history of porcelain manufacture through its exceptional holdings of Viennese porcelain as well as examples from other European porcelain manufactures.

Finally the *Textile Collection*, too, shows sections of its wide range of historical and regional possessions in temporary exhibitions.

The simple presentation of the objects in a uniform system of glass cases, frames, and platforms throughout all the collections underlines the specific character of the Study Collection: to promote the clear and comprehensive accessibility of as many artefacts as possible. Its aim is to inspire the public to view things by comparing them. Here, the abundance of objects and the versatility in the use of form and material predominate.

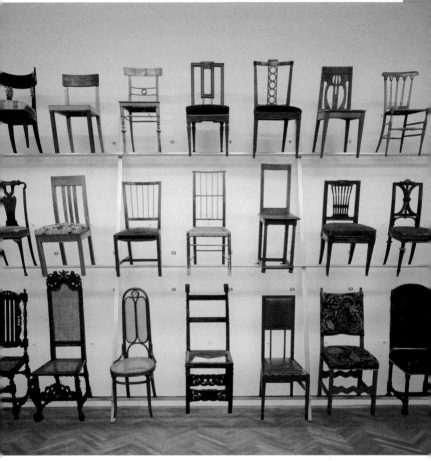

Detail of the "Chair Wall," various chronological and formal combinations

WORKS ON PAPER ROOM

Curator: Kathrin Pokorny-Nagel

Dictates of conservation make a permanent display of paper impossible. This is why during the course of adaptation of the library and reconstruction of the MAK, the former reading room was adapted to a room for temporary exhibitions of works on paper. For this purpose, a system of rails for movable frames was designed that could also be transformed into show-cases when needed.

The MAK Library and the Works on Paper Collection hold an annual exhibition from their own collections or host touring shows. Last year's themes ranging from posters, artists' books, and architecture projects to stylistic copies and Japanese woodcuts, are proof of the variety of programs the collection can yield. / Kathrin Pokorny-Nagel

MAK Works on Paper Room
View of the Exhibition "Ernst Deutsch-Dryden. En Vogue!," 2002
Design: Michael Embacher

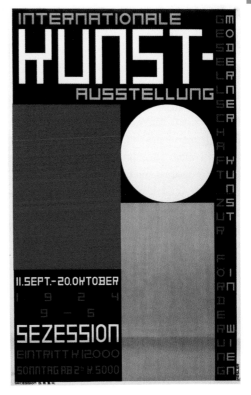

Internationale Kunstausstellung Sezession
1924
Design: Frederick J. Kiesler
Inv. no. P.I. 479/1924

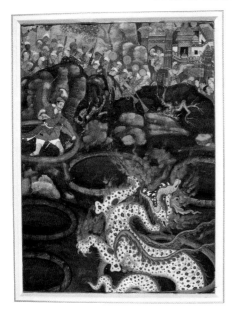

**Hamza Nama
(indo-persian heroic novel)**
1562–77
Hamza goes to Abessinia and
kills a dragon
Inv. no. K.I. 8770/15/1873

DESIGN INFO POOL

Curator: Heidemarie Caltik

Founded in 1990, the MAK Design Info Pool (DIP) is concerned with all aspects of contemporary design. As a part of the MAK's overall strategy it not only serves as communicator, clearance area, and research laboratory, it also constitutes a segment of the Museum's collection. The attempt is to lend the traditional collection an adequate virtual form beyond a mere assembly of physical objects for a better, contemporary access to various ideas.

An archive of contemporary Austrian design was established in the process of applied basic research. Its form and abundance of material make this design archive the only museum collection of its kind worldwide. Comprised of documentations of objects, portfolios, and publications of more than 800 Austrian designers, its spectrum ranges from classical industrial design to handcrafted product design, furniture and light design, textile design, fashion and jewelry, as well as fringe areas of architecture and art.

Alongside the scientific work and documentation, digital forms of design mediation have been applied since 1994 such as the design database on the Internet. Sponsored by the EU, new techniques for museum presentations as well as museum didactics are being developed in order to optimize the standards for assembling and visualizing information. This offers participants (designers, architects, artists) the option to update their portfolios and place information about their design on the Internet themselves: www.MAK.at/design

In the spring of 2001, a cycle of exhibitions called DesignShowcases© was initiated in which a selection of designers and design studios are presented in dynamic succession and at alternating venues of the MAK. Originating from the collection, this program has set itself the task of showing the various stages of development in design, building up a specialized archive and including three-dimensional works (prototypes, pilot series, and work groups) in the collection. It focuses on international Austrians, joint ventures between design and industry, design in virtual media, in public space, and the peripheral zones of art. These themes are dealt more extensively in research programs, lectures, MAK NITE© events, exhibitions, and publications. / Heidemarie Caltik

Carol Christian Poell, Fe-Male S/S 00, Male F/W 01/02
C.C.P. Special archive
Top left: sun-glasses lens with elastic leather band
Top right: diaphanous leather coat
Bottom left: skin gloves made of diaphanous mummified lamb leather
Bottom right: cotton shirt

View of the exhibition "DesignShowcases 2001: Heidi Altimonti Trendbüro"

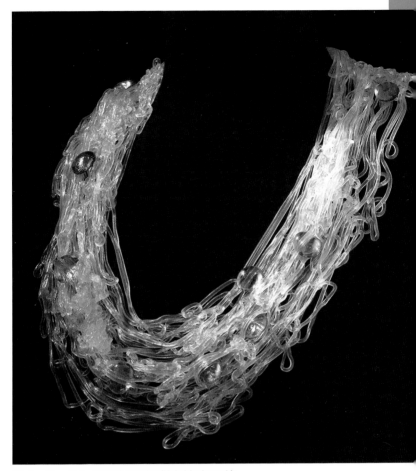

Marion Kuzmany, Hybrid Jewelry (Hybridschmuck)
2001
Necklace; silicone, glass stones,
computer generated (www.hybridschmuck.at)
Inv. no. Bi 1734/2001

STUDY COLLECTION: GLASS

Curator: Katja Miksovsky

One focus of the rearranged study collection is on glass production in the Imperial and Royal Monarchy, which had reached a high point in quality and variety around the turn of the century. This boom was brought about by the complex interaction of a number of factors and a widespread network of merchant-employers, designers, trade schools, and glassworks.

In most cases, glass was not designed, produced and refined in one and the same factory. Glassworks rather purchased designs from artists, which they then produced using their own or purchased raw glass. Trade schools were provided by the glass factories with raw glass for in-class refining and in return supplied royalty-free designs to the industry.

Merchant-employers such as J. & L. Lobmeyr or E. Bakalowits & Söhne, both based in Vienna, played an important role as intermediaries in that they provided for designs and had them executed, but without appearing as manufacturers in their own name.

Being the cultural and political capital city of the monarchy, Vienna also was the center of the art avant-garde, among whose most eminent exponents were Josef Hoffmann, Gustav Klimt, Koloman Moser, Michael Powolny, Jutta Sika, Carl Witzmann, and others. Here, the designs were created which were then produced in the traditional glass-industry regions of the Austro-Hungarian monarchy, that is, in Bohemia.

The artist designs were produced in very small series only and not directly incorporated in the glasswork's standard line of production. These extremely modern revolutionary designs nevertheless had a model character which subsequently inspired new form concepts developed for the standard line of production.

The most important glassworks and refineries that worked together with artists from Vienna included the Johann Lötz Witwe glassworks at Klostermühle (Klášterský Mlýn) in the Bohemian Forest, known for its iridescent décors; the company of Meyr's Neffe at Adolf near Winterberg (Adolfov near Vimperk), which stands for cut, engraved, and painted crystal glass; the glassworks of Ludwig Moser at Karlsbad (Karlovy Vary); the refineries of Johann Oertel & Co and Carl Schappel at Haida (Nový Bor), and others.

The trade schools were in close contact with the Austrian Museum of Art and Industry, today's MAK, and the Vienna Arts and Crafts School whose teachers created designs for the Bohemian glass industry and whose graduates often went to be teachers at the trade schools. Moreover, the schools regularly participated in the museum's winter exhibitions where they presented their latest designs.

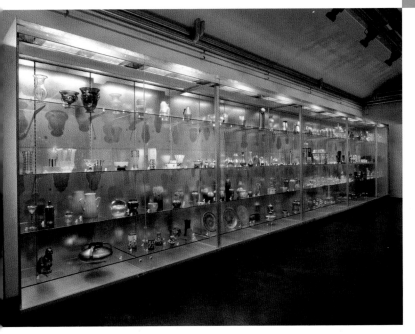

View of the re-arranged Glass Study Collection, 2007

Contemporary objects from J. & L. Lobmeyr throw a bridge right into the 21st century. Continuing the tradition of the cooperation between artists and industry, Barbara Ambrosz, Florian Ladstätter, Miki Martinek, Sebastian Menschhorn, Peter Noever, and Polka (Marie Rahm, Monica Singer) designed glass objects for J. & L. Lobmeyr, which the company, acting as an intermediary, had produced in Bohemian manufactories.

Another aspect of the Study Collection is stained glass both in the sacred and secular realms. The earliest examples, dating from the 14th century and coming from St. Stephen's in Vienna, count among the oldest extant examples of stained glass art in Austria. / **Katja Miksovsky**

Stained glass
ca. 1370
Two panes from the St. Stephen's Cathedral, Vienna (Bartholomew Chapel),
Adoration of the Three Magi
Inv. no. Gl 2227 a, b/1914

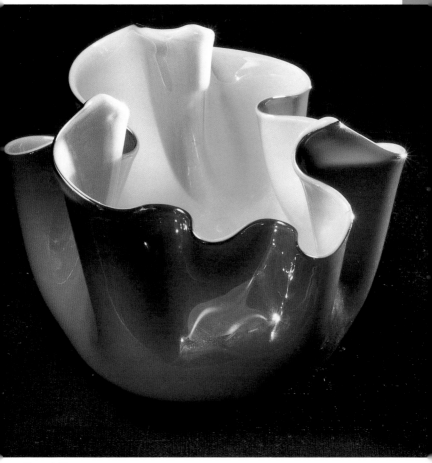

Fazzoletto
Manufacture: Venini, Murano, 1950s and 1960s; white glass with green coating;
mark: "venini murano ITALIA"
Inv. No. Gl 3528/1985

STUDY COLLECTION: CERAMICS

Curator: Katja Miksovsky

The main focus of the Study Collection Ceramics comprises objects of Viennese porcelain manufacturing (1718–1864). The artistic heritage of Viennese porcelain manufacturing changed ownership in 1864, when it was passed to the imperial and royal Austrian Museum for Art and Industry (today's MAK) where it has since become one of the important collections of ceramics. Almost the entire MAK stocks of porcelain including examples from all eras of production are on display, offering an overview of nearly 150 years of porcelain-making in Vienna. The show is completed by examples from Meissen, which was founded eight years earlier making it Europe's oldest porcelain producer.

The history of Viennese porcelain manufacturing can be divided into five periods, each one of which was marked by a distinguished perso-nality. The first person to be granted the privilege to produce and dis-tribute porcelain was Claudius Innocentius du Paquier, granted this permission in 1718 for a period of 25 years by Emperor Karl VI. Under his leadership, mainly dinner services, vases or clocks for specific pur-poses were manufactured until 1744. The second, rococo-influenced period from 1744 to 1784, in which especially high-quality porcelain sculptures as well as scenic and floral miniatures were created, is described as the "sculptural period". It was at this time that the state took over the manufacturing. Conrad Sörgel von Sorgenthal left his imprint on the classicist production from 1784 to 1805, which is mar-ked by outstanding porcelain painting using gold relief decoration and cobalt blue. Also biscuit ware porcelain – unglazed white vessels or figures – enjoyed particular popularity in classicism. Mathias Niedermayer (1805–27) and Benjamin von Scholz (1827–33), directors of manufacturing in the Biedermeier era, focused on figure and historical painting, Viennese urban pictures and depictions of flowers. From the middle of the 19th century, production is relatively insignificant, with the exception of superb individual pieces like, for example, the large format porcelain pictures with flower still-life painting by Joseph Nigg, and the series of biscuit ware heads of prominent figures of the time.

Founded in 1923 and still in existence today, the "Vienna Porcelain Manufacturers Augarten" is built upon the tradition of Viennese porcelain manufacturing. With its goal of rejuvenating the old tradition, Augarten resumed production of well-known figurative depictions as well as forms of dinner service from the baroque, rococo and classicist eras. At the same time, cooperation was undertaken with such contemporary

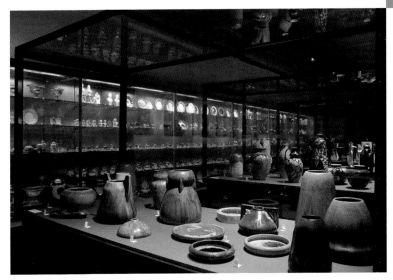

View of the Ceramics Study Collection

artists as Josef Hoffmann, Ena Rottenberg or Franz von Zülow. Founding porcelain manufacture in Vienna filled a gap. Designs which due to the lack of local production facilities had previously been made by foreign manufacturers could now be achieved by means of direct cooperation.

A second area of the rearrangement comprises those ceramics which were created at the end of the 19th and the beginning of the 20th century in Vienna, Bohemia and Moravia. The closing down of the Vienna Porcelain Manufacturing in 1864 followed upon the unhindered expansion of the ceramic industry in those countries under the rule of the Austro-Hungarian monarchy. This development was supported by the foundation of numerous applied arts schools and schools specialized in the ceramic arts, in which both artists and artisans were trained. The events in the last decade of the 19th century, the founding of the Vienna Secession in 1987, and the reformation of the Museum for Art and Industry and the affiliated school, all heralded the arrival of a new era. Both institutions were at the heart of this reform movement.

Examples are shown of the following manufacturers: Artel, Arts and Crafts Studio, Prague; Eduard Klablena, Langenzersdorfer Ceramics; Ernst Wahliss, Vienna; Vocational School Znaim; Hugo F. Kirsch, Vienna; Vienna Arts and Crafts School; Vienna Porcelain Manufacturers Josef Böck; Vienna Ceramics and the United Vienna and Gmundner Ceramics; Vienna Porcelain Manufacturers Augarten; Wiener Werkstätte.

STUDY COLLECTION: METAL
Curator: Elisabeth Schmuttermeier

Goldsmiths' work from the 16th to the 19th century forms the central focus of the metal study collection. Secular utensils made of silver, often also gilded, could be used according to function as pouring or drinking vessels, dishes, plates or platters, and centerpieces. Frequently, large and elaborate pieces of gold work acted as "prestige objects" on display buffets and, at the same time, as a capital reserve. The history of the objects is closely linked to the development of the eating and drinking habits of the wealthy and their desire for prestigious representation.

A change in table culture also brought about a change in tableware. Some of the sudden transitions in the development of tableware can now be documented only through pictorial representations, for expert opinion maintains that only about 2–4% of the total amount of earlier goldsmiths' work has survived to the present day. One reason is that constant warfare used up the monetary reserves of rulers, princes, and cities over the centuries, thus leading to a radical exhaustion of the precious metal artefacts that also served as financial assets. Another is the change in taste and eating and drinking customs, which made many of the objects seem functionally inadequate and ineffective. Vessels made of precious metals were often melted down, the money invested elsewhere.

The goldsmiths' most important commissions in the Middle Ages came from the Church. Their art was treated as equal to other art forms – architecture, painting, and sculpture. During the transition from Romanesque to Gothic the goldsmiths left their monastery and court workshops and moved to the cities. They now gained commissions, in addition, from the middle classes and craft organizations, such as fraternities and trade guilds. Guild cups or jugs, welcome-cups for artisans as well as for important guests, and presents for legations and envoys were all now part of the goldsmith's work. Cutlery, drinking cups, beakers, tankards, jugs, and flagons in manageable sizes were intended for actual use.

In the 17th century, new beverages, such as tea, coffee, and hot chocolate became popular. Their consumption called for new types of vessels, whose models were to be found in the beverages' countries of origin.

Candlesticks were amongst the most important utensils, having supported the most refined source of light for hundreds of years. Sacral and secular types of candlestick were not differentiated. The majority of church candelabra served secular purposes before they went into the ownership of the Church. It is solely the size of candlesticks that allows

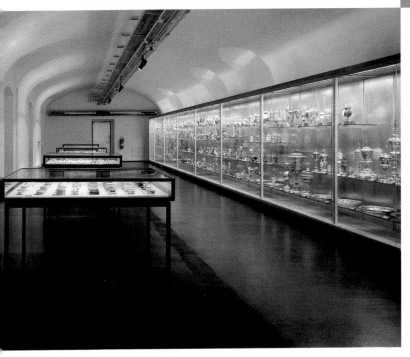

View of the Metal Study Collection

any conclusion to be drawn about their function: whether they were used to light rooms and tables, whether they were night lights, or whether they illuminated sanctuaries. Like other gold and metalwork, candlesticks were also subject to the criteria of fashion.

As in other museums, the collections of the Austrian Museum of Applied Arts are subject to certain limitations. Viewed realistically, artistic and art-historical completeness can never be attained. For this reason additional galvanized copies of originals, not held by the MAK, have been positioned amongst the genuine vessels in order to demonstrate utensil typology. Artefacts made of other materials and cultural spheres which served the European forms as models or were influenced by them, are intended to clarify the cultural-historical development even further. /
Elisabeth Schmuttermeier

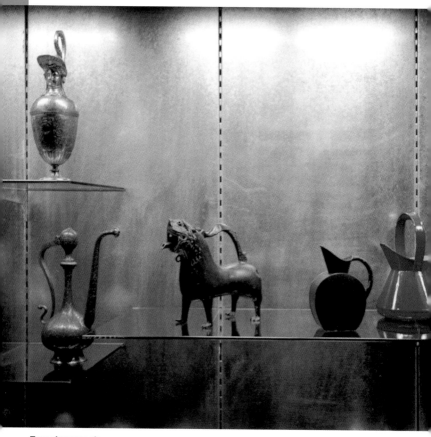

Foundry vessels
12th – 20th century

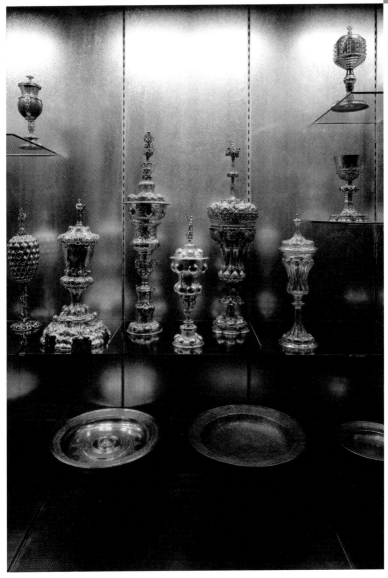

Lidded goblets, bowls
16th – 19th century

STUDY COLLECTION: SEATING FURNITURE

Curator: Christian Witt-Dörring

Part of our material memory is located in this room. Is it only a collection of arbitrarily selected household items or is it indeed history manifesting itself here as the totality of our awareness? To what extent do we still relate to these objects in a direct way? Or has an archive accumulated here of has-beens, whose lowest common denominator comprises the classifications "museum quality" or "second-hand"? We have the choice between these two associations: between the character of an artefact either as an object or as a function. The latter allows the museum piece to reinstate itself once again as a component of our day-to-day consumer society context. Instead of a one-dimensional history of style we experience a three-dimensional pedigree of our own cultural history. In the process, the self-evident receives the chance of becoming evident again. This is brought about by means of visually sensuous and nondidactic communication. The visible contrast of different or similar types, functions, stages of development, and materials succeeds in evoking an awareness of the multilayered experience involved in "seating" and, by addressing the viewer directly, elicits an evaluative reaction that may well lead to a reappraisal of our attitude to seating and how it is so often taken for granted. This stimulation may well contribute to transforming an undiscriminating consumer into a mature and responsible one by arousing in him considerations that have been obliterated by the avalanche of everyday products.

The chair is the piece of furniture closest to the human being. Its proportions are most intimately related to the human body. From the changing aesthetics and functionality of the seat the social morphology of body language can be interpreted. This seems to find expression between the two opposite poles of prestige and comfort, which emerge according to the respective defined values and set priorities. A high, straight backed armchair demands different clothing and posture from the sitter than one with a low, backward-sloping, rounded backrest. The question of principle arises as to whether furniture should conform to the human body in the sitting position, or vice versa. An extreme example of the latter is the "Sacco" or "Bean Bag," on show here, a typical model of seating furniture for the '68 generation. The concept of the suite of seat furniture, which did not arise until the 18th century, entails a number of matching seating furniture types combined to form a decorative whole. It expresses the fact that there is no longer any need to differentiate between the status of the individual users. This develop-

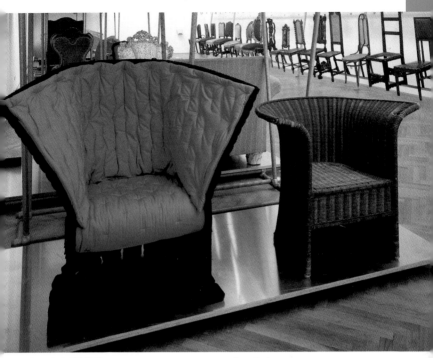

Armchair "Feltri"
Italy, 1987
Design: Gaetano Pesce
Manufacture: Cassina S. p. A., Italy
Wool felt, partly impregnated with ther-
mosetting resin, hempen strings, green
mattress in quilted fabric sewn together
with polyester padding
Inv. no. H 3099/1990

Armchair
Vienna, 1913
Design: Josef Zotti, 1913
Manufacture: Prag-Rudniker, Vienna
Rattan cane, rattan wickerwork
(formerly natural / black-striped)
Inv. no. H 2623/1981
Donation of Gino Wimmer

ment could only assert itself at a time when courtly precedent stipu-
lated a less strict hierarchy between the individual types of seating. In
our subconscious, however, this historical development lives on today.
As late as 1922, the "Handbook of Good Breeding and Fine Manners"
ordained: "As a lady your proper place is on the sofa, to the right of the
lady of the house. As a young girl you should make use of a chair."
Seating furniture unifies the language of forms and of the body into a
legible, cultural-historical whole ... / Christian Witt-Dörring

THE FRANKFURT KITCHEN

Margarete Schütte-Lihotzky

The Origins of the Frankfurt Kitchen
During the second half of the 1920s the city of Frankfurt was engaged in a comprehensive building program. First of all, it was my task to consider the basic principles involved in the planning and construction of the apartments with regard to a rationalization of household organization. Where does one live, cook, eat, and sleep? These are the four basic functions that every apartment must serve. The core function, influencing the layout decisively, is eating and cooking. My first proposal, to build living rooms and combined kitchen/dining rooms, was rejected on the grounds of cost (…).

So we decided on a single unit, comprising a compact, fully built-in kitchen separated from the living/dining room by a wide sliding door. We regarded the kitchen as a kind of laboratory, which, because so much time would be spent there, nevertheless had to be "homey." The time required to carry out the various functions was measured using a stopwatch, as in the Taylor system, in order to arrive at an optimum, ergonomic organization of the space.

The resulting compactness of the kitchen did not allow the use of the standard kitchen furniture of the time, which required more room. The cost savings resulting from the reduced size of the kitchen remained significant, however, so that the Frankfurt Kitchen offered the double advantage of lower construction costs and less work for the occupants. Only by arguing in these terms, was it possible to persuade the Frankfurt city council to agree to the installation of the kitchens, with all their sophisticated work-saving features. The result was that, from 1926 to 1930, no municipal apartment could be built without the Frankfurt Kitchen.

In this period around 10,000 apartments were built with the Frankfurt Kitchen.

The costs of the entire unit were added to the building costs and included in the rent, a solution acceptable to tenants because the kitchens no longer had to be furnished.

On this financial basis it became possible to mass-produce the Frankfurt Kitchen, saving thousands of women a lot of time and effort and thus benefiting their families and their own health. / From: Margarete Schütte-Lihotzky, Erinnerungen (Memories), unpublished typescript, Vienna, 1980–90

The MAK's Frankfurt Kitchen is a product of close cooperation between Margarete Schütte-Lihotzky and the architect Gerhard Lindner in the years 1989 and 1990. A replica based on Schütte-Lihotzky's memory, on

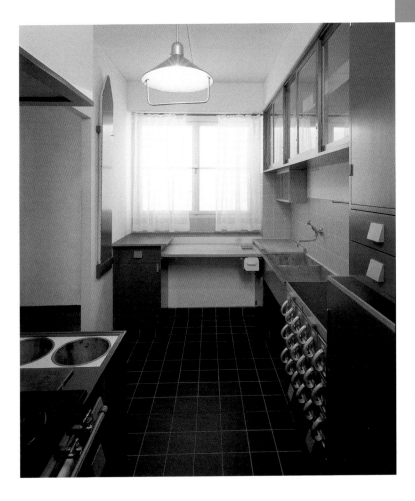

her expertise, and on her programmatic convictions, this example of the Frankfurt Kitchen occupies a position between copy and original. The original method of construction, the materials (for example, plywood instead of the original solid softwood for the drawers), and the colors were of secondary importance compared to the principles embodied in the 1926 kitchen, with its technically sophisticated solutions, balanced proportions, and a subtle color scheme that had to be reconstituted from memory.

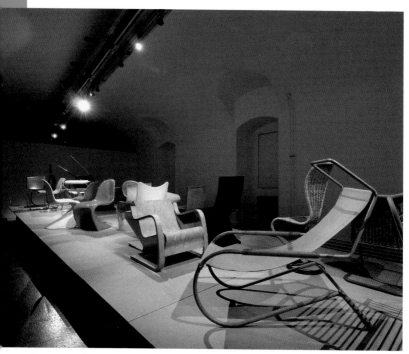

"Cantilever Chair. Architectural Manifesto and Material Experiment," view of the exhibition
2006

FURNITURE IN FOCUS

Curator: Sebastian Hackenschmidt

Since 2000, the Furniture Collection has launched annual presentations on topical collection-related subjects in its "Focus on Furniture" exhibition series. These presentations are based on exhibits from the MAK's own holdings, complemented, as the case may be, with exemplary loans from other museums or private collections. This facilitates flexibility in addressing present-day issues to bring them up for public discussion. Past exhibitions were dedicated to subjects as diverse as wood marquetry, kitchen furniture, furniture from the exile, the cantilever chair, and formless furniture./ Sebastian Hackenschmidt

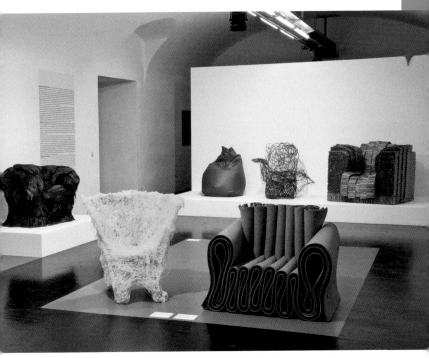

"Formless Furniture," view of the exhibition
2008

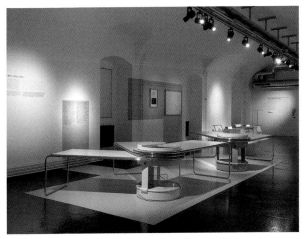

**"Robert Maria Stieg. Caution: Furniture Matters!," view of
the exhibition**
2007

STUDY COLLECTION: TEXTILES

Curator: Angela Völker

The MAK possesses an unusually rich and diverse collection of textiles whose objects date from late antiquity to the present and range from European to Oriental and East Asian items. This is why only an alternating selection can be presented here annually, even though these items are, particularly in Europe, exemplary of the art history of textiles and for their workmanship and ornamentation techniques.

One of the collection's focal points is its early acquisition of a group of Coptic garments, that is, textiles of late antiquity excavated from Egyptian graves. Highly valuable medieval textiles are represented by characteristic richly embroidered pieces. They share their origins in professional workshops north of the Alps, and miniature as well as monumental painting inspires their wealth of figurative and ornamental forms. Also exceptional in quality are the late medieval wall carpets or carpet backings, with depictions of the so-called "wild people."

The Renaissance is documented by Italian silks of the 15th century, whose patterns hark back to China, where silk weaving originated. The High Renaissance is recorded through costly velvets with pomegranate patterns, also from Italian manufacturers. Notable in this respect is also the MAK's extensive collection of valuable lace from Italy, France and the Netherlands from the 16th to the 20th century.

The patterns with small elements favored in the 16th and the 17th centuries can be admired in liturgical vestments and children's clothing. The MAK also owns costly fabrics from the Ottoman Empire and from Persia that display materials with large-scale pattern repeats, which were often used for festive attire.

The richness of invention in textile patterns of the 18th century is demonstrated in particular abundance through liturgical textiles as well as costumes and accessories. The development began with "bizarre" patterns that do justice to their name. In the meantime the center of silk weaving had established itself at Lyons, where the following styles were added: first the "lace pattern," and from the 1730s onwards the "Style Revel," which was named for one of the few textile designers who was known by name at the time. Bright in color and rich in contrast, the floral patterns were enhanced by architectural elements with total disregard to realistic proportion. Simplicity characterizes the second half of the 18th century. The patterns now became smaller and plainer, the colors lighter, and stripes and strewn floral patterns dominated until the last part of the century.

Collections of textile patterns from the first half of the 19th century assembled by the Polytechnic Institute's Cabinet of Factory Products as

well as the factory owners themselves, are yet another highlight of the textile collection. The Biedermeier fabrics are accurately dated along with a record of the manufacturer's name and facts related to their use. One can find an endless wealth of patterns that undoubtedly resulted from new, industrial production methods.

The second half of the 19th century predominantly appropriated Rococo-style patterns, although in characteristically variegated coloring, while the Middle Ages were regarded as the ideal model for liturgical textiles. The new products, with their over-exact pattern depiction, betray their identity as stylistic copies. Gifts made by manufacturers to the MAK, pattern books and purchases made in the early days of the museum document these trends.

The face of textiles changed with the 20th century. The MAK holds fabrics made after patterns by artists like Koloman Moser and Josef Hoffmann, who set a new standard in textile design. In 1903, they founded the Wiener Werkstätte, which successfully produced innovative fabrics – mostly printed materials for the garment industry and for interior decoration – from 1910 until about 1930. Apart from the archive of the Wiener Werkstätte, the MAK also owns a nearly complete documentation of their production, lengths of fabric and about 20,000 textile patterns.

The MAK's textile collection has continually pursued its interest in contemporary textiles. The complexity of the collection ranges from fabrics produced by the Rhomberg factory in Dornbirn for the fashion industry to contemporary tapestry, international fashion design, and works by contemporary artists. / Angela Völker

Hats
Vienna, 1960s and 1970s
Design and manufacture: Adele List

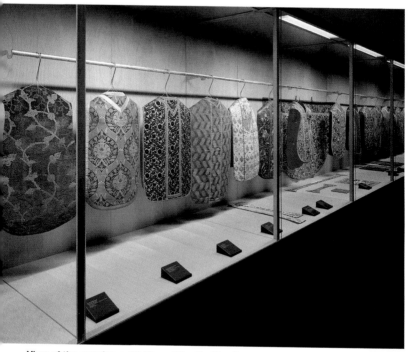

View of the opening exhibition of the Textiles Study Collection
1993 (Chasubles 13th – 19th century)

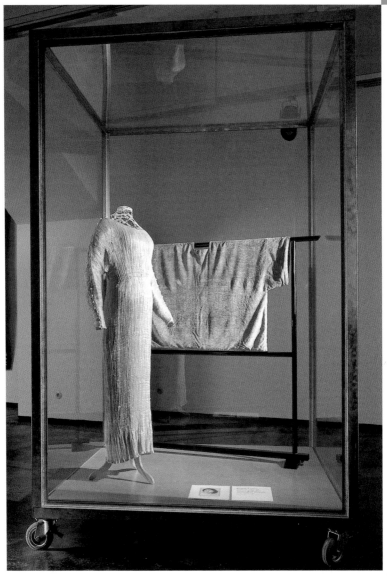

Dress "Delphos"
Venice, ca. 1925
Design: Mariano Fortuny
Pink silk; glass buttons
Inv. no. T 11674/1992

OTHER SCIENTIFIC INSTITUTIONS

LIBRARY AND WORKS ON PAPER COLLECTION

Gottfried Semper's demand for a synthesis of science industry and art, the concept underlying the foundation of the museum, materialized in 1864 in the form of the MAK Library and the Works on Paper Collection. In keeping with this idea, the museum's founding director Rudolf von Eitelberger (1817–85) persistently strived to improve the aesthetic quality and the workmanship of products from the Austrian arts and crafts industry. He thus included specialized books, literature on fine arts and on arts and crafts in the collection alongside graphic design, decorative etchings, samples, and models. Collecting in this form is a unique demonstration of the interaction between scientific knowledge, artistic design, and its execution through artisan techniques.

The library continues to use a system of classification that was established in the 19th century: its books are organized according to subject areas and applications corresponding to the various collections and departments of the museum. Thus, the MAK Library and Works on Paper Collection not only represents a museum of great art historical relevance within the museum itself but is also the only specialist library of its kind in Europe.

Comprising more than 200,000 volumes, the library's collection of historically valuable examples of printing, manuscripts, and rare, illustrated first editions deserve special mention. With the chief aim to expand its collection of applied arts, design, architecture, and contemporary art, the library is also building up a collection of books by contemporary artists as well as of new media art. Its comprehensive collection of books and magazines is supplemented by about 500,000 works on paper that include an internationally significant collection of decorative engravings, a poster and a photography collection, manuscripts, models and copies of period styles, water colors as well as plans by artists and architects. It also owns the complete edition of Piranesi's works; the archive of Josef Danhauser's furniture factory, the estate of the Viennese Porcelain Factory; drawings from the Wiener Werkstätte as well as exceptional illustrations from the times of Akbar the Great of "Hamza," the Indo-Persian epic hero. / **Kathrin Pokorny-Nagel**

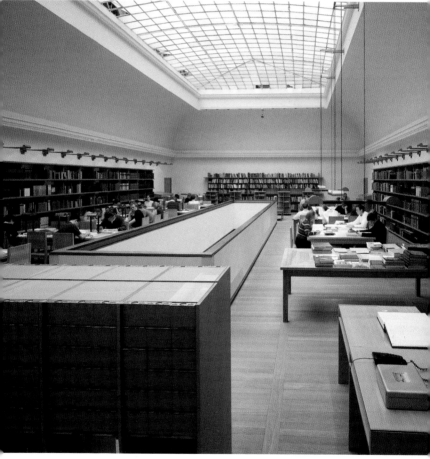

Reading Room of the MAK Library
Design: Ursula Aichwalder, Hermann Strobl

RESTORATION DEPARTMENT

The MAK runs its own department for the restoration and conservation of its comprehensive holdings. The department's seven workshops largely cover the MAK's European and oriental collections. The acceptance of the need to conserve the museum's holdings has increased and made those workshops indispensable today.

In addition to its conservation and restoration activities, the department also attends to numerous special exhibitions and lends crucial technical and analytical support to the museum's scientific programs.

The department consists of the following workshops: glass, ceramics and stone; wood and furniture; objects and sculptures; paper and graphics; textiles; upholstery and clockwork.

Once the museum became a public scientific institution it also acquired the rights to accept contracts from outside. / **Manfred Trummer**

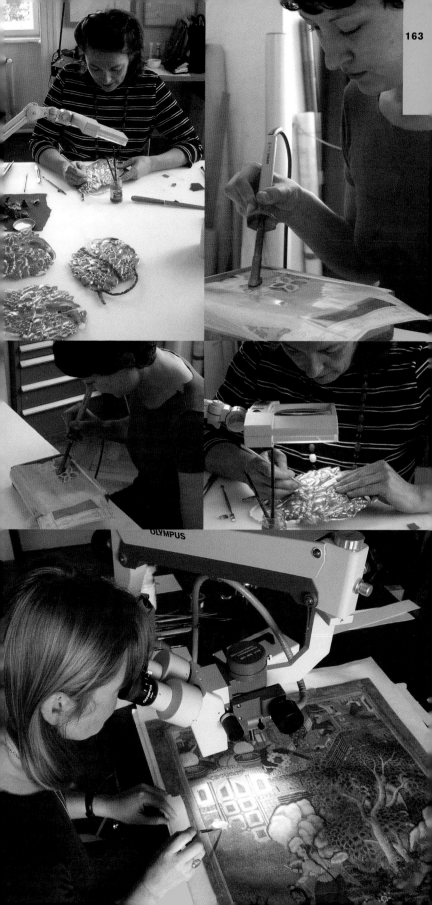

THE EXHIBITIONS

THE MOST IMPORTANT EXHIBITIONS OF THE MAK (SELECTION)

1871 – 1984

1871	Dürer-Jubiläum
1878	Participation in the World Fair in Paris
1894	Papyrussammlung Erzherzog Rainers
1896	Wiener Kongress Exhibition
1901	Werke Hokusais
1904	Alt-Wiener Porzellan
1905	Ältere japanische Kunstwerke
	Ausstellung österreichischer Hausindustrie und Volkskunst
1911	Keramikklasse Michael Powolny
1916	Mode-Ausstellung
1920	Ausstellung orientalischer Teppiche aus kaiserlichem Besitz
	Kunstschau
1923	Dagobert-Peche-Gedächtnis-Ausstellung
1926	Ausstellung neuer amerikanischer Baukunst
1930	Werkbundausstellung
1931	Die neuzeitliche Wohnung
	Der österreichische Werkbund
1937	Altes chinesisches Lackgerät
	Ostasiatische Gemälde aus der Sammlung Van der Heydt
1946	Österreichische Kunst vom Mittelalter bis zur Gegenwart
1947	Meister der modernen französischen Malerei
1949	Französische Wandteppiche
1955	Giacomo Manzú
1957	Gläser von Venini, modernes venezianisches Glas
1959	Zenga. Tuschmalerei aus Japan
1962	E. J. Wimmer-Wisgrill und die Wiener Werkstätte
1966	Selection 66
1964	100 Jahre Österreichisches Museum für angewandte Kunst
1967	Die Wiener Werkstätte. Modernes Kunsthandwerk von 1903 bis 1932
1974	Archäologische Funde der Volksrepublik China
	Indopersische Miniaturen des Hamza-Romans
1976	symon + symon. Schmuck und Objekte
1980	Neues Wohnen. Wiener Innenraumgestaltung 1918–38
1981	Kleider machen Leute (Children's Exhibition)
1982	Künstlerpostkarten der Wiener Werkstätte
1984	Achille Castiglioni – Ausdrucksformen/Design

Since 1986

Solo Exhibitions

1987	**Alfons Schilling**: Sehmaschinen
1988	**Jean-Charles de Castelbajac**: Anti-Bodies. Fashion 1970–88
1990	**Walter Pichler**: Sculpture
1991	**Donald Judd**: Architecture
	Rodchenko/Stepanova: The Future Is Our only Aim
1992	**Magdalena Jetelová**: Domestication of a Pyramid (installation)
1993	**Vito Acconci**: The City inside Us (Opening exhibition)
	Andy Warhol: The Abstract Warhol
1994	**Hans Kupelwieser**: Trans-Formation
	Donald Judd: Prints
	Ilya Kabakov: Der rote Wagon (installation)
1995	**Sergej Bugaev Afrika**: Crimania
1996	**Chris Burden**: Beyond the Limits
1997	**Bruno Gironcoli**: The Unbegotten
1998	**James Turrell**: the other horizon
1999	**Oswald Oberhuber**: Written Pictures. Up until now
	Jannis Kounellis: Il sarcofago degli sposi
2000	**Joseph Beuys.** Editions. Schlegel Collection
2001	**Dennis Hopper**: A System of Moments
	Franz West: Merciless
2002	**Richard Artschwager**: The Hydraulic Door Check
2003	**Kurt Kocherscheidt**: The Continuing Image
	Zaha Hadid: Architecture
2004	**Peter Eisenman**: Barefoot on White-Hot Walls
	Otto Muehl: Life/Art/Work. Action Utopia Painting 1960–2004
2005	**Atelier Van Lieshout**: The Disciplinator
2006	**Jenny Holzer**: XX
	Artists in Focus #1 **Arnulf Rainer**: Rainer, sonst keiner!
	Elke Krystufek: Liquid Logic
2007	**Günther Domenig**: Graphic Works at the MAK
	Artists in Focus #2 **Alfons Schilling**: Vision Machines 007
	Artists in Focus #3 **Padhi Frieberger**: No Art without Artists!
	COOP HIMMELB(L)AU: Beyond the Blue
2008	**Julian Opie**: Recent Works
	Artists in Focus #4 **Franz West**: Sit on My Chair, Lay on My Bed
	Artists in Focus #5 **Heimo Zobernig**: Total Design

Architecture and Design

1986	Architekt **Rudolph M. Schindler** (1887–1953)
	Matteo Thun: The Heavy Dress/Oberflächlichkeit als Manifest
	Wiener Bauplätze – Verschollene Träume
	Das Möbel als Architekturmanifest (Sammlung Vegesack)
1987	**Josef Hoffmann**: Embellishment between Hope and Crime
	Bernard Rudofsky: Sparta/Sybaris. Keine neue Bauweise –
	eine neue Lebensweise tut not
1988	**Günther Domenig**: The Stonehouse
1989	**Carlo Scarpa**: The Other City
1993	**Margarete Schütte-Lihotzky**. Social Architecture
1994	Tyranny of Beauty: Architecture of the Stalin Era
	Mark Mack: Easy Living. Architektur aus Kalifornien
1995	**Roland Rainer**: Vital Urbanity
1996	**Philip Johnson**: Turning Point
1999	**Shiro Kuramata** 1934–1991: Design, Design
2000	Harmonie im Kontext. **Josef Binder**: Wiener Grafik
	Luis Barragán: The Quiet Revolution
2001	Wiener Grafik in New York: **Josef Binders** grafisches Werk
	in den USA (1933–1972)
	R. M. Schindler: Architecture and Experiment
2002	**Ernst Deutsch-Dryden**: En Vogue!
	Stefan Sagmeister: Handarbeit
2003	**Carlo Scarpa**: The Craft of Architecture
2004	**Otto Mittmannsgruber, Martin Strauss**: Public Spaces go Public.
	Art Projects in Mass Media 1995–2004
2005	**Carol Christian Poell**: PUBLIC FREEDOM Collection Documents
	La Cubanidad: Cuban Posters 1940–2004
2007	**Robert Maria Stieg**. Caution: Furniture Matters!

MAK Gallery

1992	**Kiki Smith**. Silent Work (Opening exhibition of the MAK Gallery)
	Edelbert Köb: Geburt der Venus
1993	**Lauretta Vinciarelli**: Red Rooms
	Station Rose: Virtual Realities at the MAK
1995	**Jochen Traar**: Art Protects You
	Otto Mittmannsgruber, Martin Strauss: Monolog des Vertrauens
	Uli Aigner: Metanoia
	Zelko Wiener: Der große KnochenSchwund
1996	**Barbara Doser**: frame 041994.01.0-4 projekt alpha
	Anna Steininger: in-variable-steps

Valeska Grisebach: Sprechen und nicht sprechen
Kiki Kogelnik: Hangings
1997 **Heinrich Dunst**: Lost
Gerald Zugmann: architecture in the box. Photographs
Hans Weigand: SAT
1998 **Marina Faust**: Six days <In six pieces>
Béatrice Stähli: Wiener Blut
Liz Larner: I thought I saw a pussycat
The Havana Project – Architecture Again
1999 **Maria Theresia Litschauer**: NY Trespassing
Lucie Rie: Fired Clay
Josef Trattner: Block Out
2000 **Rudi Stanzel**: reformel
Kendell Geers: Timbuktu
Robert *F.* Hammerstiel: Über allen Wipfeln ist Ruh'
Iké Udé: Beyond Decorum
2001 **Raymond Pettibon**: The Books
Jun Yang: reconstruction – coming home. daily structures of life
Plamen Dejanov / Svetlana Heger: Test the World
Liam Gillick: Dedalic Convention
Hallway: In Between: Art and Architecture Rain
2002 **Maria Hahnenkamp**: Transparency
Laura Kikauka: M.A.N.I.A.C at MAK
Ulrike Lienbacher: Aufräumen
2003 **Manfred Wakolbinger:** Bottomtime
Greg Lynn: Intricate Surface
2004 **Tomoko Sawada:** Desire to Mimic
2005 **Alexandr M. Rodchenko**: Spatial Constructions
Lebbeus Woods: System Vienna
Michael Kienzer: New Properties
2006 Vertical Garden: Project to Protect the **Schindler** House, L.A.
Yves Klein: Air Architecture
2007 **Andrea Lenardin Madden/Kasper Kovitz**: Sunset: Delayed
2008 **Andreas Fogarasi:** 2008
Rebecca Baron, Dorit Margreiter: Postgravity Housing.
Americus, Georgia

Exhibitions from the Collection and Theme Exhibitions

1986 Chinesische und ostturkistanische Teppiche
1987 Universum in Seide. Chinesische Roben der Qing-Dynastie (1644–1911)
1988 Russian & Soviet Art 1910–1932 for the 1st Time in Vienna

1989	Happenings' Paintings – Actionism in Vienna 1960–65
1990	Hidden Impressions: Japonisme in Vienna 1870–1930
	The Frankfurt Kitchen
1995	African Seats
1996	Feed and Greed
	Austria in a Net of Roses
1997	Japan Yesterday. Traces and Objects from the Siebold Travels
	Japan Today. Art, Photography, Design
	Kilengi. African Sculptures from the Bareiss Family Collection
1998	Beyond Function: **Dagobert Peche** and the Wiener Werkstätte
	out of actions: Actionisms, Body Art & Performance 1949–79
1999	Cine Art. Indian Poster Painters at the MAK
2000	Art and Industry
2001	Fremde. Kunst der Seidenstraße
2002	Davaj! Russian Art Now
2003	Yearning for Beauty: For the 100th Anniversary of the Wiener Werkstätte
2005	Ukiyo-e Reloaded: The MAK Collection of Japanese Colored Woodblock Prints
2006	**Tone Fink**: Textile
	Chapeau!: **Dieter Roth**: Sculptural Fingerwear
2007	**Florian Ladstätter**: Les Fleurs du Mal
	Blue & White: Objects in Blue & White from Egypt to China
	Lace and so on… Bertha Pappenheim´s Collections at the MAK
2008	Formless Furniture

Josef Hoffmann Museum, Brtnice
A joint branch of the Moravská galerie in Brno and the MAK Vienna

1987	**Josef Hoffmann**: Ornament zwischen Hoffnung und Verbrechen
1992	Der barocke **Hoffmann**
2005	**Josef Hoffmann**: A Continuous Process
2006	**Josef Hoffmann – Carlo Scarpa**: On the Sublime in Architecture
2007	**Josef Hoffmann – Adolf Loos**: Ornament and Tradition
2008	**Josef Hoffmann – Donald Judd**: Hypothesis

MAK Center for Art and Architecture, Los Angeles

1995	The Havana Project – Architecture Again (Opening exhibition at the MAK Center)
1996	The Garage Project: Installations by **Peter Kogler, Heimo Zobernig, Liz Larner, Paul McCarthy, Svetlana Heger & Plamen Dejanov**

Final Projects: **Svetlana Heger/Plamen Dejanov, Andrea Kocevar, Flora Neuwirth, Jochen Traar** (I); **Gilbert Bretterbauer, Marta Fuetterer, Christoph Kasperkovitz, Andrea Lenardin** (II)

1997 Silent & Violent: Selected Artists' Editions

Gordon Matta-Clark: Anarchitecture

Final Projects: **Stefan Doesinger, Ulrike Müller, Judith-Karoline Mussel, Paul Petritsch & Johannes Porsch** (III); **Christine Gloggengiesser, G.R.A.M., Christof Schlegel & Christian Teckert, Nicole Six** (IV)

1998 **Martin Kippenberger**: The Last Stop West

Final Projects: **Helena Huneke, Martin Liebscher, Isa Rosenberger, Zsuzsa Schiller** (V); **Gerry Ammann, Rochus Kahr, Marko Lulic, Constanze Ruhm** (VI)

1999 **R. M. Schindler**: 12 Projects

Architecture & Revolution, Escuelas Nacionales de Arte, Havana

Raymond Pettibon, Jason Rhoades, Hans Weigand: Life/Boat

Final Projects: **Johan & Åse Frid, Gelatin (Ali Janka, Tobias Urban), Anna Meyer, Raw 'n' Cooked (Walter Kräutler & Carl Schläffer)** (VII); **Judith Ammann, Wolfgang Koelbl & Michael Wildmann, Mathias Poledna, Michael Wallraff** (VIII)

2000 **Richard Prince**: Up-state

American Pictures 1961–67: Photographs by **Dennis Hopper**

Frederick J. Kiesler: Endless Space

Final Projects: **Franka Diehnelt & Karoline Streeruwitz, Béatrice Dreux, Sophie Esslinger, Jun Yang** (IX); **Karim Najjar, Birgitta Rottmann, Markus Schinwald, Meike Schmidt-Gleim** (X)

2001 heaven's gift: CAT – Contemporary Art Tower

Final Projects: **Siggi Hofer, Susanne Jirkuff, Lisa Schmidt-Colinet/Alexander Schmöger, Florian Zeyfang** (XI); **Barbara Kaucky, David Hullfish Bailey, Dorit Margreiter, Elisabeth Hesik, Florian Pumhösl, Kaucyila Brooke, Martha Stutteregger, Michael Wildmann, Richard Sparham, Robbert Flick** (XII)

2002 **Gerald Zugmann**: Blue Universe. Architectural Manifestos by Coop Himmelb(l)au

Final Projects: **Mauricio Rafael Duk Gonzáles, Richard Hoeck, Kobe Matthys, Jose Pérez de Lama** (XIII); **Luisa Lambri, Karina Nimmerfall, Lorenzo Rocha Cito, Bernhard Sommer** (XIV)

2003 **Schindler´s** Paradise: Architectural Resistance

Final Projects: **Thomas Gombotz & Antonietta Putzu, Pia Rönicke, Una Szeemann, Zlatan Vikosavljevic** (XV); **Christoph A. Kumpusch, Suwan Laimanee, Roland Oberhofer & Nicolas Février, Corinne L. Rusch** (XVI)

2004 **Yves Klein**: Air Architecture

Final Projects: **Catrin Bolt & Marlene Haring, Robert Gfader, Florian Hecker, Deborah Ligorio** (XVII); **Paul Rajakovics, Barbara Holub, Miriam Bajtala, Constanze Schweiger, Oliver Croy** (XVIII)

2005 **Isaac Julien**: True North

Final Projects: **Sabine Bitter & Helmut Weber, Annja Krautgasser & Dariusz Krzeczek, David Zink Yi, Stefan Röhrle** (XIX); **Milica Topalovic & Bas Princen, Christoph Kaltenbrunner, Hans Schabus, Songül Boyraz** (XX)

2006 The Gen(h)ome Project

Final Projects: **Robert Huebser, Benjamin Haupt & David J. Emmer, Sonia Leimer, Elena Kovylina, David Moises** (XXI); **Wulf Walter Böttger, Andreas Fogarasi, Alfredo Barsuglia, Sonja Vordermaier** (XXII)

2007 **Arnulf Rainer**: Hyper-Graphics

Final Projects: **Alexander Dworschak & Anke Freimund, Matias Del Campo & Sandra Manninger, Julien Diehn, Nine Budde** (XXIII); **Tazro Niscino, Christina Linortner; Zenita Komad, Marc J. Cohen, Katharina Stoever & Barbara Wolff** (XXIV)

2008 **Victor Burgin**: The Little House

Final Projects: **Bernhard Eder, Theresa Krenn, Johann Neumeister, Hank Schmidt in der Beek, Sabine Müller, Andreas Quednau** (XXV); **Paul Dallas, Eldine Heep, Oona & Paul Peyrer Heimstätt, Manuela Mark, Raimund Pleschberger** (XXVI)

MAK Exhibitions Abroad

1991 **Rodchenko/Stepanova**, Pushkin Museum, Moscow
Max Peintner, Artist Association of the USSR, Moscow
C.P.P.N. (Carl Pruscha/Peter Noever), Para la Habana, Convento de Santa Clara, Havana

1992 **Hoffmann** Designs, Hermitage, St. Petersburg; IBM-Gallery, New York
New Conception of the World and Self-Glorification, Museo de la Ciudad de La Habana, Havana

1993 **Andy Warhol**. Abstracts, Kunsthalle Basel

1994 Cast Iron from Central Europe, 1800–50, The Bard Graduate Center for Studies in the Decorative Arts, New York
Japonisme in Vienna, Tobu Museum of Art, Tokyo

1995 Manifestos. International Exhibitions on Contemporary Architecture, Convento de Santa Clara, Havana
Tyrannei des Schönen. Architektur der Stalin-Zeit, Villa Stuck, Munich

1996 Austria im Rosennetz, Kunsthaus Zurich

1997 The Havana Project, Kestner Gesellschaft, Hannover

Hans Weigand: SAT, Villa Arson, Nizza, Städtisches Museum Abteiberg, Mönchengladbach (1998)

1998 **Granular Synthesis**: NoiseGate-M6, Marstall, Munich; La Maison des Arts, Créteil, France; Le Manège Scène Nationale de Maubeuge, France; Hull Time Based Arts, Hull, UK; Muziekcentrum De Ijsbreker, Amsterdam

Austria im Rosennetz, Musée des Beaux-Arts, Brussels

Wiener Werkstätte. Keuze uit Weense collecties, Museum Het Paleis, Haags Gemeentemuseum, Den Haag

1999 **Ulrike Grossarth**: red/green, grey, Hamburger Bahnhof; Museum für Gegenwart, Berlin

Granular Synthesis: NoiseGate-M6, Kunstverein Hannover; Musée d'Art Contemporain de Montréal, Canada

El Proyecto Habana – Arquitectura otra vez, CENCREM, Havana

Architecture and Revolution – Escuelas Nacionales de Arte en La Habana, Columbia University, New York; Tulane University, New Orleans; Ohio State University, Columbus

Das alte Japan. Japan Yesterday, Siebold-Museum, Würzburg; Museum Villa Rot, Burgrieden-Rot

Ernst Strouhal/Heimo Zobernig: Der Katalog, Haus der Kunst, Brno; Kunsthaus, Bregenz; Westfälisches Landesmuseum für Kunst und Kulturgeschichte, Münster; Portikus, Frankfurt am Main

2000 **Granular Synthesis**: NoiseGate-M6, Musée d'Art Contemporain de Lyon; Brooklyn Anchorage, New York

heaven's gift: CAT – Contemporary Art Tower, Max Protetch Gallery, New York; Culver City, Gateway Warehouse, L.A.

2001 Cuba – Le scuole nazionali delle Arti a l'Havana, Istituto Universitario di Architettura di Venezia (IUAV), Venice

heaven's gift: CAT – Contemporary Art Tower, Shusev State Museum of Architecture (MUAR), Moscow

Davaj! Russian Art Now, Postfuhramt Berlin

The Vienna Secession 1898–1918. The Miyagi Museum of Art, Sendai; The Bunkamura Museum of Art, Tokyo

2003 **Stefan Sagmeister**: Handarbeit, Museum für Gestaltung, Zürich

Davaj! Russian Art Now: State Museum of Fine Arts, Tscheboksary

2004 **Stefan Sagmeister**: Fait Main, Maisdo du livre et de l'affiche, Chaumont, Haute-Marne, France

2006 Yearning for Beauty: The Wiener Werkstätte and the Stoclet House, Centre for Fine Arts, Brussels

* In cooperation with Berliner Festspiele

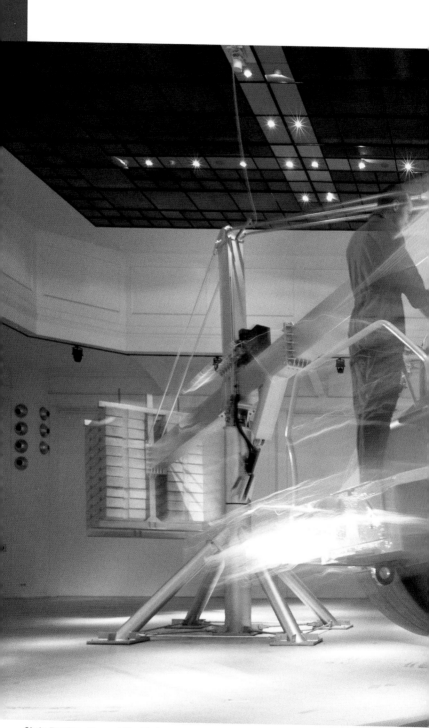

Chris Burden: Beyond the Limits
1996

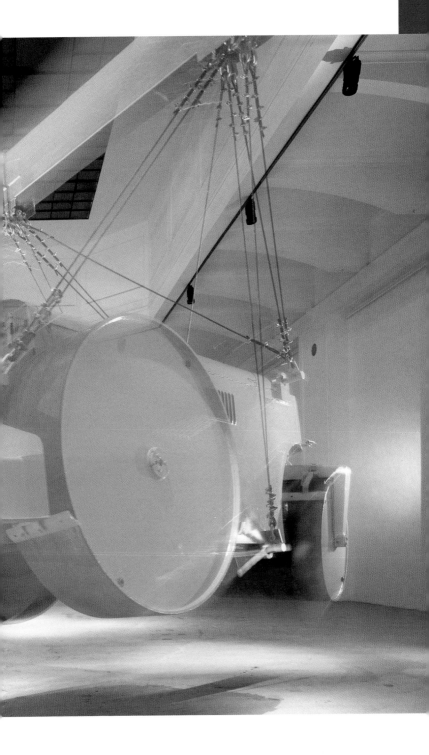

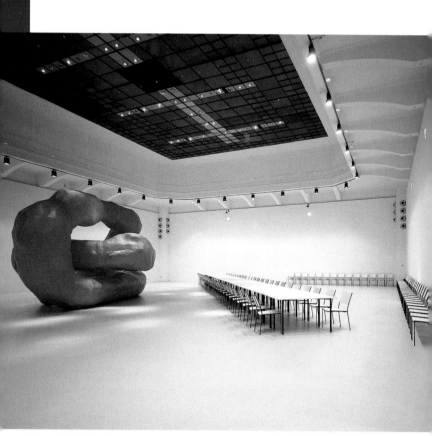

Franz West: Merciless
2001/02

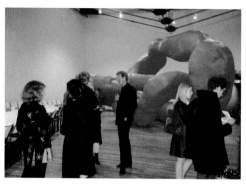

Franz West: Merciless
MASS MoCA – Massachusetts Museum of
Contemporary Art, North Adams
2002/03

Richard Artschwager: The Hydraulic Door Check
2002

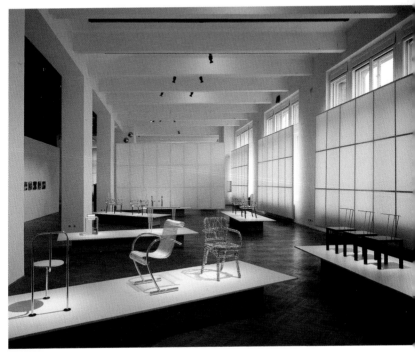

Shiro Kuramata 1934 – 1991: Design, Design
1999

Jannis Kounellis: Il sarcofago degli sposi
1999

out of actions
1998

Bruno Gironcoli: The Unbegotten
1997

**Vito Acconci at the press preview
of his exhibition "The City inside Us"**
1993

Vito Acconci: The City inside Us
1993
Opening exhibition after the renovation and reconstruction of the MAK

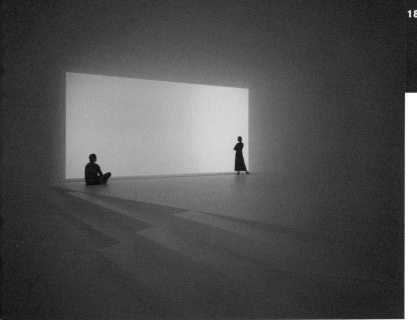

James Turrell: the other horizon
1998/99

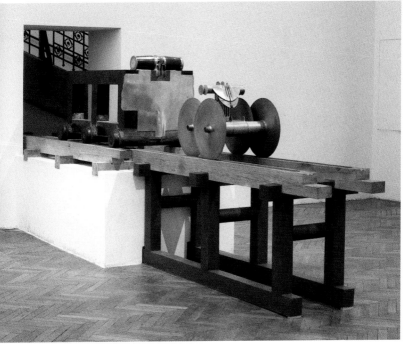

Walter Pichler: Sculpture
1990/91

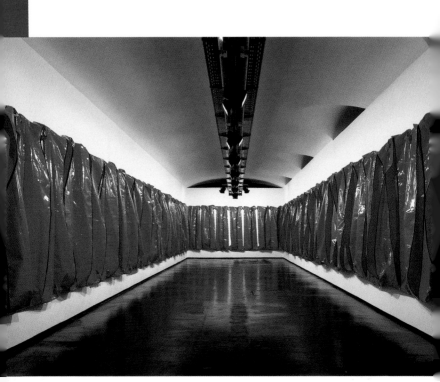

Kendell Geers: Timbuktu
2000

Raymond Pettibon: The Books
2001

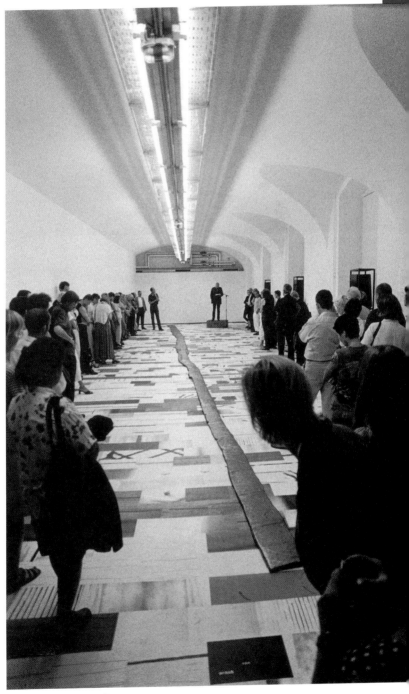

Rudi Stanzel: reformel
2000

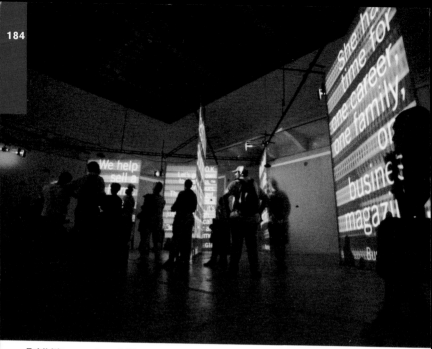

Exhibition opening of "Bruce Mau/André Lepecki: Stress"
2000

Exhibition opening of "Bruno Gironcoli: The Unbegotten"
1997

Finissage of the exhibition
"Josef Trattner: Block Out"
1999

Exhibition opening of
"Dennis Hopper:
A System of Moments"
2001

Otto Muehl, exhibition opening of
"Otto Muehl. 7"
1998

Peter Noever, Victoria and Dennis Hopper
2001

Exhibition opening of "heaven's gift"
2002

Cornelius Grupp, MARS President,
David Sarkisyan, Director Shusev State
Museum of Architecture (MUAR), Moscow,
Peter Noever, Director MAK, and Michael
Häupl, Mayor of Vienna

Exhibition opening of "Cine Art: Indian Poster Painters at the MAK"
1999

Heinz Fischer, Federal President of the Republi
Austria (right), and Peter Noever, Director MAK,
exhibition opening of "COOP HIMMELB(L)AU:
Beyond the Blue" 2007

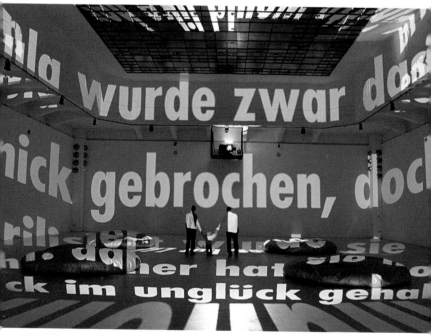

**Exhibition opening of
"Jenny Holzer: XX"**
2006

Keine Metapher, sondern eine wirkliche Präsenz. Mit Erinnerung aufgeladene Gegenwart. Was hier geschehen soll, blendet Vergangenheit nicht aus.
NOEVER · MÜLLER · EMBACHER

Martina Kandeler-Fritsch, Deputy Director Art Affair, Franz West, artist, and Eva Schlegel, artist and MARS President, exhibition opening of "heaven's gift"
2002

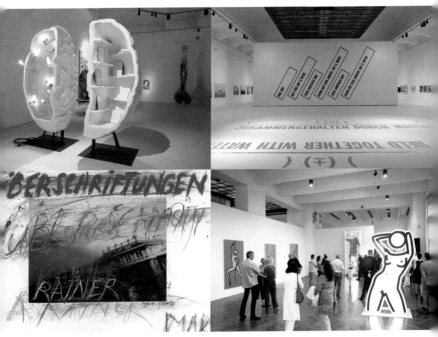

Exhibition view of "Elke Krystufek: Liquid Logic. The Height of Knowledge and the Speed of Thought"
2006

Special edition on the occasion of the exhibition "Artists in Focus #1 Arnulf Rainer. Rainer, sonst keiner!"
2006

Exhibition opening of "Held Together with Water: Art from the Sammlung Verbund"
2007

Exhibition opening of "Julian Opie: Recent Works"
2008

THE MAK BRANCHES

MAK DEPOT OF CONTEMPORARY ART GEFECHTSTURM ARENBERGPARK

Since 1995, the MAK Depot of Contemporary Art in the Gefechtsturm Arenbergpark has offered an ideal opportunity to show essential parts of the MAK collection of contemporary art in an area totaling 1,400 square meters. Spatial interventions developed specifically for the MAK by internationally acclaimed artists such as Vito Acconci, Ilya Kabakov, Hans Kupelwieser, Eva Schlegel, and Chris Burden, as well as objects by artists such as Renée Green, Kiki Smith, Bruno Gironcoli, Liz Larner, Béatrice Stähli, Birgit Jürgenssen, and Franz West are permanently presented in an adequate context. Artists' editions by Christian Boltanski, Gilbert & George, Jenny Holzer, Rebecca Horn, Juan Muñoz, Bruce Nauman, James Turrell, etc., and examples of experimental architectural projects and manifestations, including works by Raimund Abraham, Coop Himmelb(l)au, Günther Domenig, Philip Johnson, Thom Mayne, Eric Owen Moss, Roland Rainer, and Lebbeus Woods, are also on display.

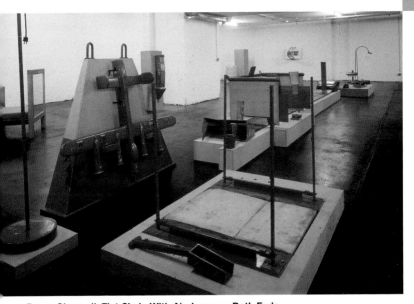

Bruno Gironcoli, Flat Chain With Airplanes on Both Ends
1971–74
Sculpture in 5 parts
Iron, non-ferrous metal, soap, aluminum cast, light-bulb
Inv. no. GK 164/1996

Chris Burden, Pizza City
1991–96
Miniature urban landscape in 26 parts
Inv. no. GK 124/1997

Ilya and Emilia Kabakov, Not everyone will be taken into the future
2001 (Installation 2002)
Wood construction, carriage fragment, electronic sign, painting
Inv. no. GK 231/2001
Permanent loan Sammlung Geyer & Geyer GmbH, Wien

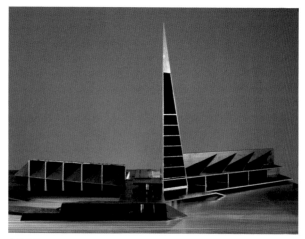

C.P.P.N., Havana Project: Puerto del Pueblo
1995/96
Architectural model, steel
Inv. no. GK 149/1996

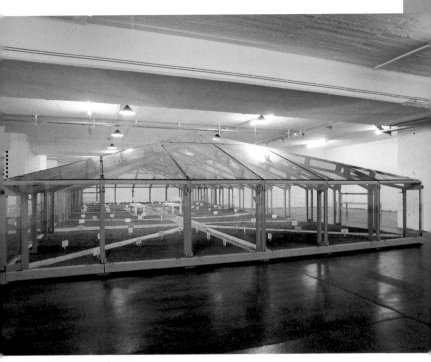

Ilya Kabakov, No Water
1995
Steel-glass construction
Inv. no. GK 126/1995

Eva Schlegel, Untitled (Ohne Titel)
1997
Sliding door in 2 parts, silk-screen print on glass
Inv. no. GK 176/1997

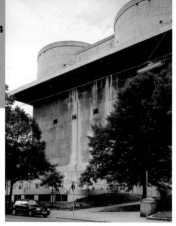

Gefechtsturm Arenbergpark

CAT – CONTEMPORARY ART TOWER

Originated in 1995, the CAT project, a programmatic strategy developed by Peter Noever, Sepp Müller, and Michael Embacher, came into being when the 2nd and 9th floors of the flak tower in Arenbergpark were adapted to a depot for the MAK's collection of contemporary art.

The chief aim of the project is to transform this structure, with its bleak historical connotations, into a vibrant center for contemporary art and new media which accommodates to the complex requirements of today's artistic productions.

The solid reinforced concrete construction and the exceptional size of the spaces available for use make the flak tower in Arenbergpark the ideal environment for a dialogue between artists and the public. Thus, a direct confrontation with works made on-site contributes toward a better understanding for contemporary art. The production as well as the presentation of art works becomes public; CAT becomes a place of direct dialogue between artists working there and visitors. By way of this exchange a laboratory is developed where new positions in contemporary art are worked out. In the course of ten to fifteen years a collection which will be unique in Vienna will evolve because the chief aim of the project is the realization of artistic productions on-site and not the purchase of already existing works of art.

This space which currently has no function is to be opened to the public and integrated into Vienna's urban and social life. With the intention of encompassing different ways to access various forms of art, this project will provide studios, workshops, a "kitchen" and other informal "junctions" for digital and analog media. An auditorium, exhibition spaces, restaurants, a café, and a bar on the roof of the building are also planned. In addition, a media and supply tower is to be erected on the west front, whose fragile and transparent construction will present a con-

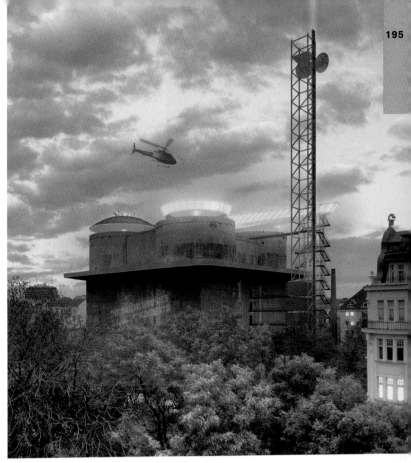

CAT – Contemporary Art Tower
rendering by Stefan Klein/MAK, 2008

scious contrast to the brutal and menacing body of the main tower. Jenny Holzer and James Turrell have created artistic interventions for the site which will become a permanent part of the architectural structure.

Jenny Holzer has suggested mounting a search light on the top of the media and supply tower to draw public attention to CAT programming and events. Xenon beams from the upper levels will project text and images onto the tower. In addition, Jenny Holzer envisages the installation of a 90 m high electronic sign which serves as a broadcasting source of art, information, and news and makes the flak tower an urban center for the "reproduction of real facts and ideas."

James Turrell envisions the construction of a circular Skyspace on one of the four platforms of the flak tower that is to give visitors the chance to perceive the space between heaven and earth as a materialized field of color and to overcome the normally unfathomable distance. Additionally, Turrell has planned a blue light intervention for the window-like openings in the outside walls of the antiaircraft tower – a measure that responds to the urban space. / Peter Noever

GEYMÜLLERSCHLÖSSEL

The so-called Geymüllerschlössel is a "summerhouse" that was built in Pötzleinsdorf, one of the suburbs of Vienna, after 1808. Named after its builder and first owner, the Viennese merchant and banker Johann Jakob Geymüller (1760–1834), the building's architectural language shows the mixture of Gothic, Indian, and Arabic stylistic elements that was then customary, especially in summerhouses. The name of the architect is still not known.

After a varied history, the building was donated to the Republic of Austria by its last owner, Dr Franz Sobek, and became a branch of the MAK. Along with the building itself, Dr Sobek also donated his important collection of old Viennese clocks (160 items) dating from 1760 to the second half of the 19th century. Alongside furnishings from the period 1800–40, also purchased by Franz Sobek, which are complemented by Empire and Biedermeier furniture from the MAK, the collection is one of the most important sights in the Geymüllerschlössel. Renovations during recent years have restored the facade and parts of the interior painting to their original state. The subsequent rearrangement of the furnishings and clocks in the various rooms of the Geymüllerschlössel allows the visitor to view an example of an Empire and Biedermeier summerhouse. Particular attention was given to the textile elements used in the building and for the furniture, so that the Geymüller-schlössel is today the only place in Austria that offers an accurate and original impression of the variety of Biedermeier interior decoration.

On the ground floor of the Geymüllerschlössel, exhibition rooms have been adapted, in addition to the display rooms, to show annually rotating topical exhibitions that deepen one's knowledge of the art and handicrafts of the first half of the 19th century. The Austrian artist Hubert Schmalix installed a sculpture called "Der Vater weist dem Kind den Weg" (The father shows the way to his child) in the garden of the Geymüllerschlössel in 1997. Also, James Turrell's "the other horizon/Skyspace" will be put up there in the near future. / **Christian Witt-Dörring**

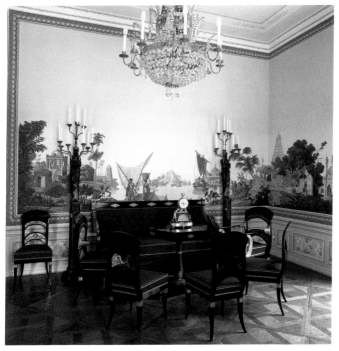

**Hubert Schmalix, Der Vater weist dem Kind den Weg (The father shows
the way to his child)**
1996
Concrete sculpture on a concrete base
Inv. no. GK 167/1997

View of the drawing-room in the Geymüllerschlössel

Donald Judd, Stage Set
1996
Stadtpark, 1030 Vienna

**Donald Judd, Stage Set
on the occasion of
the exhibition
"Donald Judd: Architecture"**
1991
MAK Exhibition Hall

THE MAK IN PUBLIC SPACE

Proportion is very important to us, both in our minds and lives and as objectified visually, since it is thought and feeling undivided, since it is unity and harmony, easy or difficult, and often peace and quiet. Proportion is specific and identifiable in art and architecture and creates our space and time. Proportion and in fact all intelligence in art is instantly understood, at least by some. It´s a myth that difficult art is difficult.[1] / Donald Judd

Donald Judd's "Stage Set" articulates an uncompromising vision of the relationship between art and architecture. Six bands of differently colored fabric are fixed at different heights within a 7.5 x 10 x 12.5 m steel structure. Exemplifying the serial elements and variations characteristic of Judd's work, the bands establish a rhythm for the open space. Donald Judd designed the sculpture for his MAK exhibition "Architecture" in 1991. It was installed in Vienna's Stadtpark in 1996.

[1] From: Donald Judd, "Art and Achitecture, 1983," in: Donald Judd – Architektur, Westfälischer Kunstverein Münster, 1989, p. 177.

Franz West, Four Lemurheads
2001
Stubenbrücke, 1010 Vienna

Franz West, Four Lemurheads (Detail)
2001
Stubenbrücke, 1010 Vienna

The "Four Lemurheads" which were originally designed for Hermann Czech's bridge at the Stadtpark were installed at the Stubenbrücke next to the MAK on the occasion of the exhibition "Franz West: Merciless." Originally planned for the duration of the show, they were permanently lent to the MAK and will now remain at this location.

Czech once asked me to make four sculptures as bridgeheads for his bridge over the River Wien. They were to represent people. Because the project was deferred so long and due to liquidity problems, the already cast heads (bronze is horribly expensive and difficult to store) found other owners. The name "Lemur" is a pejorative, and Karl Kraus also used it as such in his "Last Days of Humanity", for instance: "Two protagonists walk into a bar: red light, larvae, and lemurs." These heads are made of welded aluminum sheet, which is why their form and texture is different. They are therefore ascribed to the term "larva." Heraclitus' fragment no. 1,6: "One cannot step into the same river twice and expect new souls to step out of the wetness each time" should be placed clearly next to them, for this fragment is an integral part of the installation. Whether or not they are material, this surely makes them immaterial, if only to avoid being ranked as amusing decoration. / Franz West, 2002-06-27

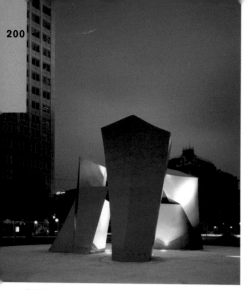

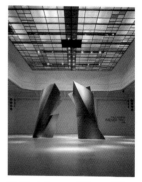

Philip Johnson, Wiener Trio
1998
Franz-Josefs-Kai/Schottenring, 1010 Vienna

Philip Johnson, Wiener Trio
on the occasion of the exhibition
"Philip Johnson: Turning Point"
1996
MAK Exhibition Hall

In December 1995 Peter Noever together with Philip Johnson finalized the content and the title of the Viennese exhibition "Turning Point."
This title should on the one hand justify Philip Johnson's surprising new form of expression in his architecture and on the other hand signal the presentation of architecture within the framework of an exhibition far from any conventional ways.
For a short period of time there was this idea, to produce the five-part object for the Putnam Sculpture Collection of the Western Reserve University, which then was in a developing stage, in duplicate: one for Cleveland, Ohio and one for Vienna. Consequently it was decided for a separate design for the MAK in Vienna, which carries the name "Wiener Trio."

In 1998, Philip Johnson's "Wiener Trio" was installed at the intersection of Franz-Josefs-Kai and Schottenring. While all three elements of the object reveal a sculptural character of their own, their ensemble constitutes an architectural form and reflects the American star architect's persistent and intensive interest in the monumental. The placement of this extraordinary work in a public space was made possible by the generous support of the Wiener Städtische Versicherung AG.

James Turrell, the other horizon, Skyspace,
1998
MAK Gardens

Michael Kienzer, Stylit
2003/4
Stubenring 5 /
Weiskirchnerstrasse,
1010 Vienna

The Skyspaces *are, basically,* Structural Cuts, *that are completely above the horizon line. The openings of all* Skyspaces *cut through ceiling and roof, though the roof may be slanted. These pieces deal with the juncture of the interior space and the space outside by bringing the space of the sky down to the plane of the ceiling. They create a space that is completely open to the sky, yet seems enclosed. The sense of closure at the juncture appears to be a glassy film stretched across the opening, with an indefinable space beyond this transparencey that changes with sky conditions and sun angles.*[1] / James Turrell

The Skyspace "the other horizon" was realized by James Turrell for the 1998 MAK exhibition.

In his piece "Stylit", Michael Kienzer addresses the subject of sculpture in the public sphere: he interprets space as an archive of objects, which he juxtaposes with an elongated vertical sculpture which, however, unlike all other urban furnishing objects and elements, is marked by perplexing difference. On the end of a several meter long rod or pipe, which grows out of a pot-like pedestal, he mounts a well pump which – unreachable for pedestrians passing by – sits at the height of the treetops and street lights.
Using simple tools and everyday (ready-made) materials, Michael Kienzer succeeds always again to break up perceptual patterns and to create shrewdly differentiated spatial situations.

[1] From: James Turrell, "Skyspaces," in: James Turrell: the other horizon, MAK Vienna and Hatje Cantz Verlag, Ostfildern-Ruit, 1998, p. 96.

THE JOSEF HOFFMANN MUSEUM, BRTNICE

Josef Hoffmann's birth place in Brtnice, Czech Republic, is operated as a joint branch of the Moravská galerie in Brno and the MAK Vienna. The Baroque town house was altered in the style of Viennese modernism by Hoffmann himself in 1910/11. The aim is to reinstate Josef Hoffmann and his importance as an architect and designer in the public perception. The exhibition themes derive from Hoffmann's life and environs as well as from the investigation of his position and those of contemporary architects and designers.

Born in Brtnice/Pirnitz, Moravia, in 1870, Josef Hoffmann remained attached to the place of his birth until after World War II. After his parents had died in 1910/11, he refurbished the building in which he had been born, a Baroque town house in the main square of the town, as a summer residence for himself and his sisters. The changes comprised a rearrangement of his parents' surviving late Biedermeier household goods and template-cast wall decorations as well as wooden décor and furniture additions after Hoffmann's designs for the Wiener Werkstätte. When refurbishing the house, the architect used his parents' home as an experimental arena for his design ideas. In 1911, Hoffmann dedicated a contribution to the magazine "Das Interieur" to his parental home. After the house had been confiscated in 1945, it was used by the local authorities, last as the town library. Following the 1992 MAK exhibition "Der barocke Hoffmann" ("Hoffmann the Baroquist"), which presented designs and objects by Josef Hoffmann in the Czech Republic again for the first time, plans for the restoration of the building were made which included the reconstruction of the wall decorations. After restoration work was completed in 2004, the interiors of the Josef Hoffmann Museum convey an idea of the spatial effect Josef Hoffmann had in mind and of his definition of a modern vernacular style informed by the import of the Wiener Werkstätte on which he had a decisive influence.

Yearly since 2005, temporary exhibitions on subjects related to Josef Hoffmann have been dedicated to positions of Josef Hoffmann and significant architects of the 20th century like Carlo Scarpa ("On the Sublime in Architecture"), Adolf Loos ("Ornament and Tradition") and Donald Judd ("Hypothesis"). In addition, the MAK Vienna and the Moravská galerie in Brno are now jointly working on the idea of a permanent exhibition, so as to raise public awareness of the life and work of a pioneering architect. / Kathrin Pokorny-Nagel

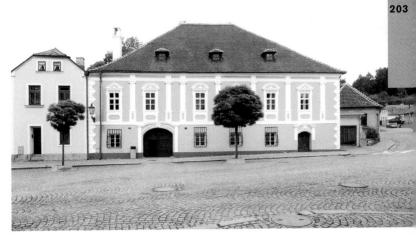

View of the Josef Hoffmann Museum, Brtnice

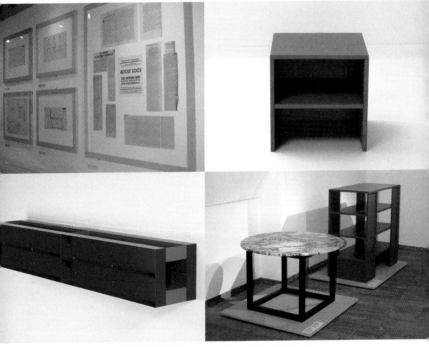

**Exhibition View "JOSEF HOFFMANN –
ADOLF LOOS. Ornament and Tradition"**
2007

Donald Judd: "Untitled", Wall Object
1989

Donald Judd: Stool
1984

**Exhibition View "JOSEF HOFFMANN –
DONALD JUDD. Hypothesis"**
2008

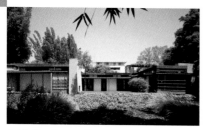

Schindler House (R. M. Schindler 1921/22)
established in 1994 as center for
contemporary art and architecture

MAK CENTER FOR ART AND ARCHITECTURE, LOS ANGELES

The MAK Center for Art and Architecture was founded in 1994 in a unique cooperation between the MAK Vienna and the Los Angeles-based non-profit organization Friends of the Schindler House (FOSH) in West Hollywood. The MAK Center is based today in three of the most important houses by Austrian-American architect Rudolph M. Schindler (1887–1953) who emigrated to the USA in 1914.

The Schindler House (1921/22) was the architect's own live-work space built on North King's Road, West Hollywood. It serves as the public center of the MAK Schindler Initiative devoted to contemporary experimental art and architecture. A social idealist and experimental architect, Rudolph M. Schindler developed a model design with regard to ground-plan and spatial quality that was, and is, a forerunner of a new architectural concept in California.

The Mackey Apartments (1939) were purchased by the Republic of Austria in 1995. In collaboration with the Austrian Ministry for Education and the Arts and the Ministry of Science and Research, the apartments have been established as the first permanent Artists-in-Residence center for Austrian artists and architecture students on scholarships in the US. The MAK Center Artists and Architects-in-Residence Program is today one of the most sought-after scholarships internationally. In 2004 the Mackey Archive (www.makcenterarchive.org) has been installed at the Mackey Apartments and is continuously being expanded and digitalized.

The Fitzpatrick-Leland House (1936), an exemplary modern residence located at the crest of Laurel Canyon Boulevard and Mulholland Drive, was donated to the MAK Center by a single donor, Russ Leland, in 2008 and since then has become the home of the new visionary Fellowship

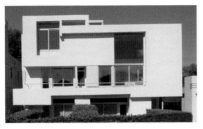

**Mackey Apartments
(R. M. Schindler 1939)**
purchased by the Republic of Austria in
1995, home of the MAK Center Artists
and Architects-in-Residence Program

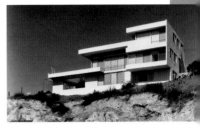

**Fitzpatrick-Leland House
(R. M. Schindler 1936)**
donated to the MAK Center by
Russ Leland in 2008, home of the
MAK UFI – Urban Future Initative
Fellowship Program

Program MAK UFI – Urban Future Initiative (www.makcenterUFI.org)
focused on contemporary urban issues and the future of the cities world-
wide. For his generous donation of the Fitzpatrick-Leland House Russ
Leland was awarded the Austrian Cross of Honor for Science and Art,
First Class, by Her Excellency Claudia Schmied, Federal Minister for
Education, Arts and Culture of the Republic of Austria, in October 2008.

With its radical contemporary orientation, the MAK Center for Art and
Architecture is today one of the most essential spaces for the production
and presentation of art and architecture and international discourse. An
Austrian cultural institution of internationally esteemed format has been
created at the West Coast of the USA. Focusing on the permanent and lively
exchange between Vienna and Los Angeles, new tendencies and interdis-
ciplinary progresses in the fields of art, architecture, urbanism, design
and discourse have been realized at the MAK Center since its foundation.
Its program concentrates on new spatial and architectural trends and
developments emanating from the interface of art and architecture –
that is, from the complementary and contradictory elements involved in
the concepts and methods employed by artists and architects. Acting as
a "think tank" for current issues, the MAK Center encourages explora-
tion of experimental, practical and theoretical trajectories in art and
architecture through exhibitions, lectures, discussions, performances,
screenings, and publications.

In this way the MAK Schindler Initiative intends to be active in two
interacting spheres of the promotion of art and architecture: on the one
hand, through its residency programs at the Mackey Apartments (see
page 230) and Fitzpatrick-Leland House (see page 236/7) and, on the
other, through public, internationally relevant activities and impulses at
the Schindler House.

VIENNA BY MAK

MAK TIPS

As a place for art and culture, the MAK's past and present have always been deeply connected with Vienna's everyday life and the needs and dreams of those living here.
Here are some suggestions for getting to know Vienna at its many levels. Starting from the MAK ...

ART AND MUSEUMS

In addition to the MAK's Collection, you should visit

**Dom zu St. Stephan
(St. Stephen's Cathedral)**
Stephansplatz, 1010 Vienna
(Walk up Wollzeile and then turn left on Rotenturmstr. to Stephansplatz, or take the U3 from Stubentor to Stephansplatz))

Erzbischöfliches Dom- und Diözesanmuseum (Archiepiscopal Church and Archdiocese Museum)
Stephansplatz 6, 1010 Vienna,
Tel 515 52-3560, Tue –Sat 10 a.m.–5 p.m. *(Walk up Wollzeile to the passageway between Wollzeile and Schulerstraße or take U3 from Stubentor to Stephansplatz)*

Friedenspagode (Peace Pagoda)
Hafenzufahrtsstr., 1020 Vienna
(U3 from Stubentor to Schlachthausg., then take bus 80B to the Friedenspagode stop)
Buddhist temple and stupa on the banks of the Danube

Generali Foundation
Wiedner Hauptstr. 15, 1040 Vienna,
Tel 504 98 80, Tue–Sun, holidays
11 a.m.–6 p.m., Thu to 8 p.m.
(U4 Landstr./Wien Mitte to Karlsplatz, then take tram 62 or 65 to Paulanerg.)
Collection & archive of contemporary art

**Heeresgeschichtliches Museum
(Museum of Military History)**
Ghegastr., Arsenal, 1030 Vienna,
Tel 795 61-0,
Sat–Thu 9 a.m.–5 p.m.
(Tram 1 from Stubentor to Schwarzenbergplatz, then take tram D to Südbahnhof)
Important example of a *gesamtkunstwerk* in the Historicism, "Turkish booty"

**Hofburg
Silberkammer (Imperial Silver),**
Innerer Burghof 1, 1010 Vienna,
Tel 533 75 70,
Sep–Jun 9 a.m.–5.30 p.m.,
Jul/Aug 9 a.m.–8 p.m., ticket office closes one hour before.
(U3 Stubentor to Herreng.)
European and Asian porcelain, former Imperial table and silverware chamber, storeroom of the Royal Household

**Japanese Garden
(Setagaya Park)**
Hohe Warte 8, 1190 Vienna,
Mar–Oct daily 7 a.m. till dusk.
(U4 Landstr./Wien Mitte to Heiligenstadt, then bus 39A to Hohe Warte)
Japanese 20th century gardening

Kaiserliches Hofmobiliendepot (Imperial Court Furniture Collection)

Mariahilferstr. 88 (Entrance at Andreasg. 7), 1070 Vienna, Tel 524 33 57-0, Tue–Sun 10 a.m.– 6 p.m. *(U3 Stubentor to Zieglerg.)* Former furniture depot of the Imperial Court, reconstructed rooms from the 18th–21st cent.

Kunstforum Bank Austria

Freyung 8, 1010 Vienna, Tel 537 33-0, daily 10 a.m.–7 p.m., Fri to 9 p.m. *(U3 Stubentor to Stephansplatz)* Exhibitions on 20th/21st century art

Kunsthistorisches Museum (Museum of Art History)

Kunstkammer (Collection of Sculpture and Decorative Arts), Maria Theresienplatz, 1010 Vienna, Tel 525 24-4401, currently closed. *(Tram 1 from Stubentor to Burgring)* Courtly arts and crafts
Schatzkammer (Treasury), Schweizerhof, 1010 Vienna, Tel 525 24-0, Wed–Mon 10 a.m.– 6 p.m., 24.12. to 1 p.m., 31.12. to 4 p.m., 1.1. 1–6 p.m., closed Tue's after Easter Sun & Pentecost. *(U3 Stubentor to Herreng.)* Coronation robes and Imperial insignia of the Kings and Emperors of the Holy Roman Empire of the German Nation, ritual vestments of the Order of the Golden Fleece
Hofjagd- und Rüstkammer (Collection of Arms and Armour), Neue Burg, Heldenplatz, 1010 Vienna, Tel 525 24-4502, Wed–Mon 10 a.m.–6 p.m., 24.12. 1–6 p.m., 31.12. 10 a.m.–4 p.m., closed Tue's after Easter Sun & Pentecost, 25. & 26.12. *(Tram 1 from Stubentor to Burgring)* European & Oriental "Plattner-kunst"

Museum für Völkerkunde (Museum of Ethnology),

Neue Burg, Heldenplatz, 1010 Vienna, Tel 525 24-5199, Mon/Tue/Thu 10 a.m.–6 p.m. Library: Mon–Thu 10 a.m.–4 p.m., Wed to 6 p.m., closed 1. & 6.1. *(Tram 1 from Stubentor to Burgring)* Non-European Art

Museum im Schottenstift (Museum in the Scottish Convent)

Freyung 6, 1010 Vienna, Tel 534 98-600, Thu–Sat 11 a.m.– 5 p.m., closed Sun & holidays. *(U3 Stubentor to Herreng.)* Collection of paintings, furniture, tapestry, as well as liturgical instruments and vestments

MuseumsQuartier

Museumsplatz 1, 1070 Vienna *(U3 Stubentor to Volkstheater/ Museumsquartier)*
Architekturzentrum Wien, Tel 522 31 15, daily 10 a.m.–7 p.m. Presentation of international architectural developments, information and database of Austrian architecture
Kunsthalle Wien, Tel 521 89-1202, daily 10 a.m.–7 p.m., Thu to 10 p.m. International contemporary art
Leopold Museum, Tel 525 70-0, daily 10 a.m.–6 p.m., Thu to 9 p.m., 26.–30.12., 2.–6.1. to 7 p.m., closed 24.12.
Mainly Vienna Secessionism, Modernism in Vienna, and Austrian Expressionism
Museum moderner Kunst Stiftung Ludwig Wien (MUMOK), Tel 525 00-0, daily 10 a.m.–6 p.m., Thu to 9 p.m. Pop Art, Photorealism, Fluxus, Nouveau Réalisme, Vienna Actionism

Zoom Kindermuseum,
Tel 524 79 08, Mon–Fri 8.30 a.m.–
5 p.m., Sat/Sun/holidays/school
vacations 10 a.m.–5.30 p.m.
Participatory shows that aim at
stimulating children's creativity

Belvedere
Tel 795 57-0, once the Baroque
summer residence of general and
art connoisseur Prince Eugene
Oberes Belvedere, Prinz-Eugen-
Str. 27, 1030 Vienna,
daily 10 a.m.–6 p.m.
*(Tram 1 from Stubentor to
Schwarzenbergplatz, then take
tram D to Oberes Belvedere)*
Austrian art dating from the
Middle Ages to the present day;
Messerschmidt heads (originally
at the MAK)
Unteres Belvedere, Rennweg 6,
1030 Vienna, daily 10 a.m.–6 p.m.,
Wed to 9 p.m.
*(Tram 1 from Stubentor to
Schwarzenbergplatz, then take
tram 71 to Unteres Belvedere)*
Insight into Baroque interior
Orangery (Unteres Belvedere),
daily 10 a.m.–6 p.m., Wed to 9 p.m.
Former "Pomeranzenhaus", used
for temporary exhibitions
Augarten Contemporary,
Scherzerg. 1a, 1020 Vienna,
Tel 79 557-0,
Thu–Sun 11 a.m.–7 p.m.
Temporary exhibitions of
contemporary art

**Österreichische Nationalbibliothek,
(Austrian National Library),
Prunksaal**
Josefsplatz 1, 1010 Vienna,
Tel 534 10-394,
Tue–Sun 10 a.m.–6 p.m.,
Thu to 9 p.m.
(U3 from Stubentor to Herreng.)
Imperial Library in its original state,
library as representation space

**Schatzkammer des Deutschen
Ordens (Treasury of the German
Order)**
Singerstr. 7/1, 1010 Vienna,
Tel 512 10 65,
Tue/Thu/Sat 10–12 a.m.,
Wed/Fri 3–5 p.m. *(Walk up
Wollzeile, through Domg. and
Blutg. to Singerstr. or take U3
from Stubentor to Stephansplatz)*
Artifacts from the late medieval
period onwards

**Schloss Schönbrunn
(Schönbrunn Palace)**
Schloss Schönbrunn, 1130 Vienna,
Tel 811 13-0, daily from 8.30 a.m.,
Apr–Jun, Sep/Oct to 5 p.m.,
Jul/Aug to 6 p.m., Nov–Mar to
4.30 p.m. *(U4 from Landstr./Wien
Mitte to Schönbrunn)*
Imperial Summer Residence with
18th/19th century furniture

Secession
Friedrichstr. 12 (Karlsplatz),
1010 Vienna, Tel 587 53 07-0,
Tue–Sun 10 a.m.–6 p.m.,
Thu to 8 p.m. *(U4 from
Landstr./Wien Mitte to Karlsplatz)*
Exhibition space of the Vienna
Secession by Joseph Maria
Olbrich, Beethoven Frieze by
Gustav Klimt, contemporary art

Wien Museum
Karlsplatz 8, 1040 Vienna,
Tel 505 87 47-0,
Tue–Sun, holidays 9 a.m.–6 p.m.,
24.12. to 2 p.m., closed 1.1., 1.5. &
25.12. *(U4 Landstr./Wien Mitte to
Karlsplatz)*
The museum focuses on every
facet of Vienna's history
Hermesvilla (Villa Hermes),
Lainzer Tiergarten, 1130 Vienna,
Tel 804 13 24, Mar 21–Oct 26,
Tue–Sun, holidays 10 a.m.–6 p.m.,
Oct 27–Mar 20, Fri–Sun, holidays to
4.30 p.m. *(U4 from Landstr./Wien*

Mitte to Hietzing, take tram 60 to Hermesstr. and then bus 60B to Lainzer Tor)
Exhibitions on mainly Viennese themes; built as summer residence for Empress Elisabeth
Uhrenmuseum der Stadt Wien,
Schulhof 2, 1010 Vienna,
Tel 533 22 65, Tue–Sun, holidays 10 a.m.–6 p.m., 31.12. to 5 p.m., closed 1.1., 1.5. & 25.12.
(Bus 1A from Dr.-Karl-Lueger-Platz to Hoher Markt)
Clock collection

J. & L. Lobmeyr, Glasmuseum (Glass Museum)
Kärntnerstr. 26, 1015 Vienna,
Tel 512 05 08, Mon–Fri 10 a.m.–7 p.m., Sat to 6 p.m. *(U3 from Stubentor to Stephansplatz)*
Glass collection from the 19th & 20th century

Outside Vienna

Sammlung Essl (Essl Collection)
An der Donau-Au 1, 3400 Klosterneuburg, Tel 02243/370 50-150,
Tue–Sun 10 a.m.–6 p.m.,
Wed to 9.00 p.m.
(U4 from Landstr./Wien Mitte to Spittelau, then Schnellbahn S40 to Klosterneuburg-Weidling)
Private collection of international contemporary art

Stift Klosterneuburg (Klosterneuburg Convent)
Stiftsmuseum, Stiftsplatz 1,
3400 Klosterneuburg,
Tel 02243/411-0,
daily 9 a.m.–6 p.m., 24. & 31.12. to 12 a.m., 1.1. 1–6 p.m.,
closed 25. & 26.12.
(U4 from Landstr./Wien Mitte to Heiligenstadt, then take bus 238, 239 to Klosterneuburg)
Verdun Altar (enamel altar by Nikolaus Verdun), collection of important Late Renaissance bronze sculptures

Thonet-Museum
Bahnhofstr. 67, 8240 Friedberg, Styria, Tel 03339/25 110,
Sun 2–4 p.m. *(Train to Friedberg from Wien-Südbahnhof)*
Large selection of Thonet chairs from the first bentwood model to contemporary designs

ARCHITECTURE

Vital architectural positions in Vienna
(selected by Ute Woltron, Walter Zschokke, and Peter Noever)

Bank Austria (former "Z" Favoriten branch)
Günther Domenig, 1975
Favoritenstr. 118, 1100 Vicnna
(U3 from Stubentor to Stephans-platz, then U1 to Reumannplatz)

Dachausbau (Attic Extension) Falkestraße
Coop Himmelb(l)au, 1987
Falkestr. 6, 1010 Vienna *(Entrance to Falkestr. opposite the MAK)*
Not open to the public

Stonborough-Wittgenstein House
Ludwig Wittgenstein, 1926–28
Kundmanng. 19, 1030 Vienna
(U3 from Stubentor to Rochusg.)

Hochhaus (Highrise) Herrengasse
Theiss & Jaksch, 1932–35
Herreng. 6–8, 1010 Vienna
(U3 from Stubentor to Herrengasse)

Juridische Fakultät der Univer-sität Wien (Law Faculty of the University of Vienna)
Ernst Hiesmayr, 1970–84
Schottenbastei 10–16, 1010 Vienna
(Tram 1 from Stubentor to Schottentor)

Kirche "Christus Hoffnung der Welt" ("Christ Hope of the World" Church)
Heinz Tesar, 1999
Donaucitystr. 2, 1220 Vienna
(U3 from Stubentor to Stephans-platz, then take U1 bis Kaiser-mühlen/Vienna) International Center)

Kleines Café
Hermann Czech, 1970–77
Franziskanerplatz 3, 1010 Vienna
(Walk across Wollzeile to Singerstr., then continue to Ballg. till you reach Franziskanerplatz)

Philips-Haus (Philips House)
Karl Schwanzer, 1962–64
Triester Str. 64–66, 1100 Vienna
(Tram 1 from Stubentor to Oper, then take tram 65 to Windtenstr.)

Restaurant Kiang
**Helmut Richter,
Heidulf Gerngross**, 1984–85
Rotg. 8, 1010 Vienna
(Tram 2 from Stubentor to Schwedenplatz)

Wohnbau (Residential Building) Frauenfelderstraße
**Dieter Henke,
Marta Schreieck**, 1991
Frauenfelderstr. 14, 1170 Vienna
(Tram 1 from Stubentor to Schottentor, change to tram 43, exit at S-Bahn station Hernals)

Wohnheim (Residential Building) Matznergasse
BKK-2 (C. Lammgruber among others), 1993
Matznerg. 8/Goldschlagstr. 169, 1140 Vienna
(U3 from Stubentor to Westbahn-hof, then take tram 52 to Diester-weggasse)

GALLERIES

Several renowned galleries have remained in the 1st district. A special dynamism has developed in Eschenbachgasse in the 1st district and in Schleifmühlgasse in the 4th district.

DESIGN

If you have not already found the most interesting objects in the MAK Design Shop

Galerie V&V, Forum for Contemporary Jewelry
Bauernmarkt 19, 1010 Vienna, Tel 535 63 34, Tue–Wed 2–6.30 p.m., Thu to 9 p.m., Fri/Sat 11 a.m.–6 p.m. *(U3 from Stubentor to Stephansplatz, walk up Rotenturmstr. to Hoher Markt and then continue to Bauernmarkt)*

KlausEngelhorn22 – contemporary design
Abeleg. 10, 1160 Vienna, Tel 512 79 40

Unit F – Office for Fashion
Gumpendorferstr. 10–12, 1060 Vienna, Tel 219 84 99-0 *(U4 from Landstr./Wien Mitte to Karlsplatz/Secession exit, walk across Getreidemarkt to Gumpendorferstr.)*

FOOD AND DRINK

Good food and beverages in high-class architectural ambience

Am Nordpol 3 8 (Restaurant)
Nordwestbahnstr. 17/Nordpolstr. 3, 1020 Vienna, Tel 333 58 54

Café Anzengruber
Schleifmühlg. 19, 1040 Vienna, Tel 587 82 97

Café Engländer
Postg. 2, 1010 Vienna, Tel 966 86 65

Café Prückel
Oswald Haerdtl, 1955
Stubenring 24, 1010 Vienna

Café Stein
Währinger Str. 6–8, 1090 Vienna, Tel 319 72 41

Cantinetta Antinori
(Restaurant / Winebar)
Jasomirgottstr. 3–5, 1010 Vienna, Tel 533 77 22

Comida (Restaurant)
Stubenring 20, 1010 Vienna, Tel 512 40 24

Dots (Restaurant / Bar)
Mariahilferstr. 103, 1060 Vienna, Tel 920 99 80

Eiserne Zeit (Restaurant)
Naschmarkt Stand 316,
Höhe Linke Wienzeile 14,
1060 Vienna,
Tel 587 03 31

Expedit (Restaurant / Bar)
Biberstr./Wiesingerstr. 6,
1010 Vienna,
Tel 512 33 13

Gasthaus Wild (Restaurant)
Radetzkyplatz 1, 1030 Vienna,
Tel 920 94 77

Haas & Haas (Teahouse)
Stephansplatz 4, 1010 Vienna,
Tel 512 26 66

Indochine 21 (Restaurant)
Stubenring 18, 1010 Vienna,
Tel 513 76 60

Kiang (Restaurant)
Helmut Richter,
Heidulf Gerngross, 1984–85
Rotg. 8, 1010 Vienna,
Tel 533 08 56

Loos-Bar
Adolf Loos, 1908
Kärntnerstr. 10, 1010 Vienna,
Tel 512 32 83

Naschmarkt Deli (Bar)
Dietrich / Untertrifaller, 2001
Naschmarkt Stand 421–436,
Linke Wienzeile, 1040 Vienna,
Tel 585 08 23

Novelli (Restaurant)
Bräunerstr. 11, 1010 Vienna,
Tel 513 42 00

Österreicher im MAK
(Gasthaus.Bar)
eichinger oder knechtl, 2006
Stubenring 5, 1010 Vienna
Tel 714 01 21

Roter Engel (Bar)
Coop Himmelblau, 1981
Rabensteig 5, 1010 Vienna
Tel 535 41 05

San Carlo (Restaurant)
Mahlerstr. 3, 1010 Vienna
Tel 513 89 84

Schwarzes Kameel (Delicatesse,
snacks, and Restaurant), founded in
1618, Bognergasse 5, 1010 Vienna,
Tel 533 81 25-0

Skopik und Lohn
(Restaurant/ Bar)
Leopoldsg. 17, 1020 Vienna
Tel 219 89 77

Trzesniewski (Buffet)
founded in 1902, Dorotherg. 1,
1010 Vienna,
Tel 512 32 91

Ubl (Restaurant)
Preßg. 26, 1040 Vienna,
Tel 587 64 37

Umarfisch am Naschmarkt
(Restaurant / Fishshop)
Naschmarkt 76–79, 1040 Vienna,
Tel 587 04 56

Unger und Klein
(Wine dealers and Buffet)
eichinger oder knechtl, 1994
Gölsdorfg. 2/Rudolfsplatz,
1010 Vienna,
Tel 532 13 23

Urania (Restaurant / Bar)
Uraniastr. 1, 1010 Vienna,
Tel 713 30 66

MUSIC

Places of young music

Fledermaus
Spiegelg. 2, 1010 Vienna,
Tel 587 01 96

Flex
Donaukanal/exit Augartenbrücke,
1010 Vienna, Tel 533 75 25

Fluc
Praterstern 5, 1020 Vienna

Porgy & Bess
Riemergasse 11, 1010 Vienna,
Tel 503 70 09

Volksgarten Pavilion
Burgring 1, 1010 Vienna,
Tel 532 09 07

In the arches between Urban-Loritz-Platz and Josefstädter-straße below the Stadtbahn or U6. Developed according to a concept by **Sonja Tilner**. The most innovative "cultural mile" in the city with a lot of live and electronic music:
Chelsea, Lerchenfeldergürtel/Arches 29–31,
Tel 407 93 09;
B72, Hernalser Gürtel/Arch 72,
Tel 409 21 28;
Rhiz, Lerchenfeldergürtel/Arch 37–38, Tel 409 25 05;
the **main library** of the Vienna Public Libraries above the underground station Burggasse

SHOPPING

For things that cannot be found just anywhere

Bäckerei Grimm (Bakery)
Kurrentg. 10 A, 1010 Vienna,
Tel 533 13 84-0

Bips (Children's wear)
Spitalg. 13–15, 1090 Vienna,
Tel 405 83 44-0

Blumenkraft (Florist)
Schleifmühlg. 4, 1040 Vienna,
Tel 585 76 39

Boutique Chegini
Plankeng. 4/Ecke Seilerg.,
1010 Vienna,
Tel 512 22 31

Buchhandlung a punkt, Brigitte Salanda (Bookshop)
Fischerstiege 1–7, 1010 Vienna,
Tel 532 85 14

Buchhandlung Judith Ortner (Bookshop)
Sonnenfelsg. 8, 1010 Vienna, Tel 512 74 69

Buchhandlung Lia Wolf (Bookshop)
Bäckerstr. 2, 1010 Vienna,
Tel 512 40 94

Demmer high tea (Tea and gifts)
Paniglg. 17, 1040 Vienna,
Tel 504 15 08

Denkstein (Shoe shop)
Bauernmarkt 8, 1010 Vienna,
Tel 533 04 80

Disaster Clothing (Boutique)
Kircheng. 19, 1070 Vienna,
Tel 524 14 09

Duft & Kultur (Perfumery)
Tuchlauben 17, 1010 Vienna,
Tel 532 39 60

Eisner (Kitchen ware)
Stumperg. 63–65, 1060 Vienna,
Tel 597 07 01

Emis (Boutique)
Wildpretmarkt 7/Tuchlauben 18,
1010 Vienna, Tel 535 28 19

firis (Boutique)
Bauernmarkt 9, 1010 Vienna,
Tel 533 42 75

Guys+Dolls (Boutique)
Schulterg. 2, 1010 Vienna,
Tel 535 42 83

Johanna Kölbl (Pearl jewelry)
Falkestr. 6, 1010 Vienna,
Tel 512 51 47

Kaffeerösterei Alt Wien
(Coffee-roasting establishment)
Schleifmühlg. 23,
1040 Vienna, Tel 505 08 00

Kaufhaus Schiepek (Pearls,
kitsch, and bric-à-brac)
Teinfaltstr. 3, 1010 Vienna,
Tel 535 15 75

Kontor
(Leather and household goods)
Spiegelg. 15, 1010 Vienna,
Tel 512 41 92

Michel Mayer (Clothing)
Singerstr. 7, 1010 Vienna,
Tel 967 40 55

Nanadebary (Cosmetics)
Bauernmarkt 9, 1010 Vienna,
Tel 533 07 09

Naschmarkt
Wienzeile between Getreidemarkt
& Kettenbrückeng., 1060 Vienna

Papierwerkstatt (Paper-makers)
Kaiserstr. 67, 1070 Vienna,
Tel 522 39 91

Piccini (Italian specialities)
Linke Wienzeile 4, 1060 Vienna,
Tel 587 52 54, 586 33 23

Pregenzer (Boutique)
Schleifmühlg. 4, 1040 Vienna,
Tel 586 57 58

Prodomo Windows (Design)
Naglerg. 29, 1010 Vienna,
Tel 533 83 82

Rauminhalt (Design 1950–70)
Schleifmühlg. 13, 1040 Vienna,
Tel 409 98 92

Red Octopus Records
Josefstädterstr. 99, 1080 Vienna,
Tel 408 12 22

Robert Horn (Leather goods)
Bräunerstraße 7, 1010 Vienna,
Tel 513 82 94

Shakespeare & Company
(Booksellers)
Sterng. 2, 1010 Vienna,
Tel 535 50 53

Shu! (Shoe shop)
Neubaug. 34, 1070 Vienna,
Tel 523 14 49

Song (Boutique)
Praterstr. 11–13, 1020 Vienna,
Tel 532 28 58

Wäscheflott (Shirtmakers)
Augustinerstr. 7, 1010 Vienna,
Tel 533 50 84

Zauberklingl / Ed. Witte
(Carnival accessories)
Führichg. 4, 1010 Vienna,
Tel 512 68 68

MAK TOURS

MAK TOUR 1

ARCHITECTURE AROUND 1900

Duration: one day

Tour begins at the MAK with
the Wiener Werkstätte and
Art Nouveau in Vienna

**MAK – Austrian Museum of
Applied Arts / Contemporary Art**
Heinrich von Ferstel, 1867–71
Stubenring 5, 1010 Vienna

>>> *On foot from the MAK across
Stubenring to* >>>

**Postsparkasse
(Postal Savings Bank)**
Otto Wagner, 1904–06 & 1910–12
Georg Coch Platz 2, 1010 Vienna

>>> *walk through the Stadtpark
or take the tram line 1 till the
Weihburggasse stop* >>>

**Stadtpark and the Wien River
constructions**
Friedrich Ohmann,
Josef Hackhofer, 1903–07

and

**Stadtbahn (Suburban Line)
Station Stadtpark**
Otto Wagner, 1897–98

>>> *take subway line U4 from
Stadtpark to Karlsplatz* >>>

Stadtbahn Pavilions at Karlsplatz
Otto Wagner, 1898–99

>>> *walk across Resselpark to
Friedrichsstraße* >>>

Secession
Joseph Maria Olbrich, 1897–98
Friedrichstr. 12, 1010 Vienna

>>> *walk away from the city,
over the Naschmarkt to
Kettenbrückengasse* >>>

Wienzeile Residential Houses
Otto Wagner, 1898–99
Linke Wienzeile 38 and 40,
1060 Vienna

>>> *take the U4 from Ketten-
brückengasse to Hietzing* >>>

Imperial Pavilion – Stadtbahn
Otto Wagner, 1894–98
Schönbrunner Schlossstr.
underground station Hietzing,
1130 Vienna

>>> *take the tram line 60 from
Hietzing/Kennedybrücke to
Gloriettegasse* >>>

Villa Skywa-Primavesi
Josef Hoffmann, 1913–15
Glorietteg. 18, 1130 Vienna

>>> *walk up Gloriettegasse till Wattmanngasse* >>>

Residence
Ernst Lichtblau, 1914
Wattmanng. 29, 1130 Vienna

>>> *walk back through Gloriettegasse to Lainzerstraße, then walk up Wenzgasse to Larochegasse* >>>

Scheu House
Adolf Loos, 1912–13
Larocheg. 3, 1130 Vienna

>>> *walk back to Lainzerstraße, away from the city to Beckgasse* >>>

Residence
Josef Plecnik, Karl Langer, 1900–01
Beckg. 30, 1130 Vienna

>>> *walk away from the city to St. Veit-Gasse, turn left uphill* >>>

Steiner House
Adolf Loos, 1910
St. Veit-G. 10, 1130 Vienna

>>> *continue uphill past Stadlergasse, then go up Hummelgasse along the railroad to Veitingergasse. Cross the tracks and turn right at Sauraugasse into Nothartgasse* >>>

Horner House
Adolf Loos, 1912–13
Nothartg. 7, 1130 Vienna

>>> *walk up Veitingergasse to Jagdschlossgasse* >>>

Werkbund Housing Estate,
Project leadership and selection of architects by **Josef Frank,** 1930–32
(Jagdschlossg., Veitingerg., Woinovichg., Jagicg., 1130 Vienna)
Architects **Gerrit Rietveld, Josef Hoffmann, Adolf Loos / Heinrich Kulka, André Lurçat, Ernst A. Plischke, Hugo Häring, Anton Brenner, Josef Frank, Oswald Haerdtl, Oskar Strnad, Walter Sobotka** (Houses built by **Oskar Strnad** and **Walter Sobotka** as well as two houses by **Hugo Häring** were bombed and destroyed in 1945)

MAK TOUR 2

ARCHITECTURE AROUND 1900

Duration: 1/2 day

>>> *Start walking from* **MAK** *and cross Stubenring to* >>>

Postsparkasse (Postal Savings Bank)
Otto Wagner, 1904–06, 1910–12
Georg Coch Platz 2, 1010 Vienna

>>> *go back across Stubenring. Walk along Weiskirchnerstraße, up Landstraßer Hauptstraße into Beatrixgasse. Now turn left into Ungargasse* >>>

Residential and Commercial Building Portoix & Fix
Max Fabiani, 1898–1900
Ungarg. 59–61, 1030 Vienna

>>> *walk back toward the city across Heumarkt into Stadtpark* >>>

Stadtpark and the Wien River constructions
Friedrich Ohmann,
Josef Hackhofer, 1903–07

and

Stadtbahn (Suburban Line) Stadtpark Station
Otto Wagner, 1897–98

>>> *take subway line U4 from Stadtpark to Karlsplatz* >>>

Stadtbahn Pavilions at Karlsplatz
Otto Wagner, 1898–99

>>> *walk across Resselpark to Friedrichstraße* >>>

Secession
Joseph Maria Olbrich, 1897–98
Friedrichstr. 12, 1010 Vienna

>>> *walk away from the city, over the Naschmarkt to Kettenbrückengasse* >>>

Wienzeile Residential Houses
Otto Wagner, 1898–99
Linke Wienzeile 38 and 40,
1060 Vienna

>>> *take the U4 from Kettenbrückengasse to Schottenring* >>>

Schützenhaus (Lock house)
Otto Wagner, 1907
Obere Donaustr. 26, 1020 Vienna

>>> *take bus line 3A from the Schottenring stop to Hoher Markt* >>>

Anker Clock
Franz von Matsch, 1911–17
Hoher Markt 10–11, 1010 Vienna

>>> *walk towards the city over Bauernmarkt* >>>

Zacherl House
Josef Plecnik, 1903–05
Bauernmarkt 5/Wildpretmarkt 2–4/
Brandstätte 6, 1010 Vienna

>>> *walk toward the city to Trattnergasse* >>>

Trattnerhof
Rudolf Krauß, 1911–12
Trattnerg./Graben 29,
1010 Vienna

>>> *walk over to Graben* >>>

Anker House
Otto Wagner, 1893–95
Graben 10, 1010 Vienna

Knize tailor's salon
Adolf Loos, 1910–13
Graben 13, 1010 Vienna

>>> *walk down Graben to
Kohlmarkt* >>>

Artaria House
Max Fabiani, 1900–01
Kohlmarkt 9, 1010 Vienna

>>> *walk from Kohlmarkt to
Michaelerplatz* >>>

Loos House (formerly Goldman
and Salatsch business location)
Adolf Loos, 1909–11
Michaelerplatz, 1010 Vienna

MAK TOUR 3

BAROQUE

Duration: 1/2 day

>>> *On foot toward the city from
the* **MAK** *across Dr. Karl Lueger
Platz to the Postgasse* >>>

Dominican Church 1631–34,
facade 1666–74
Postg. 4, 1010 Vienna

>>> *into Bäckerstraße toward the
city to Ignaz-Seipel Platz* >>>

Jesuit Church (old University
Church) built 1626–31, modified
by **Andrea Pozzo** 1703–05
Ignaz Seipel Platz, 1010 Vienna

Academy of the Sciences
(old university)
Jean Nicolas Jadot de Ville-Issey,
1753–55
Ignaz-Seipel Platz, 1010 Vienna

>>> *walk toward the city into
Bäckerstraße* >>>

Bäckerstraße residential build-
ings and city palaces from the
17th and 18th centuries

>>> *to Lugeck, then take a right
into Köllnerhofgasse* >>>

**Heiligenkreuzerhof and Schön-
laterngasse** 18th century residen-
tial buildings and courtyards

>>> *back to Lugeck, up Roten-
turmstraße to Hoher Markt* >>>

Vermählungsbrunnen (Wedding
Fountain or Josef's Fountain)
**Josef Emanuel Fischer von
Erlach**, 1729–32
Hoher Markt, 1010 Vienna

>>> *on foot down
Wipplingerstraße* >>>

Old City Hall
facade ca. 1700, portal 1781,
in the courtyard
Andromeda Fountain
Raffael Donner, 1740–41
Wipplingerstr. 8, 1010 Vienna

>>> *from Wipplingerstraße
down Fütterergasse to Juden-
platz* >>>

Bohemian Court Chancellery
**Johann Bernhard Fischer von
Erlach**, 1708–14, extension by
Matthias Gerl 1750–54
Wipplingerstr. 7/Judenplatz 11,
1010 Vienna

>>> *from Judenplatz to Platz
Am Hof via Drahtgasse* >>>

Civil Arsenal
post-1529, modified by **Anton
Ospel**, 1731–32
Am Hof 10, 1010 Vienna

Church am Hof (9 Choruses of
Angels)
facade by **Carlo Antonio Carlone**,
1607–10
Am Hof, 1010 Vienna

>>> *on foot to Renngasse via
Heidenschuss and Freyung* >>>

Batthany-Schönborn Palace
**Johann Bernhard Fischer von
Erlach**, 1698–1706
Renng. 4, 1010 Vienna

Kinsky Palace
Johann Lucas von Hildebrandt,
1713–16
Freyung 3, 1010 Vienna

Harrach Palace after plan by
Domenico Martinelli(?),
ca. 1700 Freyung 3,
1010 Wien

>>> *walk to Bahngasse via
Herrengasse* >>>

Lichtenstein Palace
after plan by **Domenico
Martinelli**, 1694–1706
Bankg. 9, 1010 Vienna

>>> *walk across Michaelerplatz
to Josefsplatz* >>>

Hofburg, National Library
redesigned by **Johann Bernhard
Fischer von Erlach** and **Josef
Emanuel Fischer von Erlach**,
1719–35
Hofburg, Josefsplatz, 1010 Vienna

>>> *on foot to Lobkowitzplatz via
Augustinerstraße* >>>

Lobkowitz Palace
Giovanni Pietro Tencala, 1685– 87,
portico by **Johann Bernhard
Fischer von Erlach**, 1709–11
Lobkowitzplatz 2, 1010 Vienna

>>> *back toward the city to
Neuer Markt via Tegethofstraße*
>>>

Capuchin Crypt since 1633 the
Emperor's Crypt with sarcophagi
of art historical importance
Neuer Markt, 1010 Vienna

Donner Fountain
Raffael Donner,
1737–1739 (original in the
Baroque Museum in Lower
Belvedere)
Neuer Markt, 1010 Vienna

>>> *via Kärntnerstraße to
Annagasse* >>>

Annagasse residential houses
and city palaces from the 17th
and 18th centuries

City Palace of Prince Eugen
(Treasury Department)
Johann Bernhard Fischer von Erlach, 1695, extension by
Johann Lucas von Hildebrandt,
1708–24
Himmelpfortg. 8, 1010 Vienna

>>> *via Rauhensteingasse and Ballgasse to Franziskanerplatz* >>>

Franciscan Church
Bonaventura Daum (?), 1603–11,
high altar by **Andrea Pozzo,**1707
Franziskanerplatz, 1010 Vienna

MAK TOUR 4

AROUND THE GEYMÜLLERSCHLÖSSEL

Duration: 1/2 day

The tour begins at the **MAK Branch Geymüllerschlössel** built as a "summer residence" after 1808.
Khevenhüllerstr. 2, 1180 Vienna

Der Vater weist dem Kind den Weg (The father shows the way to his child)
Hubert Schmalix, 1998

Skyspace James Turrell, 1998

>>> *walk up Khevenhüllerstraße, turn into Büdingergasse, walk to Starkfriedgasse to* >>>

Moller House
Adolf Loos, 1927–28
Starkfriedg. 19, 1180 Vienna

>>> *continue walking to the* >>>

Villas in Wilbrandtgasse
(Scholl House, Straus House)
Josef Frank, Oskar Wlach, Oskar Strnad, 1913–14
Wilbrandtg. 3 and 11,
1190 Vienna

>>> *turn back to Ludwiggasse, cross Pötzleinsdorferstraße to the* >>>

Pötzleinsdorfer Palace Park entrance **Two gardener's houses,** built ca. 1800
Pötzleinsdorfer Palace Park, redesigned by **Konrad A. Rosenthal, Franz Illner** from 1799 onwards, commissioned by Geymüller

>>> *take tram 41 to Gersthof, change to S-Bahn, take S-Bahn to Hernals exit* >>>

Kongress Bad (public pool)
Erich Leischner, 1928
Julius Meinl Gasse 7A,
1160 Vienna

>>> *walk to* >>>

Sandleitenhof
Emil Hoppe, Otto Schönthal, Franz Matuschek, 1924–28
Sandleiteng., Steinmüllerg.,
Metschlg., Baumeisterg., Rosa-

Luxemburg-G., 1160 Vienna
>>> *walk to Hernalser Haupt-
straße and take bus 44b through
the* >>>

Heuberg Housing Estate
Adolf Loos, 1921
Kretschkeg., Röntgeng.,
Schrammelg., Plachyg.,
Trenkwaldg., 1170 Vienna

MAK TOUR 5

MAK IN PUBLIC SPACE

Duration: 1/2 day

>>> *Have a look at the frontside
of the* **MAK** *(only observable at
night)* >>>

MAKlite James Turrell,
set up in 2004
MAK, Stubenring 5, 1010 Vienna

>>> *walk from the* **MAK** *towards
Stadtpark, at the crossing, spot
on the refuge* >>>

Stylit Michael Kienzer, 2004
set up in 2007
Stubenring 5 / Weiskirchnerstr.,
1010 Vienna

>>> *walk towards the U4 station
Konzerthaus through Stadtpark
to* >>>

Stage Set Donald Judd, 1991
set up in 1996
Stadtpark (between the Meierei
and the children's playground),
1010 Vienna

>>> *walk back through the
Stadtpark to Weiskirchnerstraße
and Stubenbrücke to* >>>

Four Lemurheads
Franz West, 2001
Stubenbrücke, 1010 Vienna

>>> *walk along Landstraßer
Hauptstraße to the U4. Take the
U4 to Schottenring to* >>>

Wiener Trio Philip Johnson, 1996
set up in 1998
Franz-Josefs-Kai (opposite the
Ringturm), 1010 Vienna

>>> *take the U2 from Schotten-
ring to Schottentor, then tram 41
to the last stop Pötzleinsdorf.
Walk along Pötzleinsdorferstraße
to the Geymüllerschlössel* >>>

Skyspace „The other Horizon"
James Turrell, 1998
(in the garden of the
Geymüllerschlössel)
Khevenhüllerstr. 2, 1180 Vienna

SERVICE

MAK
Stubenring 5, 1010 Vienna
(U4 Landstraße, U3 Stubentor, 2, 1A, 74A Stubentor)
Tel (+43-1) 711 36-0, hotline (+43-1) 712 80 00, fax (+43-1) 713 10 26
e-mail office@MAK.at, www.MAK.at

Guided tours: Tel (+43-1) 711 36-298, e-mail education@MAK.at
Press office: Tel (+43-1) 711 36-233, e-mail presse@MAK.at
MAK Design Shop: Tel (+43-1) 711 36-228, e-mail designshop@MAK.at
MAK Reading Room: Tel (+43-1) 711 36-259
MAK Design Info Pool: Tel (+43-1) 711 36-305, e-mail design@MAK.at

Opening hours
MAK Permanent Collection, MAK Study Collection, MAK Exhibitions,
MAK Design Info Pool, MAK Design Shop:
Tue MAK NITE© 10 a.m.–12 p.m., Wed–Sun 10 a.m.–6 p.m., closed Mon
Free Admission on Saturdays©
MAK Reading Room: daily 10 a.m.–6 p.m.,
closed Mon and generally in August
Open on Easter Mon and Whit Mon, December 24 and 31:
10 a.m.–3 p.m.; open on May 1, November 1 and December 8;
closed only on December 25 and January 1

MAK Depot of Contemporary Art Gefechtsturm Arenbergpark
Dannebergplatz/Barmherzigengasse, Vienna 3 (U3 / Rochusgasse;
Bus line 74A / Hintzerstraße). Every Sunday May – November

MAK Branch Geymüllerschlössel
Collection Sobek, Khevenhüllerstraße 2, Vienna 18 (Tram line 41 / Pötzleins-
dorf; Bus line 41A / Khevenhüllerstraße). Every Sunday May – November

Josef Hoffmann Museum, Brtnice
A joint branch of the MAK Vienna and the Moravská galerie in Brno
Náměstí Svobody 263, 58832 Brtnice, Czech Republic
Tel (+43-1) 711 36-250, e-mail josefhoffmannmuseum@MAK.at
www.MAK.at. November – March Sat, Sun 10 a.m.–5 p.m., April –
October Tue–Sun 10 a.m.–5 p.m., July & August daily 10–5 p.m.

MAK Center for Art and Architecture, Los Angeles
Schindler House, 835 North Kings Road, West Hollywood, CA 90069
Wed–Sun 11 a.m.–6 p.m., closed Mon, Tue
Tel (+1-323) 651 1510, fax (+1-323) 651 2340,
e-mail MAKcenter@earthlink.net www.MAKcenter.com
Mackey Apartments, 1137 South Cochran Avenue, Los Angeles, CA 90019
Every first Friday of the month 11 a.m.–6 p.m.
Fitzpatrick-Leland House, Mulholland Drive/8078 Woodrow Wilson
Drive, Los Angeles, CA 90046
Every first Friday of the month, advanced reservation required

CAT GROUP

Established to promote the development and realization of CAT – Contemporary Art Tower

Johannes Strohmayer *President*
Karl Newole *Vice-President*

Barbara Redl *Project management*

CAT International Advisory Board
Catherine David
Boris Groys
Cornelius Grupp
Andreas Treichl
Paul Virilio

MAK ACADEMY

The MAK ACADEMY is an initiative that aims at providing interested visitors and specialists expertise from the museum. The focus is on the MAK's collection and its current exhibitions.
Informing its participants about the themes of the MAK collections on the basis of originals is one of the main objectives of the MAK ACADEMY. In addition, directors of the various collections, restorers and guest lecturers will expand on specific themes through lectures, demonstrations, and occasional excursions.
The MAK ACADEMY takes place on weekends during the first half of the year; the number of participants is restricted to twenty. The program can be obtained in the fall of the previous year from www.MAK.at as well as from makakademie@MAK.at

MAK ART SOCIETY (MARS)

Since 1986 the MAK ART SOCIETY has offered art lovers the chance to participate actively in MAK activities. Members are directly involved in artistic productions. They support the MAK in research projects, the purchase of artworks or exhibition projects. The MAK ART SOCIETY organizes previews to exhibition openings, guided tours, exclusive happenings like Ladies' Guide, Ladies' Evening and "My Favourite Object", it provides numerous benefits in the MAK as well as free entry to MAK NITE℮ and all MAK branches. MINI MARS offers workshops for children

MARS Executive Office
Michaela Hartig
Tel (+43-1) 711 36-207
fax (+43-1) 711 36-213
e-mail makartsociety@MAK.at
Johannes Strohmayer (auditor)
Arno Hirschvogl (auditor)

MARS Board of Directors
Eva Schlegel
 President
Cornelius Grupp
 President
Peter Noever
 Vice-President
Gregor Eichinger
 Keeper of the Minutes
Manfred Wakolbinger
 Cashier
Martin Böhm
Ingrid Gazzari
Georg Geyer
Michael Hochenegg
Johannes P. Willheim

MAK Artist Board
Vito Acconci, New York
Coop Himmelb(l)au, Vienna
Bruno Gironcoli, Vienna
Zaha M. Hadid, London
Jenny Holzer, New York

Dennis Hopper, Los Angeles
Rebecca Horn, Bad König,
 Germany
Magdalena Jetelová,
 Bergheim-Thorr, Germany
Ilya & Emilia Kabakov, New York
Jannis Kounellis, Rome
Maria Lassnig, Vienna
Thom Mayne, Los Angeles
Oswald Oberhuber, Vienna
Roland Rainer
Kiki Smith, New York
Franz West, Vienna
Lebbeus Woods, New York
Heimo Zobernig, Vienna

**International MAK
Advisory Board**
Gerti Gürtler, Vienna
 President
Marylea van Daalen,
 Moscow-Berlin
Rolf Fehlbaum, Basel
Ernfried Fuchs, Vienna
Francesca von Habsburg, Vienna
Eva-Maria von Höfer, Vienna
Ursula Kwizda, Vienna
Ronald S. Lauder, New York
Franz-Hesso zu Leiningen,
 Tegernsee, Germany
Veronika Piëch, Vienna
Thaddaeus Ropac, Salzburg
Frederick & Laurie Samitaur Smith,
 Los Angeles
W. Michael Satke, Vienna
Penelope Seidler, Sydney
Thomas Streimelweger, Vienna
Iwan Wirth, Zurich

MAK ARTISTS AND ARCHITECTS
IN RESIDENCE PROGRAM
(Mackey Apartments,
R. M. Schindler, 1939)
In cooperation with the MAK, the
Austrian Federal Ministry for
Education, the Arts and Culture
awards annually a total of eight
scholarships for residency at the
Mackey Apartments, Los Angeles.

The main focus of the Scholarship
Program is on the purposeful long-
term support of individual free-
lance artists, advanced students
of architecture, and graduates of
architecture immediately after
completion of their degree, and on
creating new interdisciplinary
opportunities and confrontations
through a lively exchange pro-
gram.
The clear orientation towards
experimentation at the borderline
of art and architecture is at the
center of the Program. Due to its
purposeful and practice-oriented
structure (involvement in organiz-
ing the programs at the Schindler
House, cooperation with universi-
ties, artists and architects, and
exhibition activities) the Scholar-
ship Program provides an oppor-
tunity for a broad discourse with
topical questions of art and archi-
tecture.
The decision is made once a year
by an international jury. Former
artists and architects in residence
included among others Swetlana
Heger & Plamen Dejanov, G.R.A.M.
(Martin Behr, Günther Holler-
Schuster, Ronald Walter, Armin
Ranner), Gelatin (Ali Janka &
Tobias Urban), Jun Yang, Dorit
Margreiter, Richard Hoeck.
Information:
Tel (+43-1) 711 36-274,
fax (+43-1) 711 36-252,
e-mail exhib@MAK.at,
www.MAK.at

MAK EDUCATIONAL PROGRAM
AND GUIDED TOURS
The MAK places great emphasis
on its art mediation program.
The spectrum ranges from the
smallest module (guided tours),
lectures, workshops, the MAK
ACADEMY, to discussions on art.

Children's program 2002

Information on various current activities, such as weekly guided tours, can be obtained from the homepage and the two-monthly program.

Preparing topics related to the MAK's collections and exhibitions for certain age groups is the basis for the monthly program such as MAK SENIORS, MAK4FAMILY, and MINI MAK.

With similar intentions, specific programs are also developed for school children (from primary to professional schools) or universities and are further supplemented on the basis of personal experience.

Interested individuals and groups can avail of all these theme-based programs by prior appointment. The preoccupation with the object and the history of its cultural and stylistic development are to show the visitor how adequate information and expanded context can make a visit to the museum a stimulating experience.

MINI MAK

MINI MAK is the MAK's program for our youngest museum visitors. Together we "discover, explore, and comment" on the collections and the exhibitions of the MAK. All observations are put to practice in workshops.

Further adventures for children include the summer break game and MINI MAK before Christmas. There are guided tours and workshops every third Sunday in the month at 11 a.m. for children from 4 years.

Special MINI MAK programs for festivals and school excursions can be organized at any time upon request. Free admission for children 6 years or younger, charge for pupils and accompanying adults.

MAK4FAMILY

Special family tours are offered one Saturday per month at 3 p.m. Free admission, tour and service charge, free for children at the age of 6 and younger.

MAK SENIORS

On every third Wednesday of the month at 3 p.m., tours of current exhibitions or focused on specific highlights of the collection, combined with a subsequent visit to the restaurant ÖSTERREICHER IM MAK, giving the opportunity to discuss the subjects. Overall fee, booking required.

MAK TOURS

Every Saturday at 11 a.m. in German and every Sunday at 12 p.m. in English. For major exhibitions the MAK offers specific art education programs with tours of the exhibition, as well as continuous information services

and short tours (Sat 2–4 p.m.).
On selected Thursdays at 5 p.m.
MAK curators guide through their
exhibitions. Tour charge.

MAK for Schools

A comprehensive program for
schools with individual offerings
for groups from kindergarten to
secundary school. Tours focusing
on certain aspects of applied art:
on objects, materials, periods,
and special topics are combined
with workshops. Groups free of
charge, booking required.

Free Admission

On October 26, the Austrian
national holiday, and the MAK
DAY – Open House, the MAK
charges no admission.
Free Admission on Saturdays©.
POWERED BY *Verbund*

In addition to its regular weekly
program, the MAK gladly offers
individual tours on request.
Languages, subjects, and number
of participants depend on the
visitors' preferences.
Booking required.
Information:
Tel (+43-1) 711 36-248,
(Tue–Sun 10 a.m.–6 p.m.)
Booking: Gabriele Fabiankowitsch
Tel (+43-1) 711 36-298
(Mon–Fri 10 a.m.–4 p.m.)
fax (+43-1) 711 36-388
e-mail education@MAK.at

MAK DESIGN INFO POOL

The services offered by the MAK
Design Info Pool (DIP) include an
interactive monitor to provide
visitors information about the
MAK, information services on the
World Wide Web:
www.MAK.at/design and target
group mailings as well as com-

missioned research.
Information:
Tel (+43-1) 711 36-305
(Mon–Fri 1 p.m.–5 p.m.)
e-mail design@MAK.at
www.MAK.at/design

MAK DESIGN SHOP

The MAK Design Shop, remodeled
in 2007, is a treasure trove for
fans of sophisticated design. The
shop offers select international
design and young Austrian design,
design classics and new discover-
ies, design products specifically
developed for the MAK exhibitions,
artists' editions, catalogues and
premium publications etc. – the
best presents to be had in the
city at a range of prices. Design
meets public after the After Work
Meeting Point on several Thurs-
days per year: young designers
present their newest products.
Opening hours:
Tue MAK NITE© 10 a.m.–12 p.m.,
Wed–Sun 10 a.m.–6 p.m.
Information:
Tel (+43-1) 711 36-228
fax (+43-1) 711 36-213
e-mail service@makdesignshop.at
Online orders:
www.MAKdesignshop.at

MAK LOUNGE
FOR MARS MEMBERS ONLY

Information: Michaela Hartig
Tel (+43-1) 711 36-206
fax (+43-1) 711 36-213
e-mail makartsociety@MAK.at

MAK NITE©: EVERY TUESDAY FROM 10 A.M.–12 P.M.

MAK NITE© is a weekly event at
the MAK. It works as a laboratory
for various positions and presen-
tations with current relevance.
As an interdisciplinary event,
MAK NITE© not only incorporates

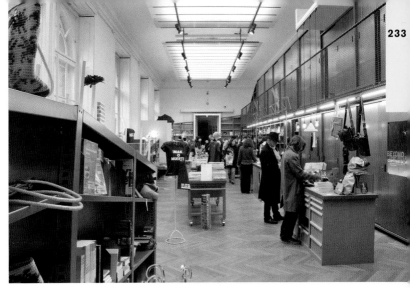

MAK Design Shop, remodeled in 2007

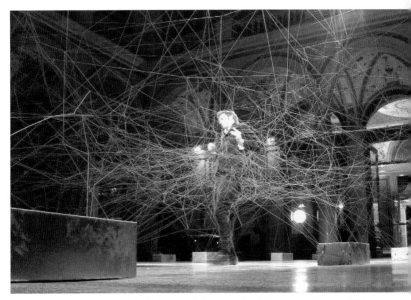

MAK NITE^c, networking red hall, thomas j. hauck und sabine kaeser (das archiv) 2002

the exhibition-related fringe program of architecture/design but also performance art, music, and fashion. The emphasis here is on artistic interventions that react to the complexity of the venue and of the space.

Apart from guided tours through the MAK and the exhibitions, MAK NITE[©] also offers art-lovers a comprehensive program that introduces architects and designers who are working as a collective and who represent the complex interaction between architecture, design, and art. The program extends further to book presentations, readings, and public discussions with artists.

Music lovers, too, get their share

ÖSTERREICHER IM MAK

with projects that expand their various genres to achieve singular variations of contemporary forms of music.

The MAK NITE© fashion series will be continued. Well received by the public, it offers the national and international fashion scene a forum at the MAK.

ÖSTERREICHER IM MAK

At the restaurant.bar designed by the Austrian architects eichinger oder knechtl, renowned chef Helmut Österreicher creates Viennese cuisine in a contemporary ambiente.

Opening hours:
Tue–Sun 8.30 a.m.–2 a.m.,
cuisine: 8.30 a.m.–11.30 p.m.,
closed on Mondays
Tel (+43-1) 714 01 21

MAK PUBLICATIONS

See p. 239 and www.MAK.at

MAK Reading Room

MAK READING ROOM

In the process of reconstructing the MAK, a second ceiling was put in so that additional space for a reading room was created (designing artists: **Ursula Aichwalder** and **Hermann Strobl**). This public study room allows for the holdings to be used.

Both the historical and the new acquisitions are now also available to the public on the Internet under www.MAK.at/service. Books found on the Web can be ordered and immediately accessed in the reading room during opening hours. A wide range of current magazines, lexicons, and art guides as well as lap-top work space and the MAK's Design Info Pool database are available to visitors in the open-shelf area.

Color copies, scans, and photos can be commissioned and appointments made for the use of the Works on Paper Collection by prior arrangement on phone or under library@MAK.at. Scientific information can also be obtained on the phone. Thus, since its opening in 1993, the MAK Library's reading room has rapidly established itself as a center for dialogue and information.

Opening hours:
Tue–Sun 10 a.m.–6 p.m.,
free admission
Research on publications:
www.MAK.at/service
Use of the Works on Paper Collection and scientific information service by appointment only: Tel (+43-1) 711 36-259
fax (+43-1) 711 36-222
e-mail library@MAK.at

MAK RESTORATION DEPARTMENT
We restore for you!
We accept contracts from outside.
Information:
Manfred Trummer
Tel (+43-1) 711 36-260
fax (+43-1) 711 36-222

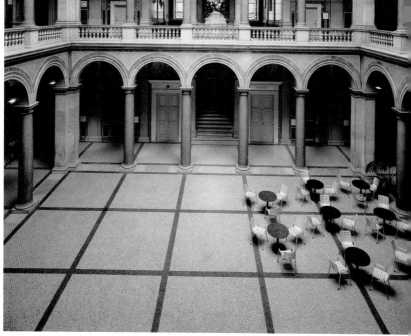

MAK Columned Main Hall

MAK RENTALS

The representative rooms of the MAK, such as its columned main hall, its lecture hall, and its exhibition halls are perfect locations for events. The backdrop of the MAK exhibitions and special programs makes dinners, symposia, and product presentations in the house on Stubenring an unforgettable experience.

Information
Irmtraut Hasenlechner
(Special Events)
Tel (+43-1) 711 36-205
fax (+43-1) 711 36-213

e-mail
commercial-events@MAK.at
www.MAK.at

MAK UFI – URBAN FUTURE INITIATIVE
(Fitzpatrick-Leland House, R. M. Schindler, 1936)

The MAK UFI – Urban Future Initiative is a fellowship program of the MAK Center for Art and Architecture funded by a major grant from the U.S. Department of State's Bureau of Culture and Education ($ 410,000 over the course of two years, starting in

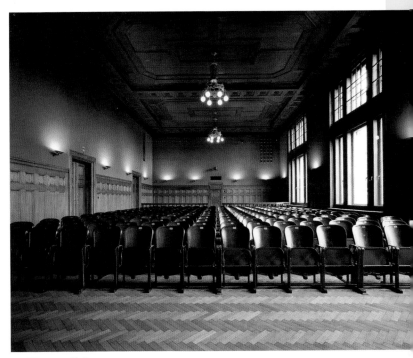

MAK Lecture Hall

2008) in which cultural resear-
chers from diverse nations come
to Los Angeles for two months,
live in the exemplary L.A. modern
Fitzpatrick-Leland House and
pursue a research topic related to
urban phenomena. The fellows
come from nations that are under-
represented in the Los Angeles
discourse; the MAK Center works
closely with them to create a
meaningful cross-cultural ex-
change. The goal is to generate
concepts for the urban future by
stimulating dialogue and mining
both Los Angeles and internatio-
nal resources. UFI fellows inclu-
ded Marco Kusumawijaya
(Indonesia), Éfren Santana
(Venezuela), Ismail Farouk (South
Africa), Xiangning Li (China),
Alexia Leon (Peru), Nasrin
Tabatabai and Babak Afrassiabi
(Iran), Alaa Mohamed Ahmed
Khaled and Salwa Ali Rashad
(Egypt).
Information:
Tel (+1-323) 651-1510,
fax (+1-323) 651-2340,
www.MAKcenterufi.org

MAK PUBLICATIONS

MAK PUBLICATIONS SINCE 1986
(SELECTION)

Josef Hoffmann, 1870–1956. Ornament zwischen Hoffnung und Verbrechen. Ed. Peter Noever, Oswald Oberhuber. Salzburg: Residenz 1987, out of print

Art and Revolution. Russian and Soviet art 1910–1932. Catalogue of displayed works. Ed. Peter Noever. Vienna 1988, out of print

Bernard Rudofsky: Sparta / Sybaris. Keine neue Bauweise, eine neue Lebensweise tut not. Salzburg, Vienna: Residenz 1987, out of print

Aktionsmalerei – Aktionismus, Wien 1960–1965. Ed. Peter Noever. Vienna: Gesellschaft für Österreichische Kunst 1989, out of print

Walter Pichler. Skulptur. Ed. Peter Noever. Vienna: Residenz 1990, out of print

Donald Judd. Architecture. Ed. Peter Noever: Vienna: MAK 1991, new edition 2003, € 35

Aleksandr M. Rodchenko, Varvara F. Stepanova. The Future is our only goal ... Ed. Peter Noever. Munich: Prestel 1991, € 20

Josef Hoffmann Designs. MAK – Austrian Museum of Applied Arts, Vienna. Ed. Peter Noever. Munich: Prestel 1992, out of print

Magdalena Jetelová. Domestizierung einer Pyramide. Ed. Peter Noever. Wien: MAK 1992, € 10

Vito Acconci. The City inside Us. Ed. Peter Noever. Vienna: MAK 1993, € 20

The End of Achitecture? Documents and Manifestos: Vienna Architecture Conference. Ed. Peter Noever. Munich: Prestel 1993, € 25

Positionen zur Kunst/Positions in Art. MAK Round Table. Ed. Peter Noever. Vienna: MAK; Ostfildern: Cantz 1994 € 14

Sergej Bugaev Afrika. Crimania. Ed. Peter Noever. Ostfildern: Cantz 1995, € 25

Roland Rainer. Vitale Urbanität. Wohnkultur und Stadtentwicklung. Vienna, Cologne, Weimar: Böhlau 1995, out of print

MAK Center for Art and Architecture. R. M. Schindler. Ed. Peter Noever. Munich, New York: Prestel 1995, out of print

Silent & Violent. Selected Artists' Editions. Ed. Peter Noever. Zurich: Parkett, Ostfildern: Cantz 1995, € 20

Chris Burden: Beyond the Limits. Jenseits der Grenzen. Ostfildern: Cantz 1996, out of print

Architecture Again. The Havana Project. International conference on architecture, Havana, Cuba. Ed. Peter Noever. Munich, New York: Prestel 1996, € 23

Austria im Rosennetz. Eine Ausstellung von Harald Szeemann. Ed. Peter Noever, Gesellschaft für Österreichische Kunst im MAK, Vienna, und Kunsthaus Zurich. Vienna, New York: Springer 1996, out of print

Margarete Schütte-Lihotzky. Social Architecture. Zeitzeugin eines Jahrhunderts. Ed. Peter Noever, MAK. Vienna, Cologne, Weimar: Böhlau 1996, out of print

Philip Johnson: Turning Point. Ed. Peter Noever. Vienna, New York: Springer 1996, € 20

japan today. Kunst, Fotografie, Design. Ed. Peter Noever. Vienna: MAK 1997, € 14

Bruno Gironcoli. Die Ungeborenen. The Unbegotten. Ed. Peter Noever. Ostfildern: Hatje 1997, € 18

japan yesterday. Traces and Objects of the Siebold Travels. Ed. Peter Noever, Gesellschaft für Österreichische Kunst im MAK, Vienna. Munich, New York: Prestel 1997, € 22

Art in the Center. Zwei Gespräche zur documenta X. Ed. Peter Noever. Stuttgart: Cantz 1997, € 10

Christopher D. Roy: Kilengi. Afrikanische Skulpturen aus der Bareiss-Sammlung. Ed. Carl Haenlein, Kestner Gesellschaft. Hannover: Th. Schäfer 1997, € 35

Otto Muehl. 7. Ed. Peter Noever. Ostfildern: Cantz 1998, € 20

Martin Kippenberger. The Last Stop West. Ed. Peter Noever. Ostfildern-Ruit: Cantz 1998, € 16

James Turrell. the other horizon. Ed. Peter Noever. Ostfildern: Cantz 1998, € 30

Visionary Clients for New Architecture. Ed. Peter Noever, Munich: Prestel 2000, € 21

Jannis Kounellis. Il sarcofago degli sposi. Ed. Peter Noever. Ostfildern: Hatje, Cantz 1999, € 21

Oswald Oberhuber. Geschriebene Bilder. Bis heute / Written pictures. Up until now. Ed. Peter Noever. Vienna, New York: Springer 1999, € 23

Spielwerke. Musikautomaten des Biedermeier aus der Sammlung Sobek und dem MAK. Ed. Peter Noever. Vienna: MAK 1999, out of print

Joseph Beuys. Editionen. Sammlung Reinhard Schlegel. Ed. Heiner Bastian, Peter Noever. Bielefeld: Tiemann 1999, Vienna: MAK 2000, out of print

Richard Prince. The Girl Next Door. Ed. Peter Noever. Ostfildern: Hatje Cantz 2000, € 14

Bruce Mau, André Lepecki: Stress. Remembering the Body. Ed. Gabriele Brandstetter, Hortensia Völckers. Ostfildern: Hatje Cantz 2000, € 28

Kunst und Industrie. Die Anfänge des Museums für angewandte Kunst in Wien. Ed. Peter Noever. Ostfildern: Hatje Cantz 2000, € 25

Peter Noever, Sepp Müller, Michael Embacher: **heaven's gift. CAT – Contemporary Art Tower. A New Programmatic Strategy for the Presentation of Contemporary art.** Ed. Peter Noever. Ostfildern: Hatje Cantz 2000, € 14

Frederick J. Kiesler. Endless Space. Ed. Dieter Bogner, Peter Noever. Ostfildern: Hatje Cantz 2001, € 28

Cine Art. Indische Plakatmaler im MAK. Indian Poster Painters at the MAK. Ed. Peter Noever. Vienna: MAK 2001, € 20

Dennis Hopper. A System of Moments. Ed. Peter Noever. Ostfildern-Ruit: Hatje Cantz 2001, € 32

Joseph Binder. Wien – New York. Ed. Peter Noever. Vienna: MAK 2001, € 15

Angela Völker: **Die orientalischen Knüpfteppiche im MAK.** Ed. Peter Noever. Vienna: Böhlau 2001, € 95

the discursive museum. Ed. Peter Noever. MAK Ostfildern-Ruit: Hatje Cantz 2001, € 18

Franz West. Merciless. Ed. Peter Noever. Ostfildern-Ruit: Hatje Cantz 2001, out of print

R. M. Schindler. Architektur und Experiment. Ed. Elizabeth A. T. Smith, Michael Darling. Ostfildern-Ruit: Hatje Cantz 2001, € 43

Davaj! Russian Art Now. Ed. Peter Noever, MAK, Joachim Sartorius, Berliner Festspiele. Ostfildern: Hatje Cantz 2001, € 20

Richard Artschwager. The Hydraulic Door Check. Ed. Peter Noever. Cologne: Verlag der Buchhandlung Walther König 2002, € 26

Ernst Deutsch-Dryden. En Vogue! Ed. Peter Noever. Vienna: MAK 2002, € 23

Zaha Hadid. Architecture. Ed. Peter Noever. Ostfildern: Cantz 2003, € 35

Kurt Kocherscheidt. The continuing image. Ed. Peter Noever. Cologne: Verlag der Buchhandlung Walther König 2003, € 34,80

Carlo Scarpa. The Craft of Architecture. Ed. Peter Noever. MAK Ostfildern: Cantz 2003, € 28, 80

Yearning for Beauty. For the 100th anniversary of the Wiener Werkstätte. Ed. Peter Noever. Ostfildern: Cantz 2003, € 49,90

Schindler's paradise: Architectural resistance. Ed. Peter Noever. Ostfildern-Ruit: Cantz 2003, € 25

Otto Muehl. Life/Art/Work. Action Utopia Painting. Ed. Peter Noever. Cologne: Verlag der Buchhandlung Walther König 2004, € 44

Birgit Jürgenssen. Schuhwerk. Ed. Peter Noever. Vienna: Holzhausen 2004, € 19

Yves Klein: Air architecture 1951–2004. Ed. Peter Noever. Ostfildern-Ruit: Cantz 2004, € 24,80

Peter Eisenmann. Barefoot on White-Hot Walls. Ed. Peter Noever. MAK, Ostfildern-Ruit: Cantz 2004, € 34

Schindler by MAK. Ed. Peter Noever. Munich: Prestel 2005, € 15

Lebbeus Woods. System Wien. Ed. Peter Noever. Ostfildern-Ruit: Cantz, Wien: MAK 2005, € 29,80

Atelier van Lieshout. The disciplinator. Ed. Peter Noever. Vienna 2005, € 21

Alexandr Rodchenko – Inventory of Space. Ed. Peter Noever. Vienna: Schlebrügge 2005, € 21

Yearning for Beauty. The Wiener Werkstätte and the Stoclet House. Ed. Peter Noever. Ostfildern-Ruit: Cantz 2006, € 58

J. & L. Lobmeyr. Between Tradition and Innovation. Ed. Peter Noever. MAK Vienna/ Munich: Prestel 2006, € 29.80

Jenny Holzer. XX. Ed. Peter Noever. Vienna: Schlebrügge 2006, € 25

Handle with Care. Contemporary Ceramics from Austria. Ed. Peter Noever. Vienna: MAK 2006, € 19

Elke Krystufek. Liquid Logic. Ed. Peter Noever. Ostfildern-Ruit: Cantz 2006, € 35

Gottfried Semper. The Ideal Museum. Practical Art in Metals and Hard Materials. Ed. Peter Noever. Vienna: Schlebrügge 2007, € 68

Sunset: Delayed. Andrea Lenardin Madden / Kasper Kovitz. Ed. Peter Noever. Vienna: MAK 2007, € 10

Held Together with Water*. Art from the Sammlung Verbund. Ed. Gabriele Schor. Ostfildern-Ruit: Cantz 2007, € 39

Laces and so on ... Bertha Pappenheim's Collections at the MAK. Ed. Peter Noever. Vienna: Schlebrügge 2007, € 23

Padhi Frieberger. No Art without Artists! Ed. Peter Noever. Vienna: MAK 2007, € 19

COOP HIMMELB(L)AU. Beyond the Blue. Ed. Peter Noever. Munich: Prestel 2007, € 39.90

Formless Furniture. Ed. Peter Noever. Ostfildern-Ruit: Cantz 2008, € 25

Julian Opie. Recent Works. Ed. Peter Noever. Ostfildern: Cantz 2008, € 35

INDEX OF
ARTISTS AND PERSONS

INDEX OF ARTISTS AND PERSONS

A number in bold type indicates the page on which a work of art (or the artist himself) is illustrated. Other numbers refer to names in the texts.

A

Abraham, Raimund 96, 103, 190
Acconci, Vito 102, 167, 190, 229, 232, 240; **180, 233**
Aichwalder, Ursula 233; **161**
Aigner, Uli 168
Altimonti, Heidi **136**
Ammann, Gerry 171
Ammann, Judith 171
Archduke Rainer 8, 9, 166
Archduchess Sophie **52**
Artěl **82**
Artschwager, Richard 167, 242; **177, 186**
Augarten 142
August, the Elector of Saxony 120

B

Bajtala, Miriam 172
Baron, Rebecca 169
Barragán, Luis 168
Barsuglia, Alfredo 172
Bast, Gerald 11
Baumann, Ludwig 9
Bayer, Herbert 102
Becker, Konrad 169
Beitl, Karl **81**
Benjamin, Walter 71
Bernard, Cindy 171
Beuys, Joseph 167, 242
Binder, Josef 168, 242
Bitter, Sabine 172
BKK-2 212
Bloom, Barbara 5, 17, 60, 61, 126; **58, 59**
Böck, Josef 142
Bolt, Catrin 171
Boltanski, Christian 190
Böttger, Wulf Walter 172
Boyraz, Songül 172
Brenner, Anton 218
Bretterbauer, Gilbert 171
Breuer, Marcel 70
Brod, Max **93**
Brooke, Kaucyila 172
Brus, Günter 102
Budde, Nine 172
Bugaev, Sergej Afrika 167, 240
Burden, Chris 167, 190, 241; **174, 175, 191**
Burgin, Victor 172

C

C.P.P.N. (Carl Pruscha/Peter Noever) 172; **192**
Campo, Matias Del 172
Carlone, Carlo Antonio 221
Cassina S.p.A. **149**
Castelbajac, Jean-Charles de 167
Castigioni, Achille 166
Chardin, Jean-Baptiste Siméon 30
Cito, Lorenzo Rocha 172
Cohen, Marc J. 172
COOP HIMMELB(L)AU 96, 103, 167, 190, 212, 229; **97**
Croy, Oliver 172
Czech, Hermann 5, 201, 212, 232
Czobor von Szent-Mihály 34
Czobor, Maria Antonia von 34

D

Dallas, Paul 172
Danhauser'sche Möbelfabrik 160; **51**
Daum, Bonaventura 222
Dejanov, Plamen 169, 170, 230
Deutsch-Dryden, Ernst 168, 242; **132**
Diehn, Julien 172
Diehnelt, Franka 171
Doesinger, Stefan 171
Domenig, Günther 96, 103, 167, 168, 190, 212
Donner, Raffael 221
Doser, Barbara 168
Dreux, Béatrix 171
Driendl*Steixner 96
Du Paquier, Claudius Innocentius 34, 142
Dubsky von Trebomyslic, Franz 34
Dunst, Heinrich 169
Dürer, Albrecht 166
Dworschak, Alexander 172

E

Eames, Charles 168
Eames, Ray 168
Eder, Bernhard 172
Egermann, Friedrich **54**
Eichinger oder Knechtl 5, 70, 71, 126, 213, 214; **68, 69**
Eichinger, Gregor 102, 126
Eisenman, Peter 167
Eitelberger, Rudolf von 8, 160
Embacher, Michael 194, 242; **132, 195, 237**

Emmer, David J. 172
Emperor Franz Josef 8
Erbrich, Adolf **90**
Esslinger, Sophie 171
Esterhazy, Mathis 20; **18, 19**
Export, Valie 214

F
Fabiani, Max 219, 220
Faust, Marina 169
Ferstel, Heinrich von 8, 217
Février, Nicolas 171
Finiguerra, Maso **26**
Fink, Tone 170
Fischer von Erlach, Johann Bernhard 221, 222
Fischer von Erlach, Josef Emanuel 220, 221
Fischer, Heinz **186**
Fischer, Herbert **51**
Flick, Robbert 172
Fogarasi, Andreas 169, 172
Förg, Günther 5, 20, 126; **18, 19**
Forstner, Leopold 71
Fortuny, Mariano **157**
Frank, Heinz 102
Frank, Josef 70, 218, 222
Franz, Karl Adolf **79**
Freimund, Anke 172
Frid, Åse 171
Frid, Johan 171
Friedberger, Padhi 102, 167
Fuetterer, Marta 171

G
Gallé, Emile 138
Gangart 5, 110, 126; **108, 109**
Geers, Kendell 169; **182**
Gelatin 171, 230
Gehry, Frank O. 103; **96**
Gerl, Mathias 221
Gerngross, Heidulf 212, 213
Geymüller, Johann Jakob 198
Gfader, Robert 171
Gilbert & George 190
Gillick, Liam 169
Gironcoli, Bruno 102, 167, 190, 229, 241; **179, 184, 191**
Gloggengiesser, Christine 171
Gombotz, Thomas 171
Gonzáles, Mauricio Rafael Duk 172
Graf, Franz 5, 41, 126; **38, 39**
Gräfin Regine d'Aspremont **33**
G.R.A.M. 171, 230
Granular Synthesis 167, 169, 172, 173
Green, Renée 190
Grisebach, Valeska 169
Grossarth, Ulrike 169, 173

H
Haberstrumpf, Nikolaus **32**
Hackhofer, Josef 217, 219
Hadid, Zaha 96, 103, 167, 229; **99**
Haerdtl, Oswald 70, 213, 218
Hahnenkamp, Maria 169
Hammerstiel, Robert F. 169
Haring, Marlene 171
Häring, Hugo 218
Harrach'sche Glasfabrik **54**
Hauck, Thomas J. **234**
Haupt, Benjamin 172
Hauslab, Franz von **33**
Haydn, Joseph 37
Hecker, Florian 171
Heep, Eldine 172
Heger, Swetlana 169, 170, 230
Hejduk, John 96, 103
Henke, Dieter 212
Herend Porcelain Factory 34
Hesik, Elisabeth 171
Hiesmayr, Ernst 212
Hildebrandt, Johann Lucas von 221, 222
Hoeck, Richard 169, 172, 230
Hofer, Siggi 171
Hoffmann, Josef 9, 11, 70, 71, 86, 138, 142, 155, 168, 172, 202, 203, 217, 218, 240; **64, 80, 83, 88, 92, 203**
Hofmann, Alfred 86
Holub, Barbara 172
Holzer, Jenny 5, 50, 127, 167, 190, 195, 229; **48, 49, 51, 186, 196, 197**
Hoppe, Emil 222
Hopper, Dennis 167, 171, 229, 242; **185**
Horn, Rebecca 190, 229
Hrabal, Florian **79**
Hrazdil, Caspar **78**
Huebser, Robert 172
Hullfish Bailey, David 172
Huneke, Helena 171

I
IKEA 17, 60
Illner, Franz 222
Innsbruck Imperial Glass Factory **44, 47**

J
Jabornegg & Pálffy 208
Jadot de Ville-Issey, Jean Nicolas 220
Jaksch, Hans 212
Jetelová, Magdalena 102, 167, 229, 240
Jirkuff, Susanne 171
Johnson, Philip 5, 102, 168, 190, 202, 223, 241; **202**
Judd, Donald 5, 17, 30, 70, 102, 127, 167, 170, 200, 223, 240; **28, 29, 37, 103, 200, 203**
Julien, Isaac 172
Jürgenssen, Birgit 102, 190

K

Kabakov, Emilia 229; **192**
Kabakov, Ilya 167, 190, 229; **192, 193**
Kaeser, Sabine **234**
Kahr, Rochus 171
Kaltenbrunner, Christoph 172
Kamprad, Ingvar 60
Kasperkovitz, Christoph 171
Kaucky, Barbara 172
Kern, Josef **55**
Keyll, Johann **46**
Kienzer, Michael 5, 169; **201**
Kiesler, Friedrich (Frederick J.) 96, 103, 171, 242; **133**
Kikauka, Laura 169
Kippenberger, Martin 5, 171, 241
Kirsch, Hugo F. 142
Klablena, Eduard 142
Klein, Yves 169
Klimt, Gustav 70, 71, 211; **72, 73, 74, 75**
Knechtl, Christian 126
Knizak, Milan 102
Köb, Edelbert 168
Kocevar, Andrea 170
Koch, Konrad **88**
Kocherscheidt, Kurt 167
Koelbl, Wolfgang 171
Kogelnik, Kiki 169
Kogler, Peter 170
Kohn, J. & J. **64, 65**
Kollmann, Rayner I. 37
Komad, Zenita 172
Kothgasser, Anton 138; **56**
Kounellis, Jannis 167, 229, 241; **178**
Kovitz, Kasper 169
Kovylina, Elena 172
Kowanz, Brigitte 102
Krasnik, Antoinette 142
Kraus, Karl 201
Krauß, Rudolf 219
Krautgasser, Annja 172
Krenn, Rosa 70; **79**
Krenn, Theresa 172
Krystufek, Elke 167; **187**
Krzeczek, Dariusz 172
Kulka, Heinrich 218
Kumpusch, Christoph A. 171
Kunigunde 21; **21, 22**
Kupelwieser, Hans 102, 167, 190; **106**
Kuramata, Shiro 168; **177**
Kurz, Sebastian 34
Kuzmany, Marion **137**

L

Ladstätter, Florian 170
Laimanee, Suwan 171
Lama, Jose Pérez de 172
Lambri, Luisa 172
Langer, Karl 218

Larner, Liz 169, 170, 190
Lassnig, Maria 229
Lechner, Heinz 168
Leimer, Sonia 172
Leischner, Erich 222
Leitner, Heinz 102
Leland, Russ 204; **205**
Lenardin Madden, Andrea 169, 171
Lepecki, André 167, 242; **184**
Libeskind, Daniel 96; **98**
Lichtblau, Ernst 218
Liebscher, Martin 171
Lienbacher, Ulrike 169
Lieshout Van, Joep 167
Ligorio, Deborah 171
Lindner, Gerhard 151, **151**
Linortner, Christina 172
Lissy, Christoph 102
List, Adele **156**
Litschauer, Maria Theresia 169
Lobmeyr, J. & L. 138, 211
Loetz **82**
Loos, Adolf 70, 168, 170, 213, 218, 220, 222, 223; **65**
Lulic, Marko 171
Lurçat, André 218
Lynn Greg 169

M

Macdonald, Margaret 70, 71; **76, 77**
Mack, Mark 168
Mackintosh, Charles Rennie 71
Maeterlinck, Maurice 71; **76, 77**
Manninger, Sandra 172
Manzú, Giacomo 166
Margreiter, Dorit 169, 172, 230
Mark, Helmut 102
Mark, Manuela 172
Martinelli, Domenico 221
Martitz, Wilhelm Gottlieb **35**
Matsch, Franz von 219
Matta-Clark, Gordon 171; **104**
Matthys, Kobe 172
Matuschek, Franz 222
Mau, Bruce 167, 242; **184**
Mayne, Thom – Morphosis Architects 96
Mayne, Thom 190, 229
McCarthy, Paul 170
Meierhofer, Christine 169
Meißen 142
Messerschmidt, Franz Xaver 210
Meyer, Anna 171
Mildner, Johann Josef 138
Mittmannsgruber, Otto 168
Mohn, Gottlieb **56**
Mohn, Samuel 138
Mohn, Sigismund 138
Moises, David 172
Moser, Koloman 9, 86, 139, 142, 155; **78,**

81, 87, 89, 90, 91
Moss, Eric Owen 96, 103, 190
Muehl, Otto 167, 241; **185**
Müller, Sabine 172
Müller, Sepp 5, 194, 242; **13, 195**
Müller, Ulrike 171
Mundus **63**
Muñoz, Juan 190
Mussel, Judith-Karoline 171
Myrbach, Felician von 9

N
Nauman, Bruce 190
Nebel, Christoph 169
Neumeister, Johann 172
Neuwith, Flora 170
Niedermayer, Mathias 142
Nigg, Joseph 142
Nimmerfall, Karina 172
Ninsei, Nonomura **125**
Niscino, Tazro 172
Noever, Peter 5, 102, 127, 240, 241, 242; **4, 11, 12, 100, 101, 118, 119, 195, 237**
Nolte, Nick 60

O
Oberhofer, Roland 171
Oberhuber, Oswald 102, 167, 229, 241
Ohmann, Friedrich 217, 219
Olbrich, Joseph Maria 211, 217, 219
Opie, Julian 167; **187**
Ørrefors 139
Ospel, Anton 221

P
Paquier, Claudius Innocentius du 142
Pappenheim, Bertha 170
Passow, Beate 171
Peche, Dagobert 70, 86, 166, 170, 173, 241, 242; **90**
Peintner, Max 172
Pesce, Gaetano **149**
Petritsch, Paul 171
Pettibon, Raymond 169, 171; **182**
Peyer, Anton **36**
Peyrer-Heimstätt, Oona 172
Peyrer-Heimstätt, Paul 172
Piati von Tirnowitz, Emanuel 34
Piati, Emanuela von 34
Piati, Johann Georg von 34
Pichler, Walter 102, 167, 240; **13, 181**
Piranesi 160
Plecnik, Josef 218, 219
Pleschberger, Raimund 172
Plessy, Claude le Fort du **33**
Plischke, Ernst A. 218
Poell, Carol Christian 168; **135**
Poledna, Mathias 171
Pollion, Dionysius **36**

Ponocny, Karl **90**
Porsch, Johannes 171
Powolny, Michael 142, 166
Pozzo, Andrea 220, 222
Prag-Rudniker **149**
Prince Metternich 61
Prince Richard 169, 171, 242
Prince Eugen von Savoyen **33**
Princen, Bas 172
Pruscha, Carl 96, 103
Pumhösl, Florian 172
Putzu, Antonietta 171

Q
Quednau, Andreas 172

R
Rainer, Arnulf 102, 167, 172; **187**
Rainer, Roland 168, 190, 229, 240
Rajakovics, Paul 171
Raw 'n' Cooked 171
Rhoades, Jason 171
Rhomberg 155
Richter, Helmut 96, 212, 213
Rie, Lucie 169, 242
Rietveld, Gerrit 218
Rodchenko, Alexandr M. 167, 169, 172, 240
Roentgen, David **31**
Röhrle, Stefan 172
Roller, Alfred 9
Rönicke, Pia 171
Rosenberger, Isa 171
Rosenthal, Konrad A. 222
Rosipal, Josef **82**
Roth, Dieter 170
Rottenberg, Ena 142
Rottmann, Birgitta 171
Rudofsky, Bernard 168, 240
Ruhm, Constanze 171
Rusch, Corinne L. 171

S
Sagmeister, Stefan 168, 173
Salner, Georg 169
Sanktjohanser, Hubert Matthias 152; **153**
Sarpaneva, Timo 139
Sawada, Tomoko 169
Scala, Arthur von 8
Scarpa, Carlo 168, 170
Schabus, Hans 172
Schiller, Zsuzsa 171
Schilling, Alfons 102, 167, 240; **107**
Schindler, Rudolph M. 11, 96, 103, 167, 168, 169, 171, 204, 242; **204, 205**
Schinwald, Markus 171
Schlegel, Christof 171
Schlegel, Eva 102, 190; **193**
Schmalix, Hubert 102, 198, 222; **199**
Schmidt-Colinet, Lisa 171

Schmidt-Gleim, Meike 171
Schmidt in der Beek, Hank 172
Schmöger, Alexander 171
Scholz, Benjamin von 142
Schönthal, Otto 222
Schreieck, Marta 212
Schufrid, Jakob **57**
Schütte-Lihotzky, Margarete 130, 150, 151, 168, 241; **151**
Schwanzer, Karl 212
Schwarzkogler, Rudolf 102
Schweiger, Constanze 172
Seguso 139
Semper, Gottfried 160
Siebold, Franz-Philipp 170
Sika, Jutta 142
Singer, Franz 70; **78**
Six, Nicole 171
Smith, Kiki 168, 190, 229
Sobek, Franz 198
Sobotka, Walter 218
Sommer, Bernhard 172
Sorgenthal, Conrad Sörgel von 142
Sparham, Richard 172
Stähli, Béatrice 169, 190
Stanzel, Rudi 169; **183**
Station Rose 168
Steininger, Anna 168
Stepanowa, Warwara F. 167, 172, 240
Stieg, Robert Maria 168; **153**
Stoever, Katharina 172
Strauss, Martin 168
Streeruwitz, Karoline 171
Strnad, Oskar 218, 222
Strobl, Hermann 233; **161**
Strobl, Ingeborg 102
Strouhal, Ernst 173
Stutteregger, Martha 172
Sultan Lagin **117**
Szeemann, Una 171

T
Teckert, Christian 171
Tencala, Giovanni, Pietro 221
Terzic, Mario 102
Tesar, Heinz 212
Thater, Diana 171
Theiss, Siegfried 212
Thonet Brothers 211; **61, 65, 66, 67**
Thonet, Michael 60, 61; **62**
Thun, Matteo 167
Thürheim, Christoph Wilhelm the Older **46**
Tiffany, Louis C. 138
Tilner, Sonja 214
Topalovic, Milica 172
Traar, Jochen 168, 170
Trattner, Josef 169; **185**
Trethan, Therese **81**

Trockel, Rosemarie 168
Turk, Herwig 168
Turrell, James 5, 102, 167, 190, 195, 198, 203, 222, 223, 241; **105, 181, 203**

U
Udé, Iké 169

V
Velde, Henry van de 70
Venini 139, 166; **141**
Verdun, Nikolaus 211
Viennese Mosaic Factory 71
Viennese Porcelain Factory 34, 130, 142, 160; **54, 143**
Vikosavljevic, Zlatan 171
Vinciarelli, Lauretta 168
Vordermaier, Sonja 172

W
Waerndorfer, Fritz 71, 76, 86
Wagner, Otto 9, 70, 204, 217, 219, 220
Wahliss, Ernst 142
Wakolbinger, Manfred 5, 96, 102, 127, 169; **94, 95**
Wallraff, Michael 171
Warhol, Andy 167, 172
Weber, Helmut 172
Weibel, Peter 167
Weigand, Hans 102, 169, 171, 172
Weiner, Lawrence **187**
Weiss, Pierre 168
West, Franz 5, 102, 167, 173, 190, 201, 223, 230, 242; **106, 176, 187, 201**
Wiener Werkstätte 71, 86, 138, 155, 160, 166, 170, 173, 208; **80, 81, 83, 87, 88, 89, 90, 91, 92, 93**
Wiener, Zelko 168
Wieselthier, Vally **92**
Wildmann, Michael 171
Wimmer-Wisgrill, Eduard Josef 70, 166
Wines, James/SITE 5; **12**
Wittgenstein, Ludwig 212
Wlach, Oskar 222
Wolff, Barbara 172
Woods, Lebbeus 96, 103, 169, 190, 230

Y
Yamagata, Hiro 167
Yang, Jun 169, 171, 230

Z
Zeyfang, Florian 171
Zink, Yi David 172
Zobernig, Heimo 5, 86, 102, 128, 167, 170, 173, 230; **84, 85**
Zotti, Josef **149**
Zugmann, Gerald 169, 172
Zülow, Franz von 142

MAPS

+1 First Floor

A Foyer
B MAK Lecture Hall
C MAK Exhibition Hall
D Design Info Pool
E 20th/21st Centuries Architecture (Manfred Wakolbinger)
F Art Nouveau Art Déco (eichinger oder knechtl)
G Wiener Werkstätte (Heimo Zobernig)
H MAK Reading Room
I MAK Works on Paper Room
J James Turrell: MAKlite

0 Ground Floor

A MAK Exhibition Hall
B MAK Media Room
C Romanesque Gothic Renaissance (Günther Förg)
D Renaissance Baroque Rococo (Franz Graf)
E Baroque Rococo Classicism (Donald Judd)
F Orient (Gangart)
G Empire Style Biedermeier (Jenny Holzer)
H Historicism Art Nouveau (Barbara Bloom)
I MAK DESIGN SPACE
J MAK Design Shop
K *ÖSTERREICHER IM MAK*
L MAK Lounge
M James Wines/SITE: Tor zum Ring
N Walter Pichler: Tor zum Garten

-1 Basement

A Seating Furniture
B Ceramics
C Glass
D The Frankfurt Kitchen (Margarete Schütte-Lihotzky)
E Study Collection Furniture
F MAK Gallery
G Asia
H Textiles
I Metal

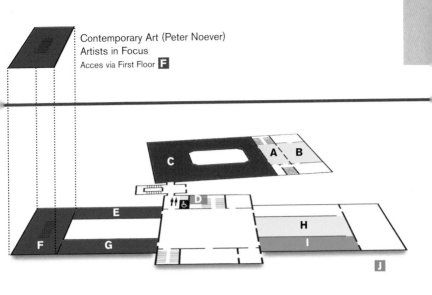

Contemporary Art (Peter Noever)
Artists in Focus
Acces via First Floor **F**

Entrance
Weiskirchnerstraße

Entrance Stubenring

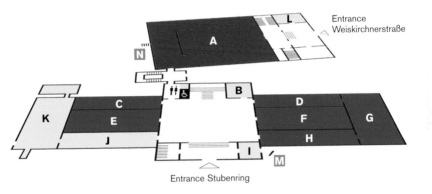

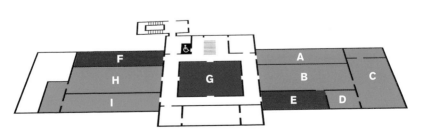

Exhibitions
Permanent Collection
Study Collection
MAK Service
Permanent Installation

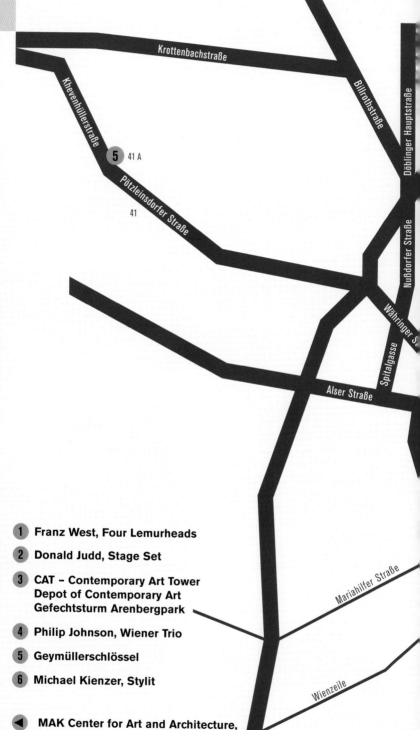

Krottenbachstraße

Billrothstraße

Döblinger Hauptstraße

Khevenhüllerstraße

5 41 A

Pötzleinsdorfer Straße

41

Nußdorfer Straße

Währinger S

Spitalgasse

Alser Straße

1 Franz West, Four Lemurheads

2 Donald Judd, Stage Set

3 CAT – Contemporary Art Tower
Depot of Contemporary Art
Gefechtsturm Arenbergpark

4 Philip Johnson, Wiener Trio

5 Geymüllerschlössel

6 Michael Kienzer, Stylit

◀ MAK Center for Art and Architecture,
Los Angeles

Mariahilfer Straße

Wienzeile

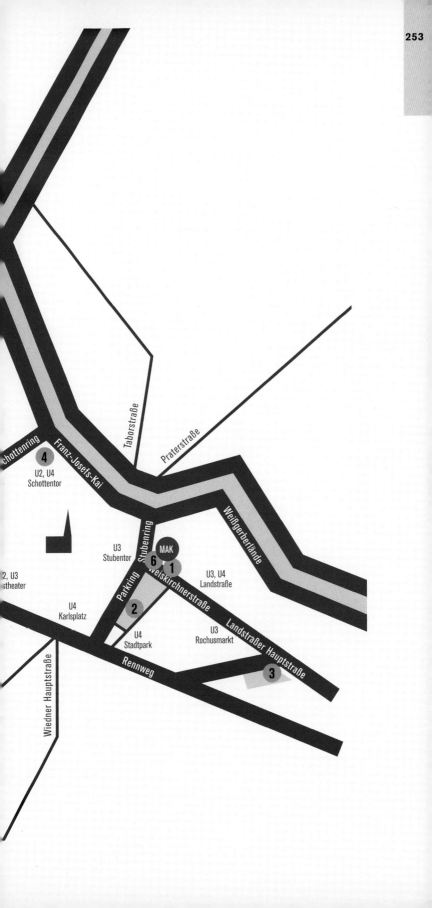

Taborstraße

Praterstraße

Schottenring

Franz-Josefs-Kai

4
U2, U4
Schottentor

Weißgerberlände

Stubenring

U3
Stubentor

MAK

6 **1**

U3, U4
Landstraße

Parkring

Weiskirchnerstraße

2, U3
stheater

U4
Karlsplatz

2

U4
Stadtpark

U3
Rochusmarkt

Landstraßer Hauptstraße

3

Wiedner Hauptstraße

Rennweg

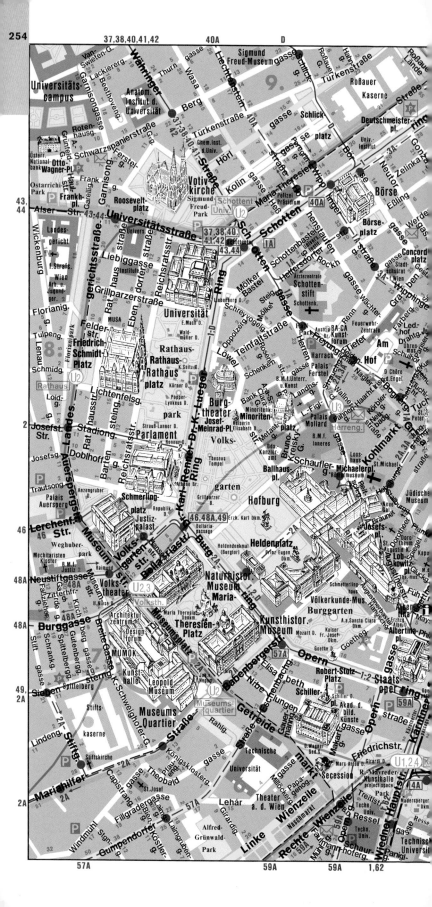

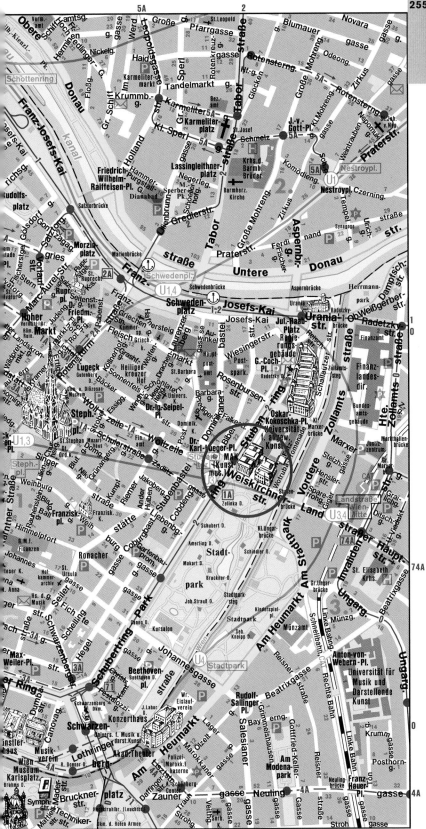

PHOTO CREDITS

All photos by Gerald Zugmann, except in the following cases: Lukas Beck (p. 186 top right), Manfred Burger (p. 180 top), Théodore Coulombe (p. 195), Herbert Fidler (p. 103, 193 bottom), Freytag & Berndt (p. 254/255), Corinna Gab (p. 185 top right), J. Getty Trust. Used with permission. Julius Shulman Photography Archive. Research Library at the Getty Research Institute (p. 204, 205), Pez Hejduk (p. 11, 185 upper top left), MAK/Andreas Krištof (p. 234), MAK/Georg Mayer (p. 12 top, 72/73, 74, 75, 76/77, 117 bottom, 133, 136, 137, 182 bottom, 201 right 231, 233 top), MAK/Manfred Trummer (p. 163), MAK/Ulf Wallin (p. 4, 186 upper top right), Karl Michalski/MAK (p.11), Peter Noever (p.176 bottom), Steve Seleska (p. 135 top, bottom right), Margherita Spiluttini (p. 183), Rupert Steiner (Cover), Katharina Stögmüller (p. 181 top, 184), Studio Acconci/MAK (p. 233 bottom), Wolfgang Woessner/MAK (p. 139, 143, 152, 153, 203, 233), Stefan Zeisler (p. 135 bottom left), Laurent Ziegler (p. 185 top left, bottom, 186 bottom, top left, 187)